This book is dedicated to
the people and land of Fukushima
and to the memories of
Sam Miller and Kyoko Hayashi

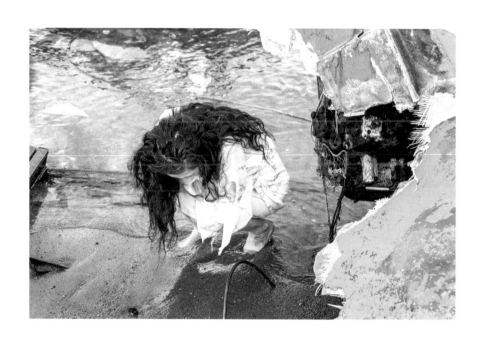

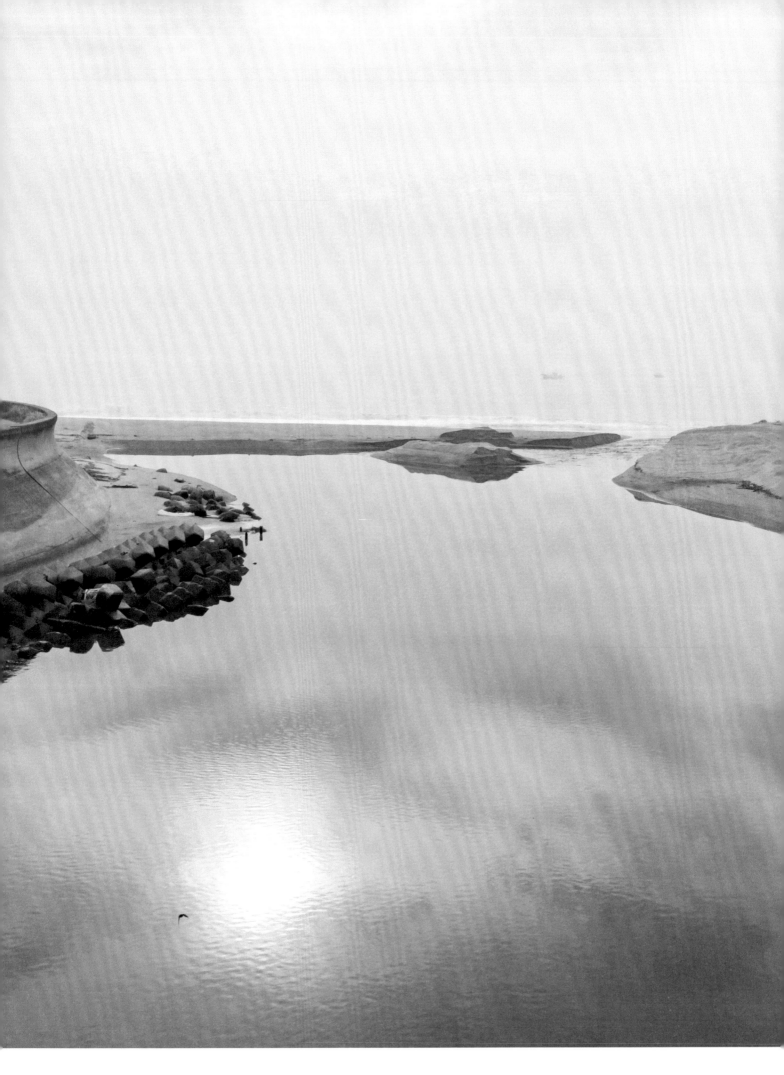

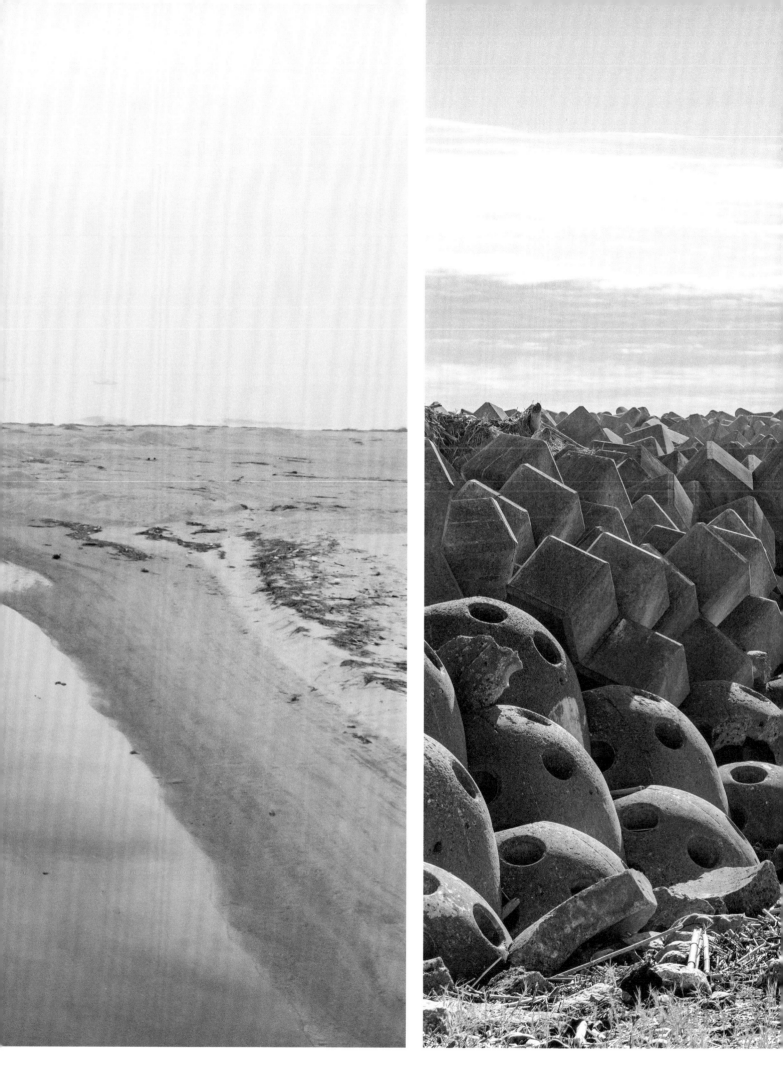

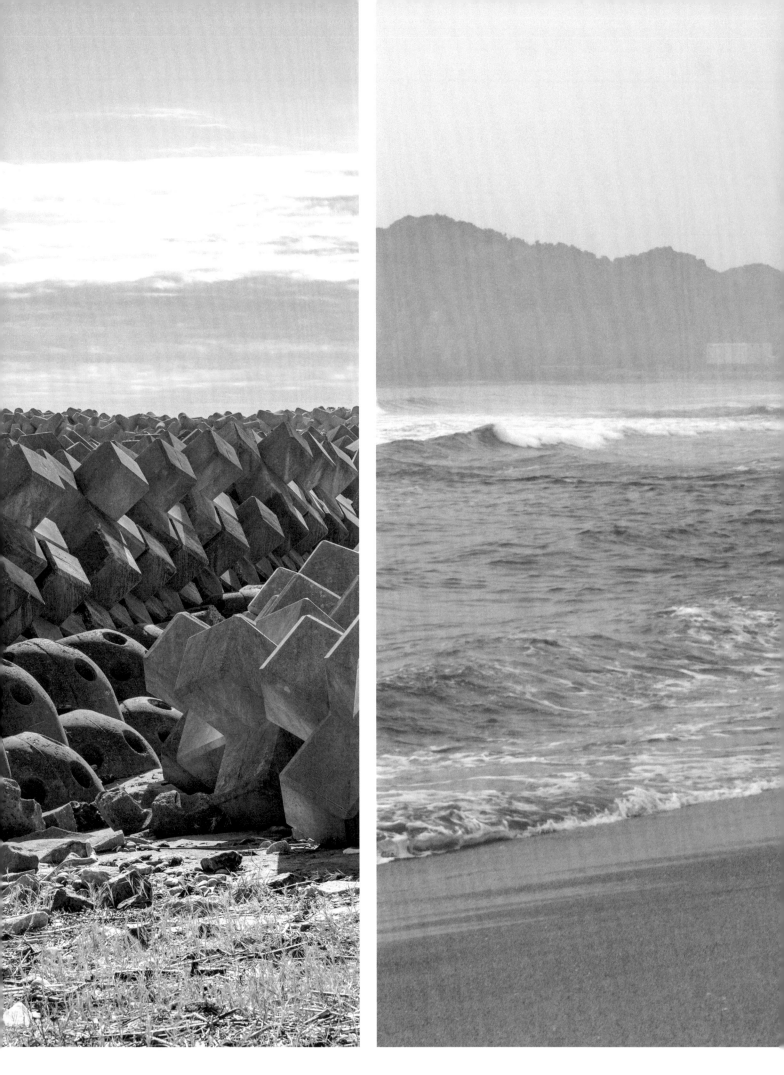

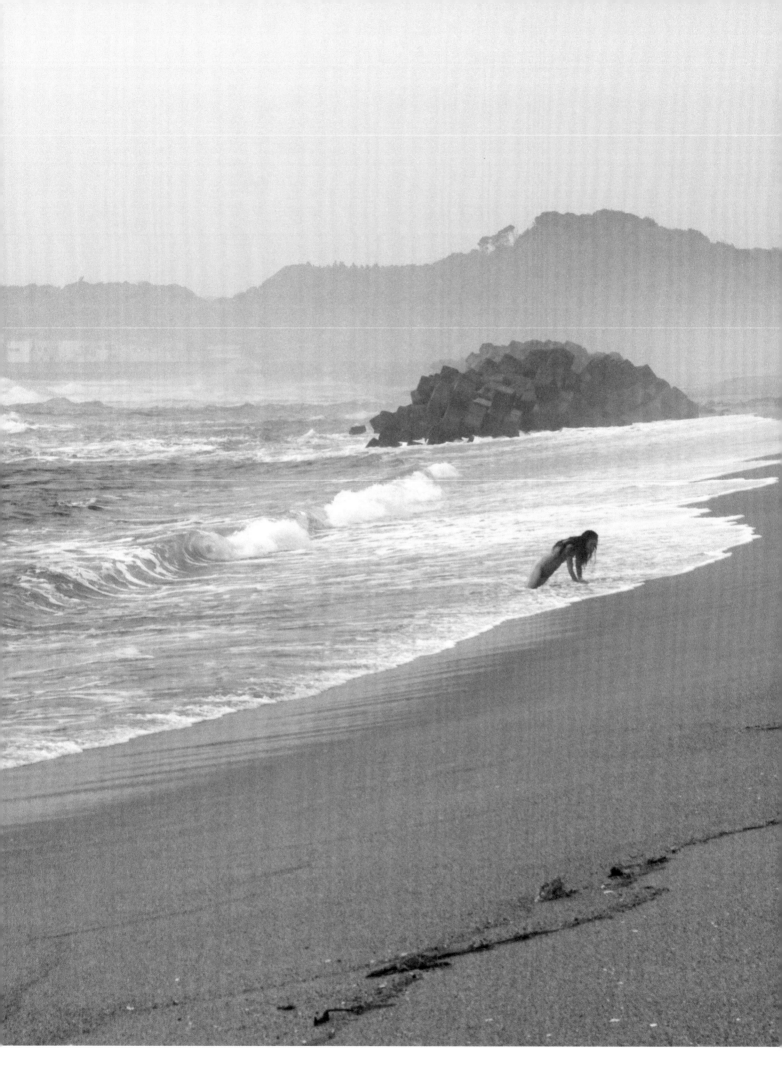

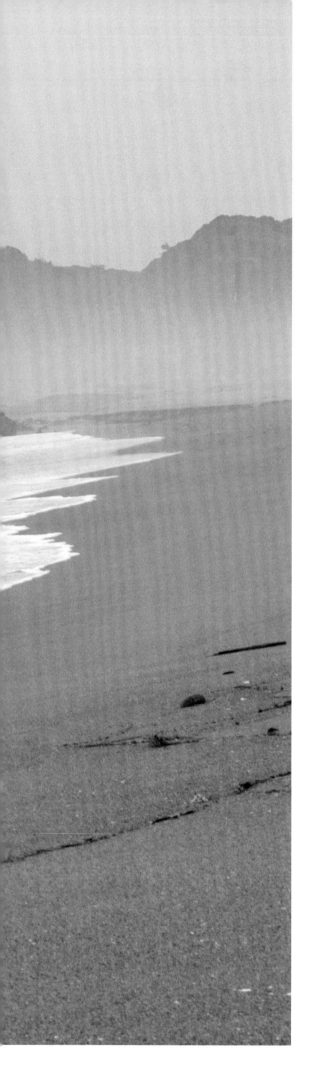

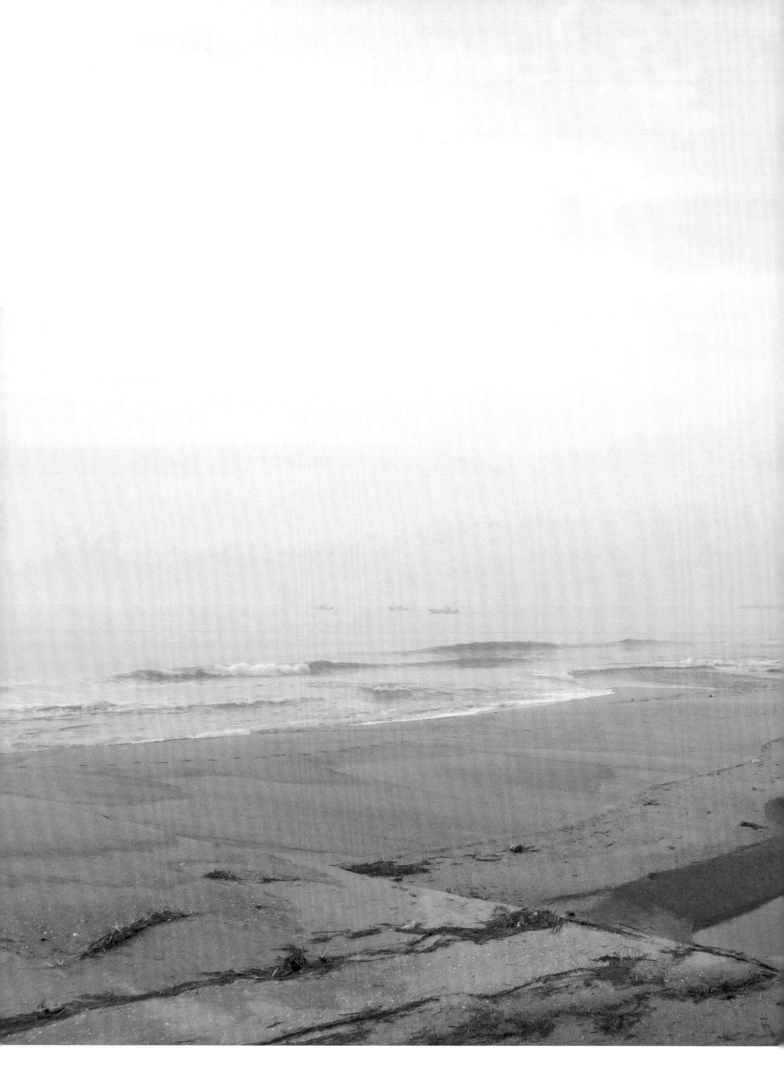

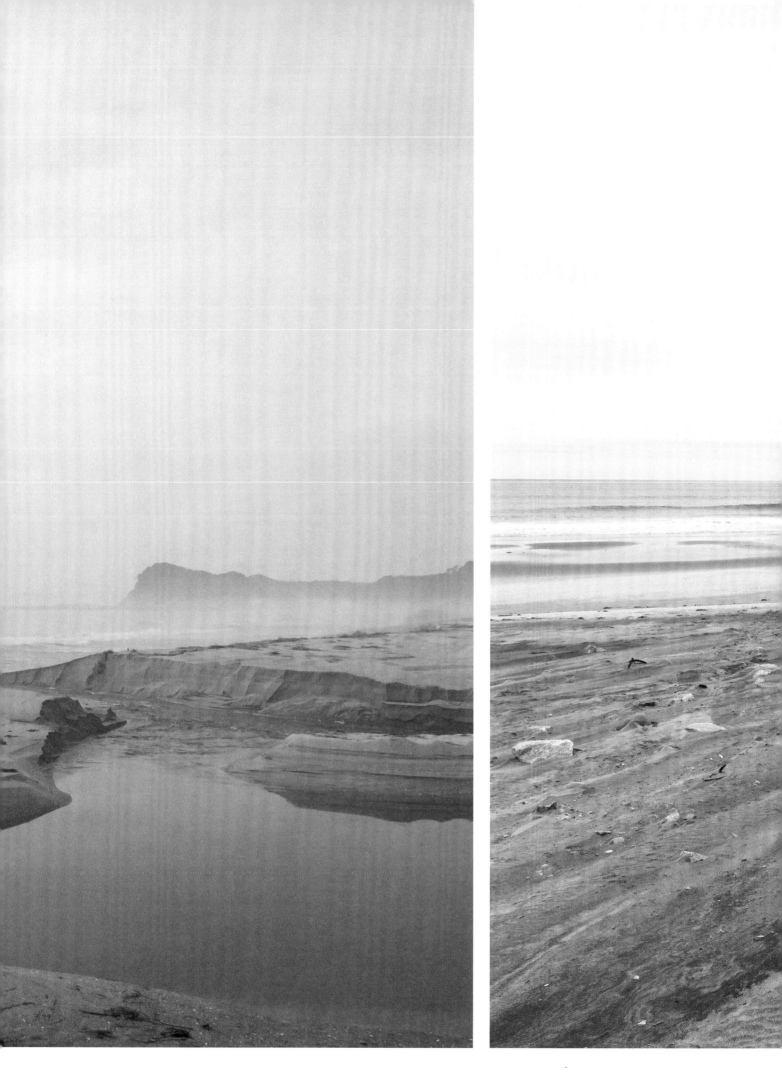

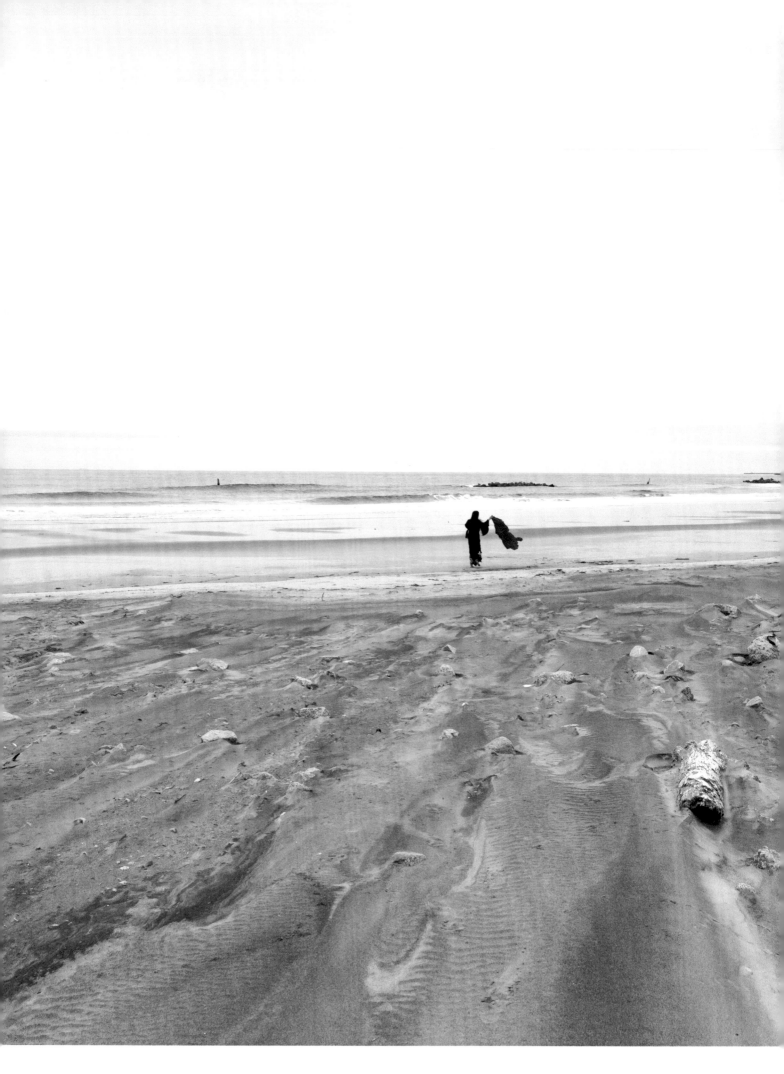

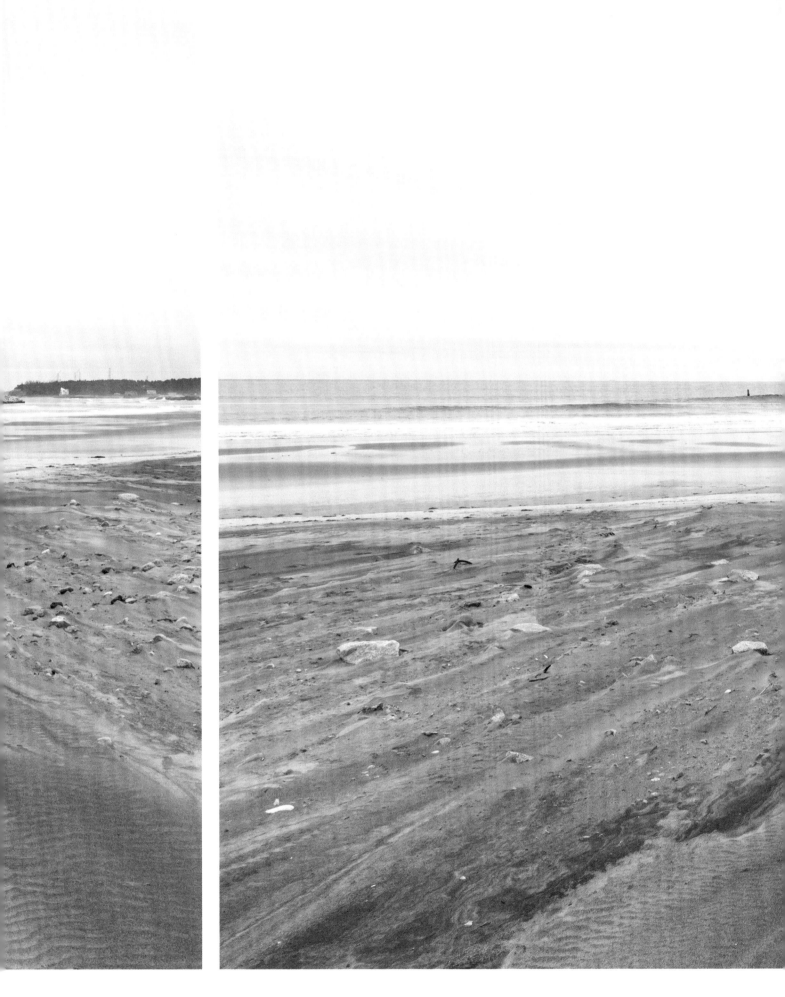

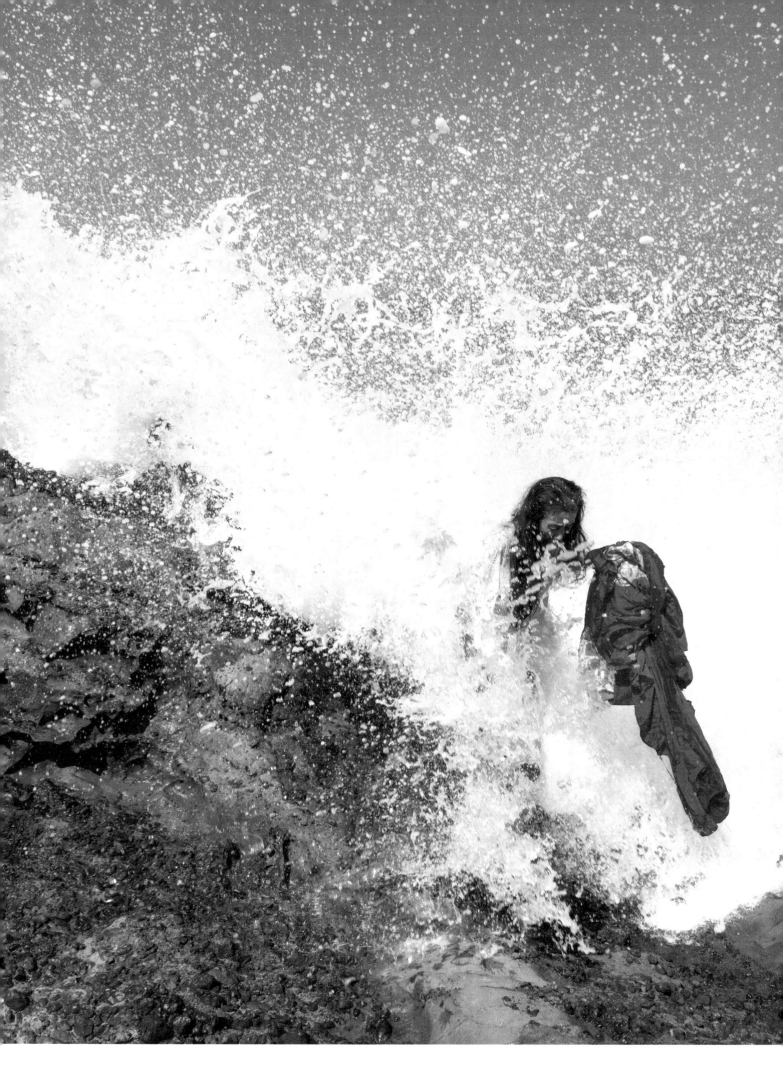

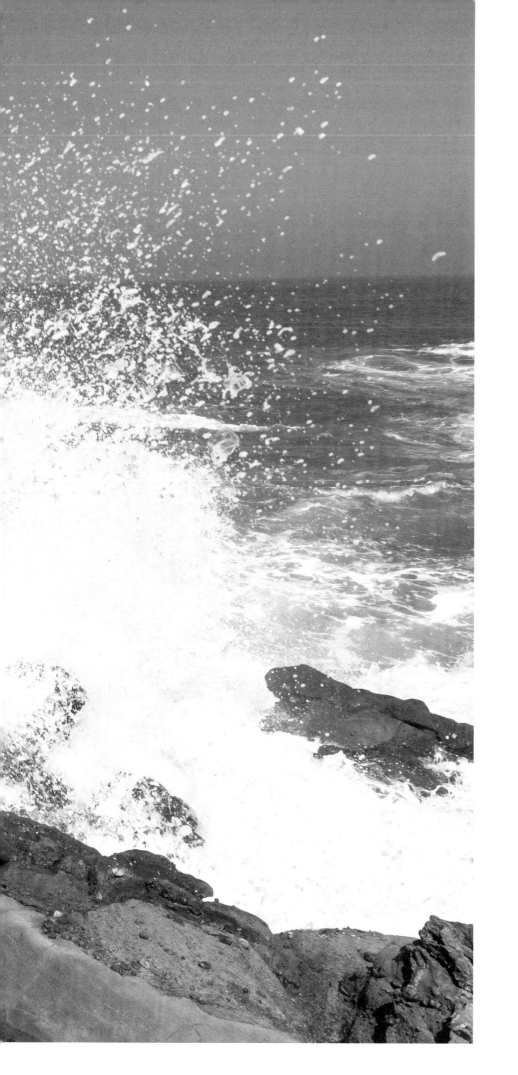

WESLEYAN UNIVERSITY PRESS MIDDLETOWN, CONNECTICUT

A BODY

EIKO OTAKE + WILLIAM JOHNSTON

IN FUKU— SHIMA

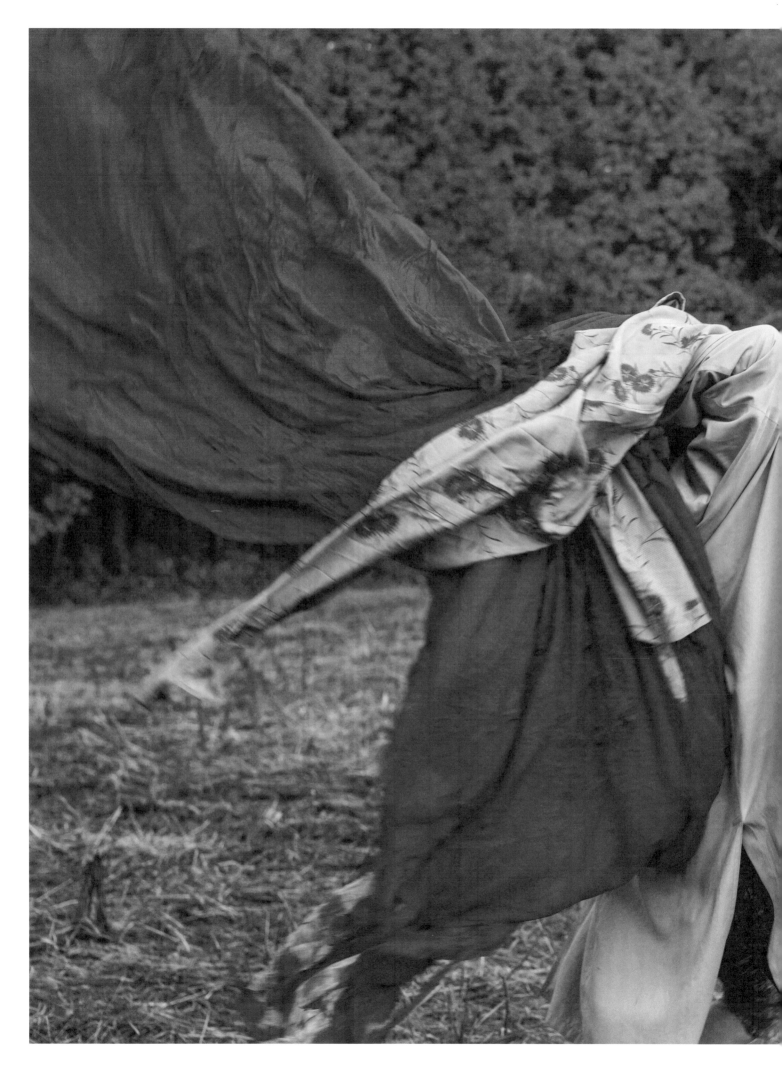

CONTENTS

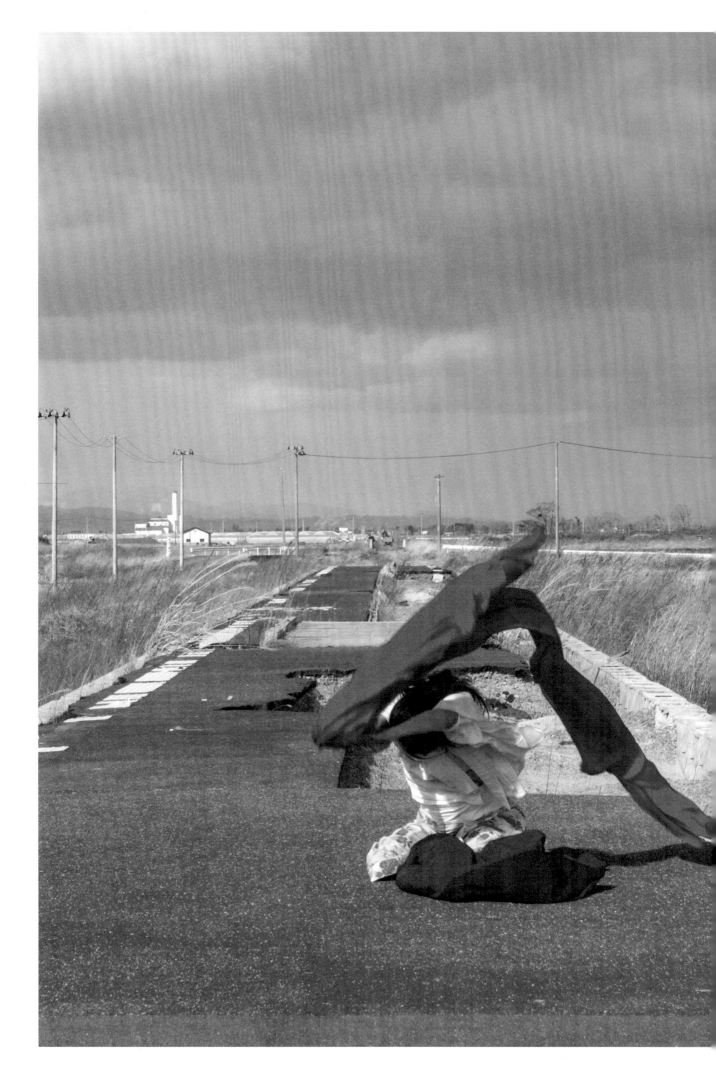

A BODY
IN FUKUSHIMA

THIS IS A BOOK OF FUKUSHIMA. THIS IS A BOOK OF WAILING AND UPSET, inhabiting time after March 11, 2011 and imagining time before then. This is a book of the irradiated landscape of Fukushima. This is a book of violence, and of disasters, fast and slow. This is a book of people, mountains, fields and the sea. This book is *A Body in Fukushima*: the body of a performer— an immigrant artist from Japan, and the body of a historian who is also a photographer, and the body of the land itself.

We traveled together to Fukushima five times between 2014 and 2019. Eiko performed in the disrupted landscapes. Bill photographed the performances. Together we selected the photographs and writings for this book, and Bill wrote the captions.

The year 2021 marks the tenth anniversary of the Fukushima nuclear disaster. The *Timeline* in the book extends to include a deeper history that is part of this tragedy and this place. And *Places Visited* shows the coast-line where we performed and photographed. We hope that these images allow you to enter Fukushima, to feel and smell it. **EO & WJ**

EDO PERIOD, C. 1603–1868

▷ Fukushima Prefecture is divided into multiple domains (*han*); in 1868, the han of Aizu violently opposes the new imperial government.

MEIJI ERA, 1868–1912

▷ Fukushima Prefecture, because of historic opposition to the imperial government, is branded as traitorous to the emperor and remains politically disadvantaged for decades.

▷ During the Meiji era, industrial pollution results in environmental catastrophes in several parts of Japan, and central and local governments respond slowly, if at all. The most egregious disaster is at the Ashio Copper Mine in Tochigi Prefecture, south of Fukushima.

EARLY TWENTIETH CENTURY

▷ Following World War One, Japan experiences a major economic downturn, and Fukushima Prefecture is badly affected. Farmers here suffer high taxes and lower prices for their crops, so that many go into debt and become tenant farmers. These changes are widespread during the Great Depression of the 1930s, and many farmers choose to go to urban areas seeking factory work.

▷ During World War Two, many residents of northeast Japan (Tohoku), including Fukushima, support Japanese expansionism and militarism.

AUGUST 1945

▷ On August 6, Americans explode a nuclear bomb made of uranium-235 over Hiroshima, killing approximately 120,000 civilians and 20,000 military personnel.

▷ On August 9, a bomb made of plutonium-239 explodes over Nagasaki, killing at least 74,000, almost all civilians. Japan surrenders on August 15.

1950s

▷ After World War Two, much of Fukushima remains impoverished.

▷ In April 1952, the San Francisco Peace Treaty is signed, ending U.S. occupation of Japan.

▷ In 1953, U.S. President Dwight D. Eisenhower promotes "Atoms for Peace," advocating for expansion of nuclear-based generation of electricity.

▷ In 1954, Nakasone Yasuhiro and others obtain government funding to begin development of nuclear power in Japan.

▷ In 1955, the Japanese Diet passes the Atomic Energy Basic Law, further encouraging the construction of nuclear power plants.

▷ In January 1956, Shōriki Matsutarō, owner of the *Yomiuri Shimbun* newspaper, becomes chair of the newly created Japanese Atomic Energy Commission, and in May of that year is appointed head of the new Science and Technology Agency.

▷ Backed by the U.S. Central Intelligence Agency, Shōriki works nationwide to popularize nuclear energy as safe and community-friendly.

1960s

▷ In 1963, Japan's first nuclear-powered electrical generator, at Tōkaimura in Ibaraki Prefecture, becomes operational. With promises of local jobs and tax revenues, in 1967 construction begins on the Fukushima Daiichi Nuclear Power Plant.

1970s

▷ Between 1971 and 1979, all six reactors at the Fukushima Daiichi Nuclear Power Plant are put into commercial operation, managed by the Tokyo Electric Power Company (TEPCO).

1990s

▷ Tōkaimura Nuclear Plant experiences major accidents in 1997 and 1999. Many accidents at nuclear plants result in cover-ups and their releases of radiation and other pollutants are not revealed.

2000s

▷ TEPCO ignores numerous warnings
from scientists of potential tsunami and
earthquake damage to the Fukushima
Daiichi nuclear complex.

MARCH 11, 2011

▷ An earthquake of magnitude 9.1 strikes
off coast of northeast Japan, and a 46-foot
tsunami pours over the Fukushima
Daiichi seawall, built to withstand only a
19-foot tsunami. With cooling pumps
submerged and backup generators flooded,
the reactors overheat and meltdowns
commence. Residents within 1.9 mi. (3 km.)
of Fukushima Daiichi are ordered to
evacuate.

MARCH 12–15, 2011

▷ Of the six nuclear reactors at the
Fukushima Daiichi site, two are success-
fully shut down, but Units 1, 2, 3, and 4 all
explode and their fuel rods are damaged,
disgorging radioactive materials including
iodine, cesium, and plutonium into the
atmosphere. Fires continue. By March 12,
residents within 12.4 mi. (20 km.) are
ordered to evacuate.

MARCH 25, 2011

▷ Radiation emissions continue. Transporta-
tion is provided for voluntary evacuation
of residents up to 18.6 mi. (30 km.) from the
crippled reactors. Eventually, over 160,000
persons are evacuated.

MAY 2011

▷ In order to encourage people to return to
irradiated areas and allow schools to stay
open, the Japanese government changes
the official limit for a "safe" dose of radia-
tion from one millisievert (mSv) per year to
20 mSv per year. For comparison, natural
radiation exposes people to 2–3 mSv a year;
exposure to 7–8 mSv all at once is lethal.

DECEMBER 16, 2011

▷ A cold shutdown of all four Fukushima
Daiichi reactors is achieved.

OCTOBER 12, 2012

▷ TEPCO admits that more extensive
measures to prevent disasters at nuclear
plants had not been pursued for fear
of creating popular opposition to nuclear
power and pressure to shut down reactors.

SEPTEMBER 5, 2015

▷ Evacuation orders lifted for Naraha Town
in Fukushima Prefecture.

APRIL 1, 2017

▷ Evacuation orders lifted for parts of eleven
more towns in Fukushima Prefecture.

SEPTEMBER 19, 2019

▷ Although earlier civil lawsuits against
TEPCO and the Japanese government have
been upheld, a criminal court acquits
three TEPCO executives of criminal
negligence—charges that were supported
by 13,262 co-signers—for having ignored
warnings in 2008 that a tsunami over 50
ft. (15 m.) high could flood the Fukushima
Daiichi complex.

JUNE 2020

▷ The Japanese federal government
announces that decommissioning of
Fukushima Daiichi will last an estimated
thirty to forty years, producing 880 tons
of melted nuclear fuel and at least 770,000
tons of solid radioactive waste. What
will be done with these waste products
remains unclear. Radioactive ground water
continues to be pumped into tanks, making
eventual release into the Pacific Ocean
inevitable. Approximately only 20 percent
of total evacuees have returned home to
towns in the Fukushima area.

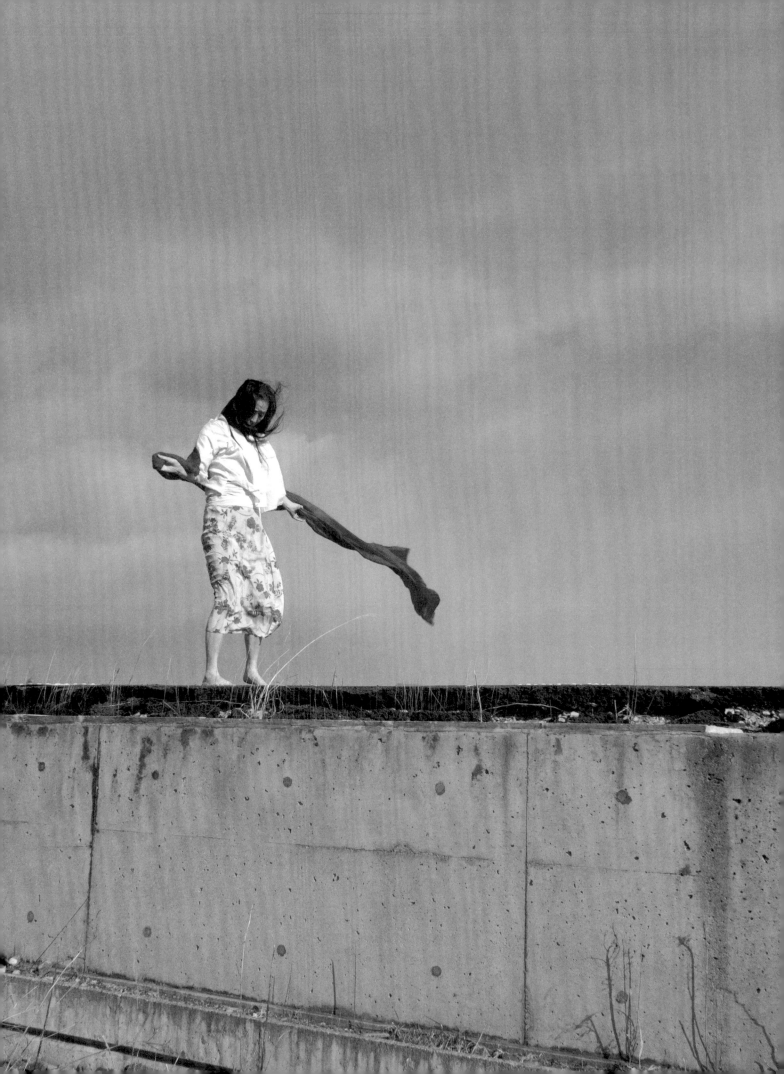

PLACES VISITED

JAPAN

PACIFIC OCEAN

SAKAMOTO STATION　坂元駅

KOMAGAMINE STATION　駒ヶ嶺駅

SHIOGAMA SHRINE　塩釜神社

SOMA CITY　相馬市街

FUKUSHIMA INARI SHRINE　福島稲荷神社

YASAWA　八沢

OTA RIVER　太田川河口

TSUNOBEUCHI　角部内

MOMOUCHI STATION　桃内駅

KINUNONE SHRINE　絹布根神社

NAMIE TOWN　浪江町

YACHIHATA　谷地畑

UKEDO　請戸

YONOMORI　夜ノ森

FUKUSHIMA DAIICHI

KOBAMA　小浜

TOMIOKA TOWN　富岡町

FUKUSHIMA DAINI

NAMIGURA INARI SHRINE　波倉稲荷神社

TATSUTA STATION　竜田駅

MAEBARA　前原

KIDO STATION　木戸駅

YABUREMACHI　破町

YAMADAHAMA　山田浜

HISANOHAMA　久の浜

HATTACHI BENTEN　波立弁天

SHINMAIKO BEACH　新舞子浜

TABITO　田人

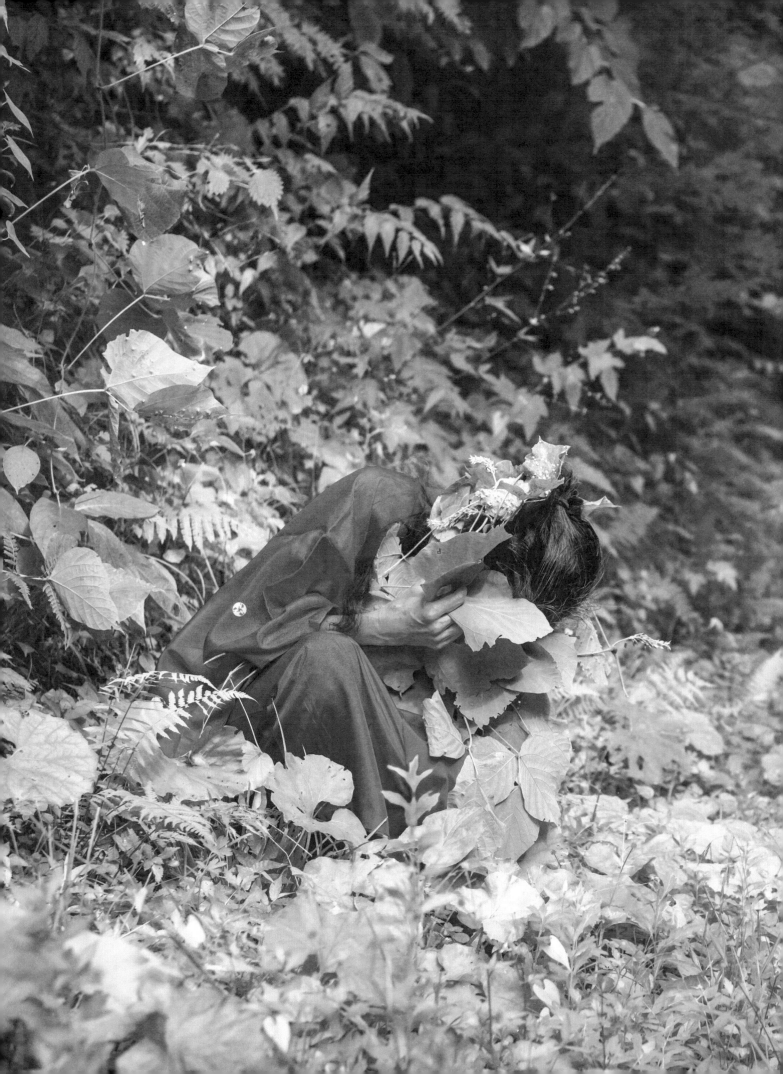

WHY

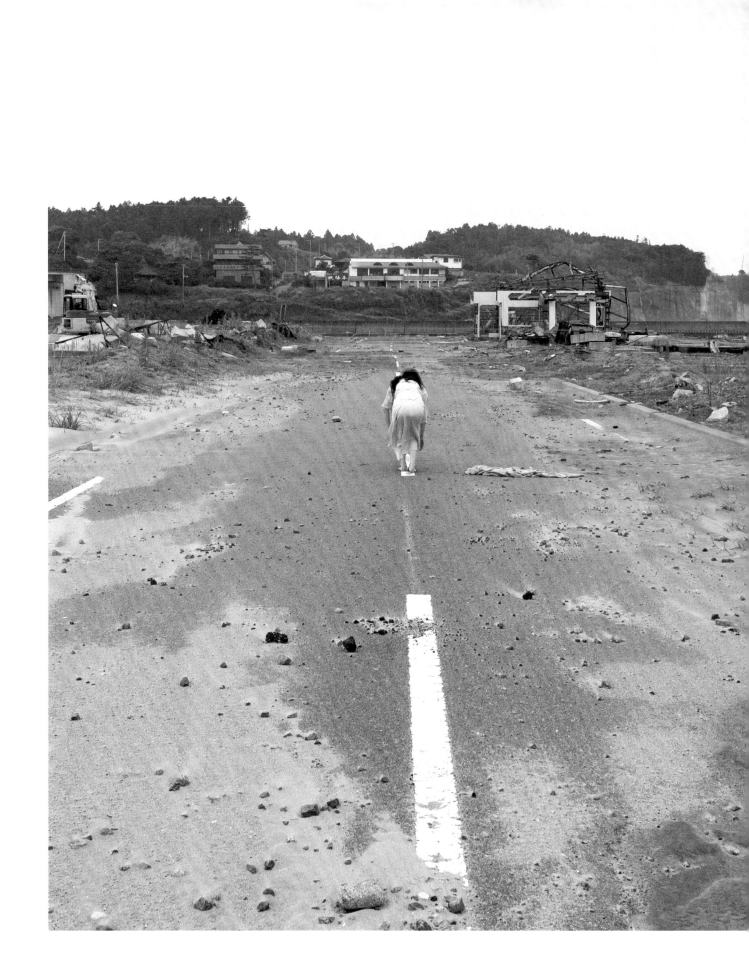

NOVEMBER 4, 2013. I AM IN A WAITING ROOM OF THE 30TH STREET STATION in Philadelphia. I observe the station to think about a performance I have committed to do here in a year. Four Fridays. Three hours each. This will be the first time I will perform alone without Koma, my long-time partner and collaborator. I am nervous. Many people walk fast in their business suits. They are in transit to their destinations.

I am an immigrant artist. Immigration is a process that never ends. I did not grow up here. I have not gotten a cultural base by looking up toward Europe or visions of America's founding fathers. I come from a very different place—postwar Japan. I was born in 1952, the year the U.S. occupation ended. I learned early on that Japan was an aggressor. From that upbringing, buildings that are generally described magnificent—such as 30th Street Station and the Metropolitan Museum of Art—look different. They are not *my* pantheon. I have to enter and deal with that otherness, that "greatness," differently.

I think about how to make it necessary for me to perform in a certain place. I use the word *place* to avoid the abstractness of *space*, which is usually used for modern and contemporary dance. Even when I perform in theaters and museums, I consider each site as a particular place. By observing each place, I begin to feel my own narratives and poetry. These ground my movements, gestures, and time in being there, but I don't feel I have to necessarily share all of them with viewers. I don't want my performance to be either about just accepting an invitation or stating my motivations. I want to create a process that makes each performance urgent.

To perform in this station is to place a body among these people busily in transit. Those sitting on benches around me are going somewhere. I notice one person, who seems to have lost her destination. No train or friend is coming for her.

> *Where am I supposed to have come from*
> *and where am I supposed to go?*

This place is monumental, but I sense that is not enough. And if it is not personally significant for me, then what could it be for viewers?

> *What could I bring that's not here? How do I make performance in this station necessary?*

I remember the deserted stations in Fukushima that I saw more than two years ago. After the earthquake and tsunami on March 11, 2011, Fukushima Daiichi Nuclear Plant underwent a series of disasters: three meltdowns and three hydrogen explosions. I went there in August 2011. Since then I have carried the regret I felt: "I did nothing to prevent this. I am lying if I act surprised." This is the emotion I trust, and not addressing that emotion seems wrong. The deserted stations in Fukushima are contrary to the busy 30th Street Station. I feel my desire to carry Fukushima here, somehow.

In 2011 I visited Fukushima with my friend Hiroko. She was the only other girl among the thirteen students who barricaded our high school for ten days in 1969. Forty-two years later, we travelled to Fukushima. The road barriers of the twenty-kilometer exclusion zone were tightly guarded. But radiation cannot be contained with an arbitrary line. Hiroko and I walked around the area utterly speechless. I knew we were chewing and swallowing the same regrets.

What have we done?
What have we not done?

I have always been against nuclear power. *Why have I not thought about this more deeply?* Nuclear meltdowns have always been more certain than probable. I have somehow managed to live without focusing on this reality. I just felt impossibly stupid.

Desolate train stations and weed-covered rails in Fukushima shocked me. I thought then, *The train will not run here. People will not come back here.* Fukushima's stations are 6,600 miles away from the 30th Street Station. *What if I dig a hole into this marble floor to reach Fukushima?* A passage to another world, like Alice's hole into Wonderland.

All of a sudden it is clear to me.
I will go back to the abandoned train stations.
I will go back to Fukushima.
My body will connect Fukushima and Philadelphia.
My body will carry a piece of Fukushima.

When I perform within the grandeur of the 30th Street Station, I want to, I have to, remember Fukushima's desolation and the sense of deep wrongness. I want to present my body as both having been to, and going back to, Fukushima. *It is necessary.*

A week later, I call William Johnston. I need someone to photograph me.

Fukushima is about radiation. Bill and I taught a course on the Atomic Bomb. He is a professor of Japanese history, with a research focus on public health and war violence in Japan. He did not need much convincing. We made our travel plans.

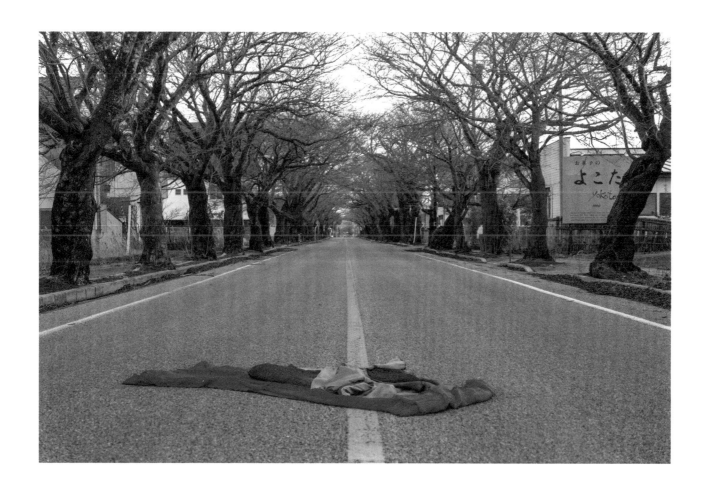

TRIP ONE

木戸駅 KIDO STATION

竜田駅 TATSUTA STATION

破町 YABUREMACHI

前原 MAEBARA

富岡駅 TOMIOKA STATION

桃内駅 MOMOUCHI STATION

駒ヶ嶺駅 KOMAGAMINE STATION

富岡町 TOMIOKA TOWN

坂元駅 SAKAMOTO STATION

JANUARY 2014

Kido is the name of a village created in 1889 with the consolidation of five surrounding hamlets, and was named after the river on the town's northern edge. It was originally an agricultural community but became a bed town for workers at the Fukushima Daiichi nuclear plant from the 1970s, and later became the headquarters for Japan's national soccer teams. Residents were evacuated after the meltdowns in March 2011, and the former soccer fields became the staging ground for crews working at the damaged reactors. As part of the 20-km. evacuation zone but not the highly radioactive total exclusion zone, the town was open for short visits by the time we visited in 2014. Kido Station was 11.7 mi. (18.8 km.) south of the Fukushima Daiichi reactors.

The plan for our first trip to Fukushima, in January 2014, was for Eiko to perform in a series of train stations along the Jōban Line, which follows the coastline north from Tokyo to Sendai. Kido Station was to be the first. It was late in the afternoon when we arrived there and walked around the surrounding area. The station was sealed; large bags of radioactive trash surrounded the station; earthquake-damaged buildings remained as they had been at the time the town was evacuated in March 2011. Although Eiko did not perform there until our last visit, in 2019, it was an important stop for us.

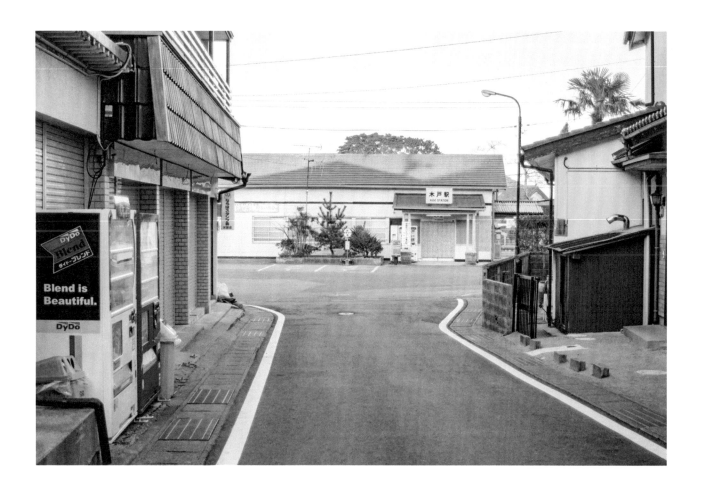

KIDO STATION 木戸駅

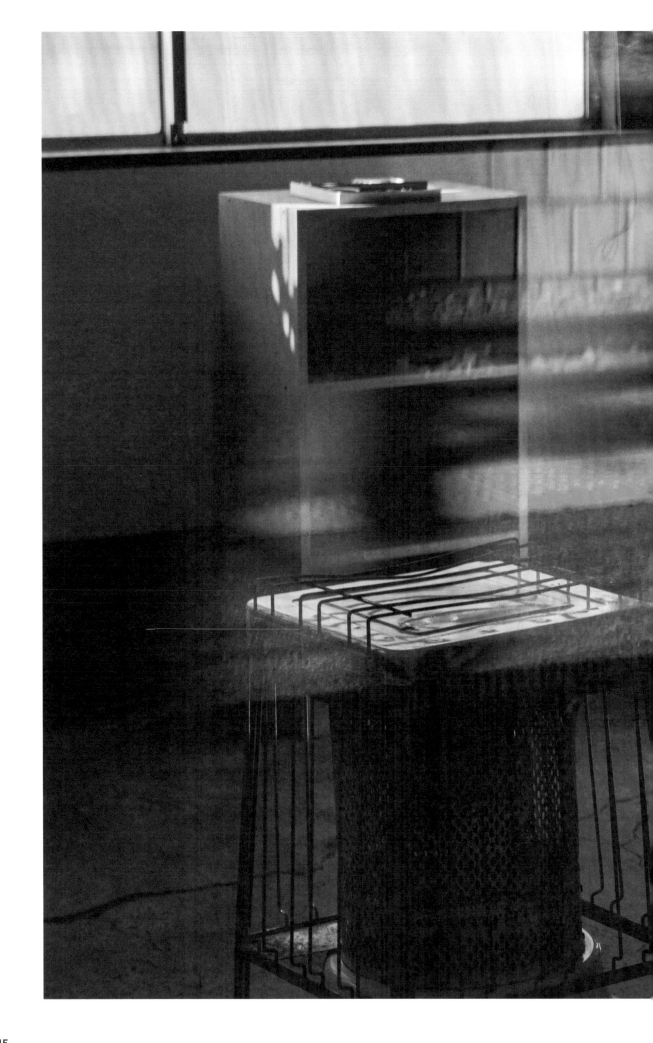

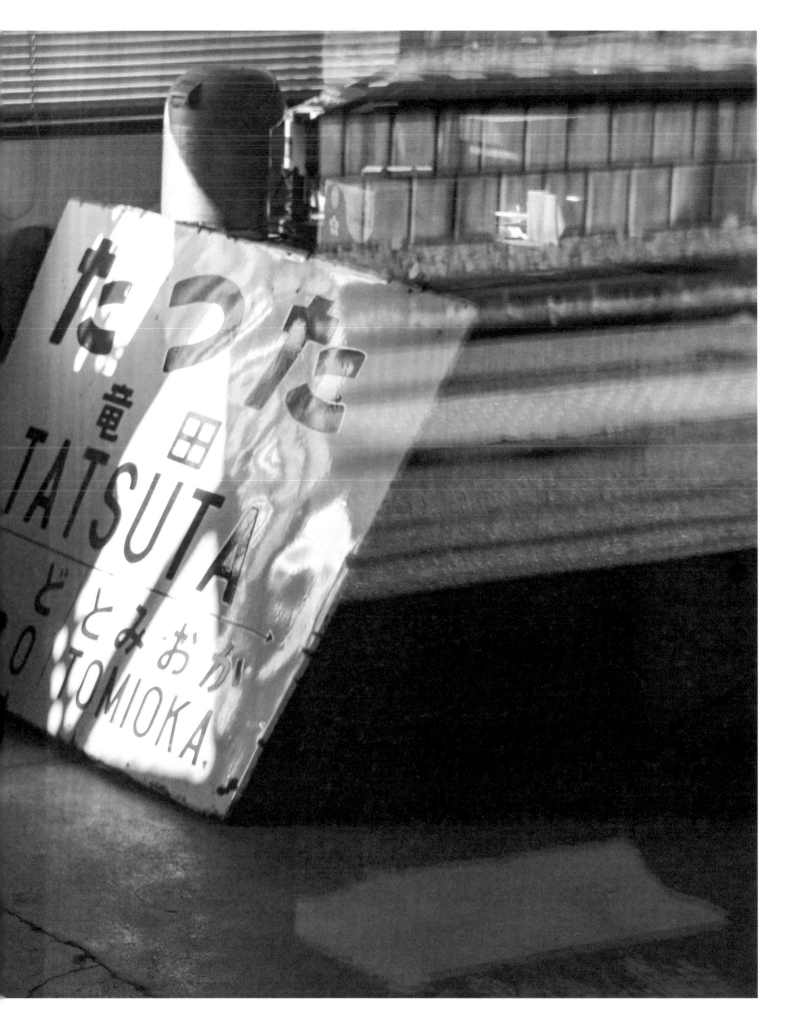

TATSUTA STATION 竜田駅

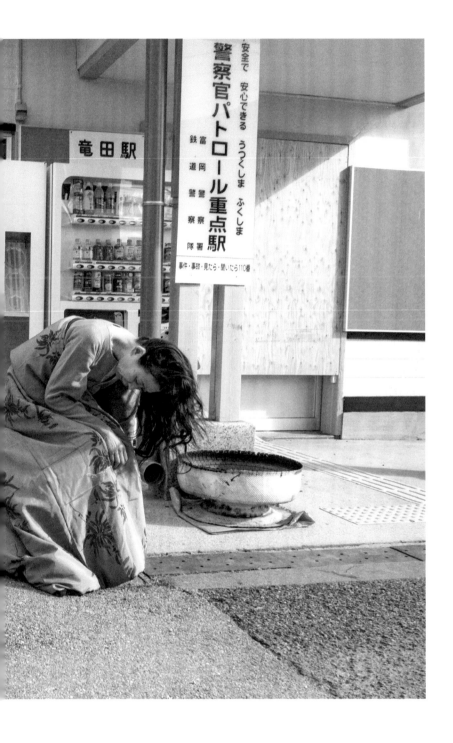

竜田駅

警察官パトロール重点駅

安全で　安心できる　うつくしま　ふくしま

富岡警察署
鉄道警察隊

事件・事故・見たら・聞いたら110番

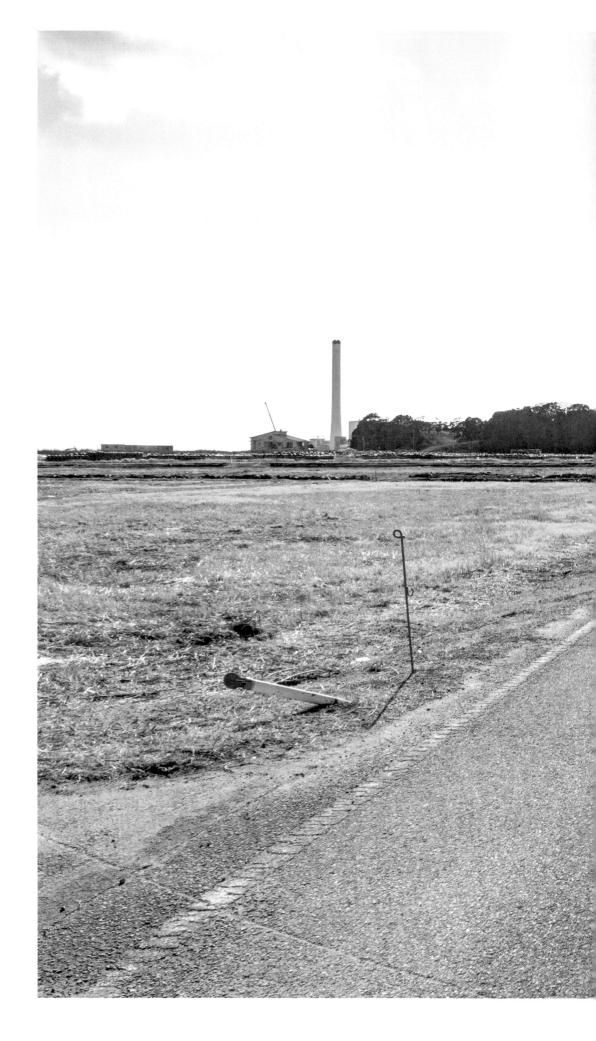

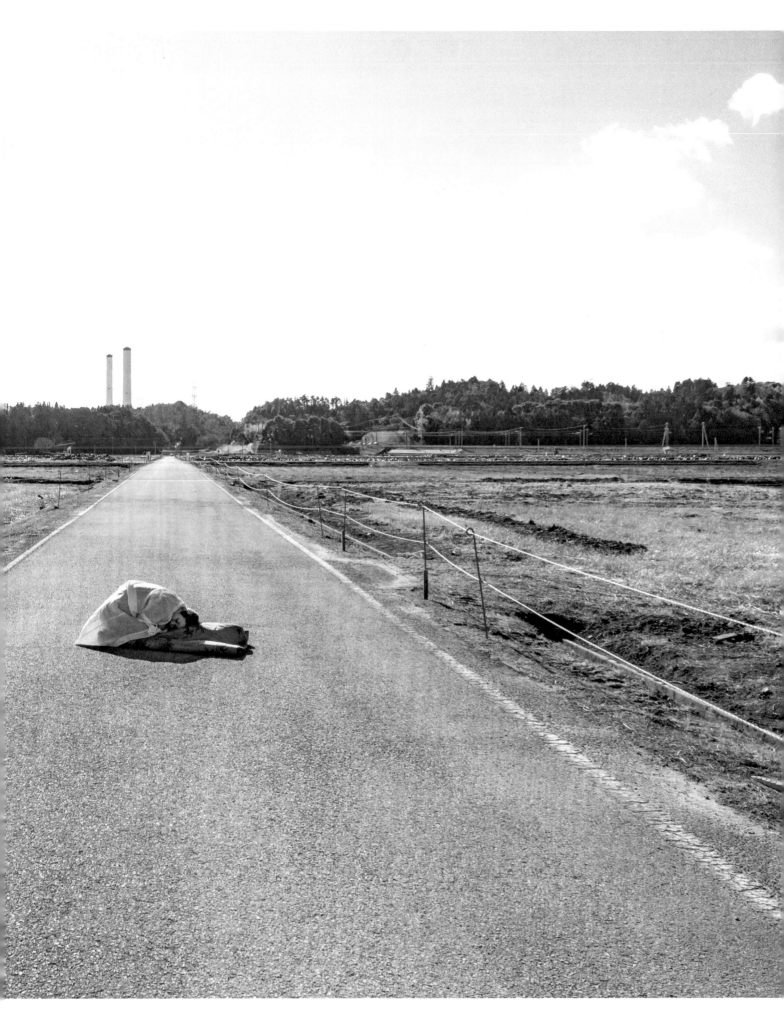

YABUREMACHI 破町

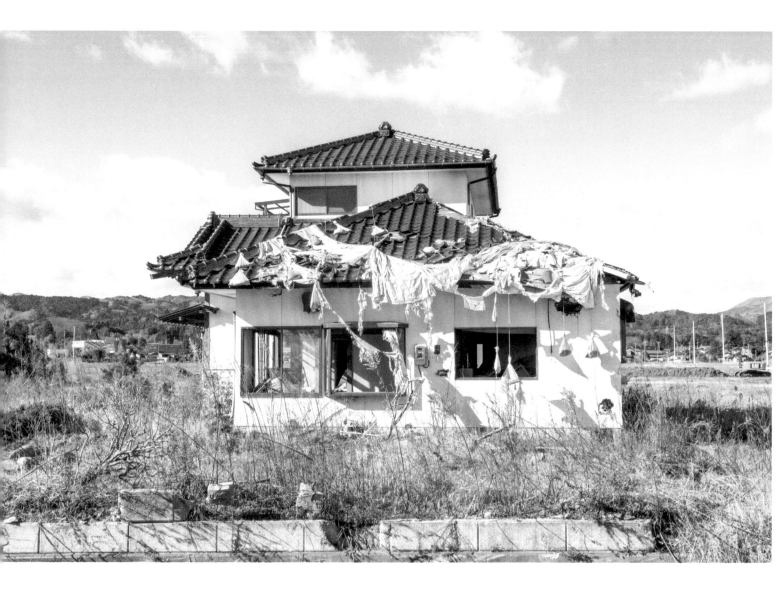

Yaburemachi (literally "Broken Town") was near Kido Station, 11.6 mi. (18.6 km.) south of the Fukushima Daiichi reactors. On the morning of our first full day in Fukushima we explored the area between Kido Station and the sea. A once elegant but tsunami-damaged house (page 48) stood next to an empty field. The house recalled a comfortable lifestyle that ended on March 11, 2011. Three years after the nuclear meltdowns, personal belongings covered the floor of the house; an upright piano had fallen over and a beam lay across it. Open boxes of shoes were lined up across the floor of the veranda. Two chairs had been placed together, seemingly so that the owners could sit down next to each other (pages 114–15). Here, Eiko decided to perform for the camera in places other than train stations. Yaburemachi changed the project of "A Body in Stations" into "A Body in Fukushima."

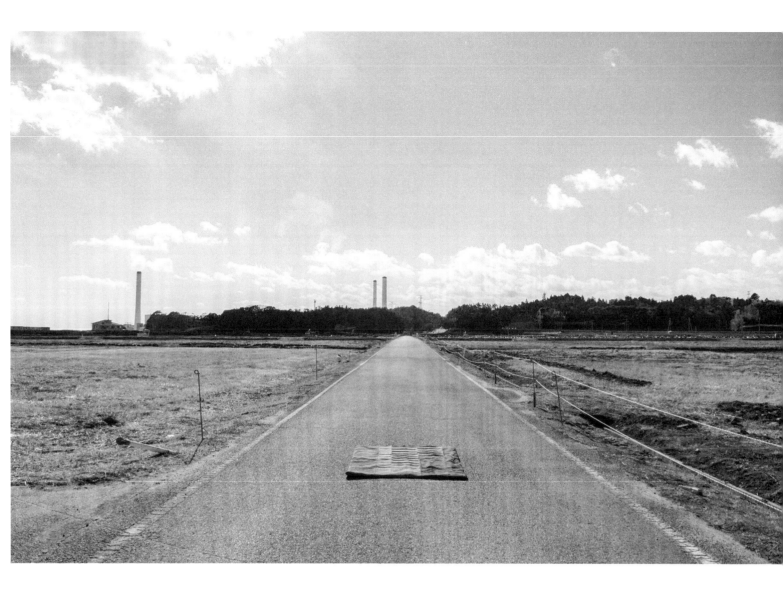

YABUREMACHI 破町

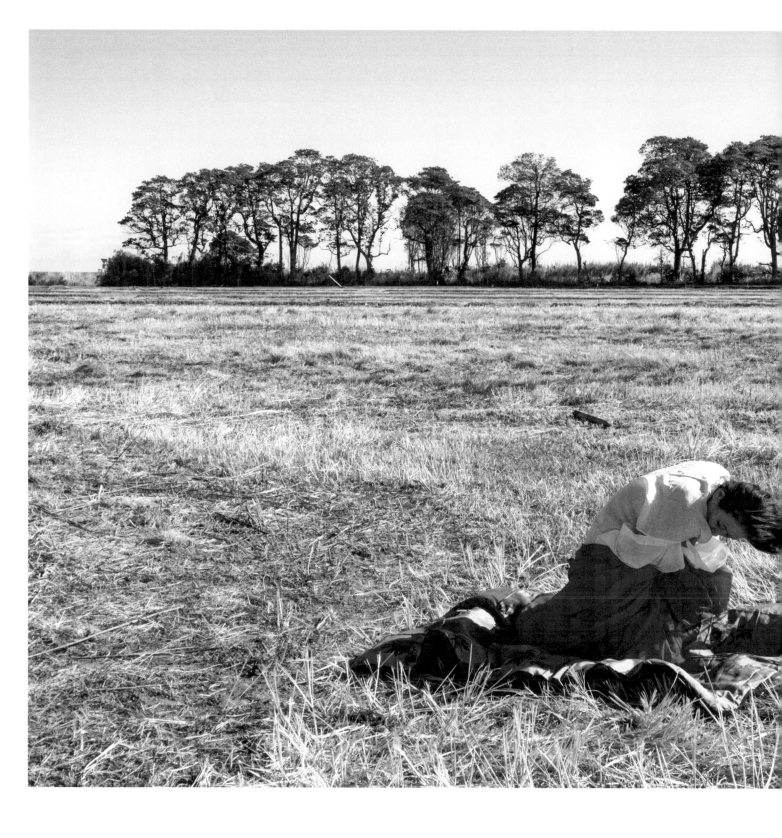

A row of trees separated the field in front of the house from the sea. Here, the tsunami had risen to approximately six feet. In the summer of 2014, blossoms and greenery surrounded the house (pages 104–105, 107). By 2016, a fifteen-foot high mound of dirt covered with weeds had replaced the house (pages 153–54). Little had changed when we visited in 2019, when a camellia, lone survivor of the garden, still blossomed (pages 222–23).

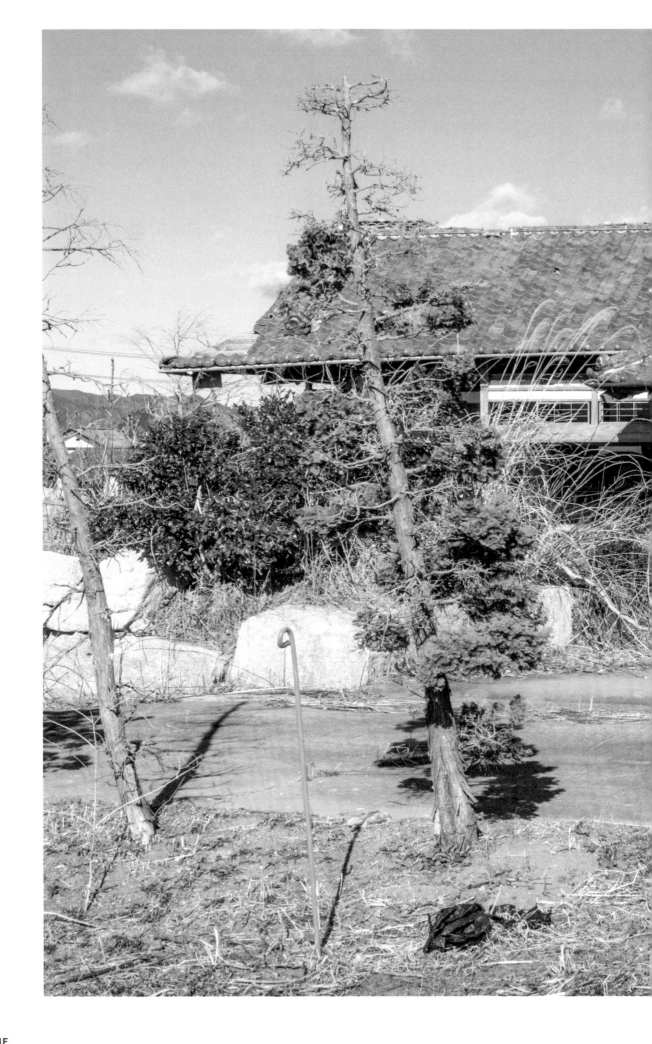

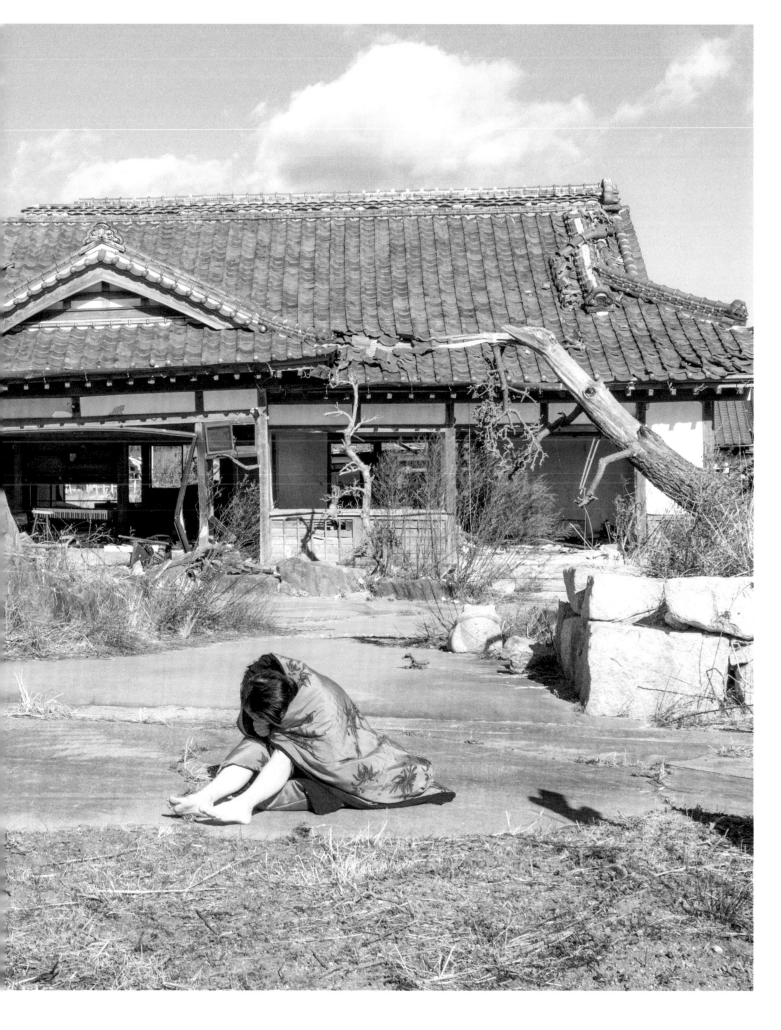

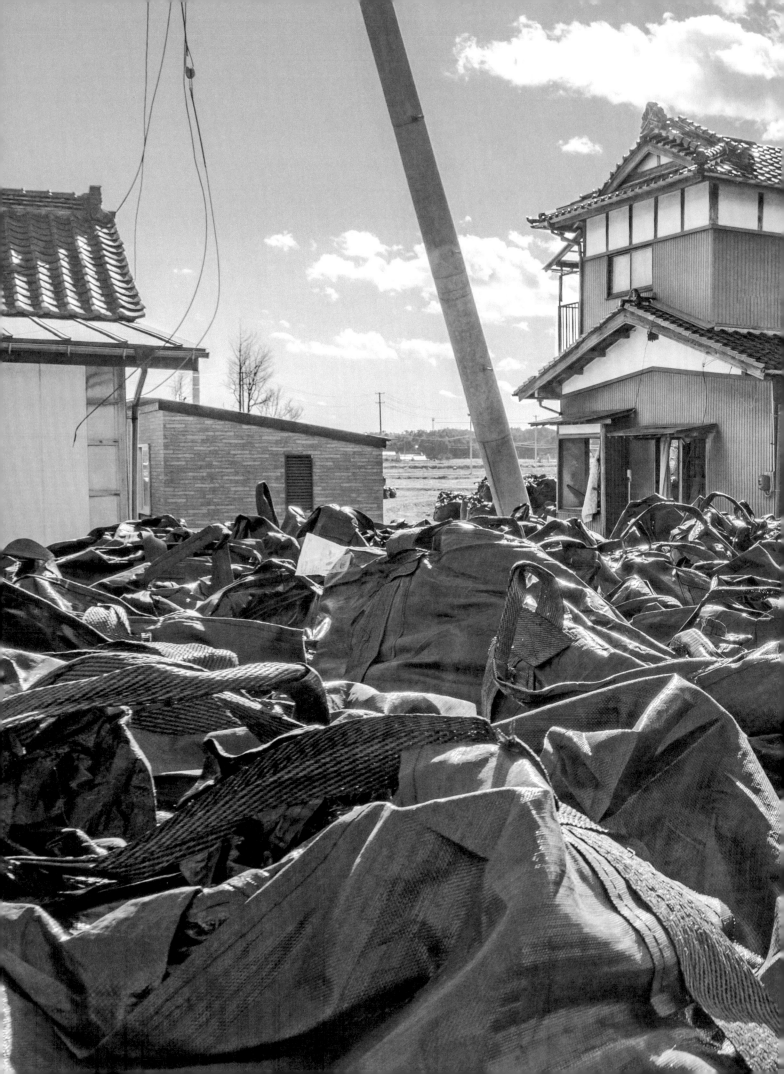

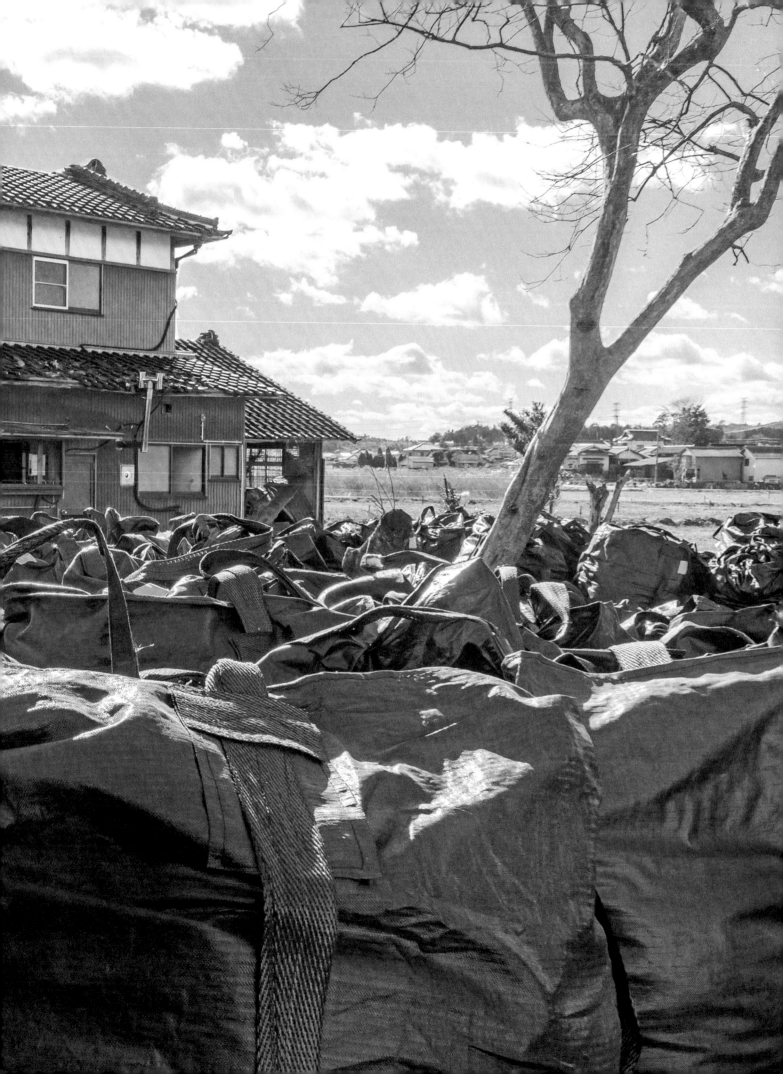

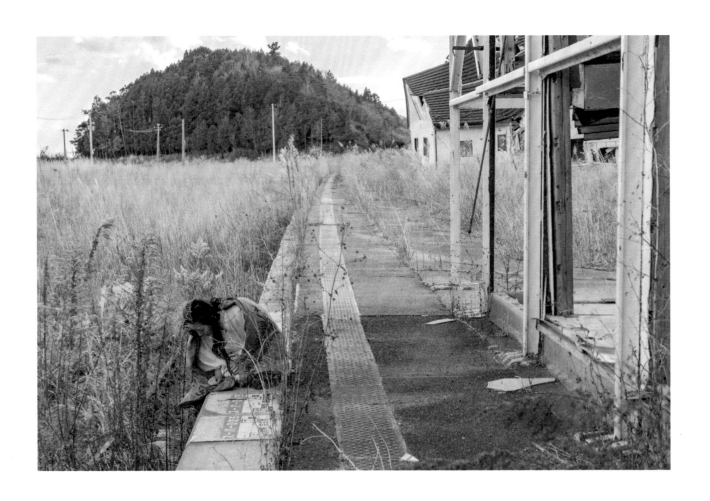

TOMIOKA STATION 富岡駅 (left), MOMOUCHI STATION 桃内駅 (above), MAEBARA 前原 (previous page)

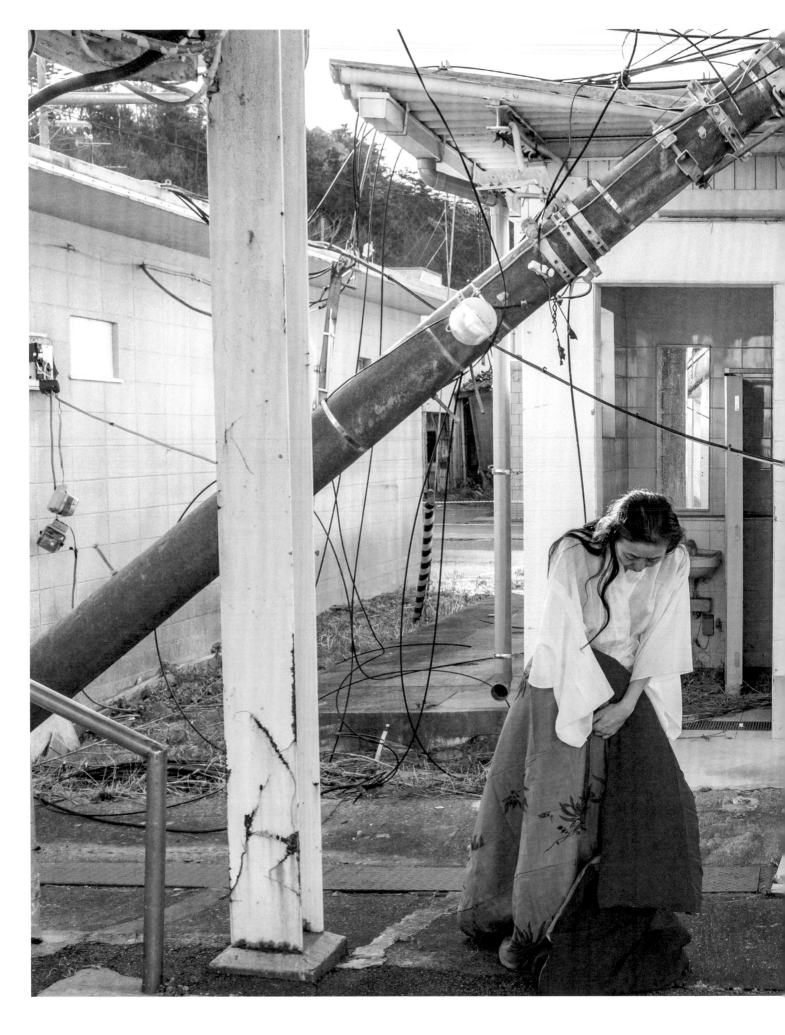

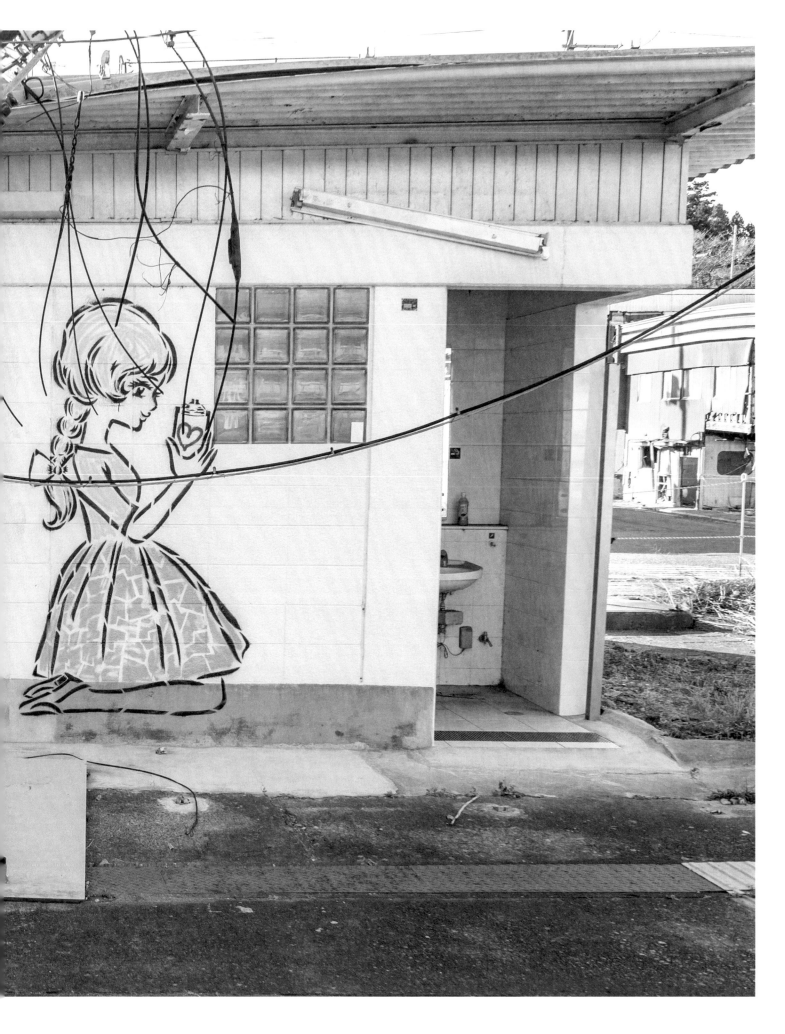

TOMIOKA STATION 富岡駅

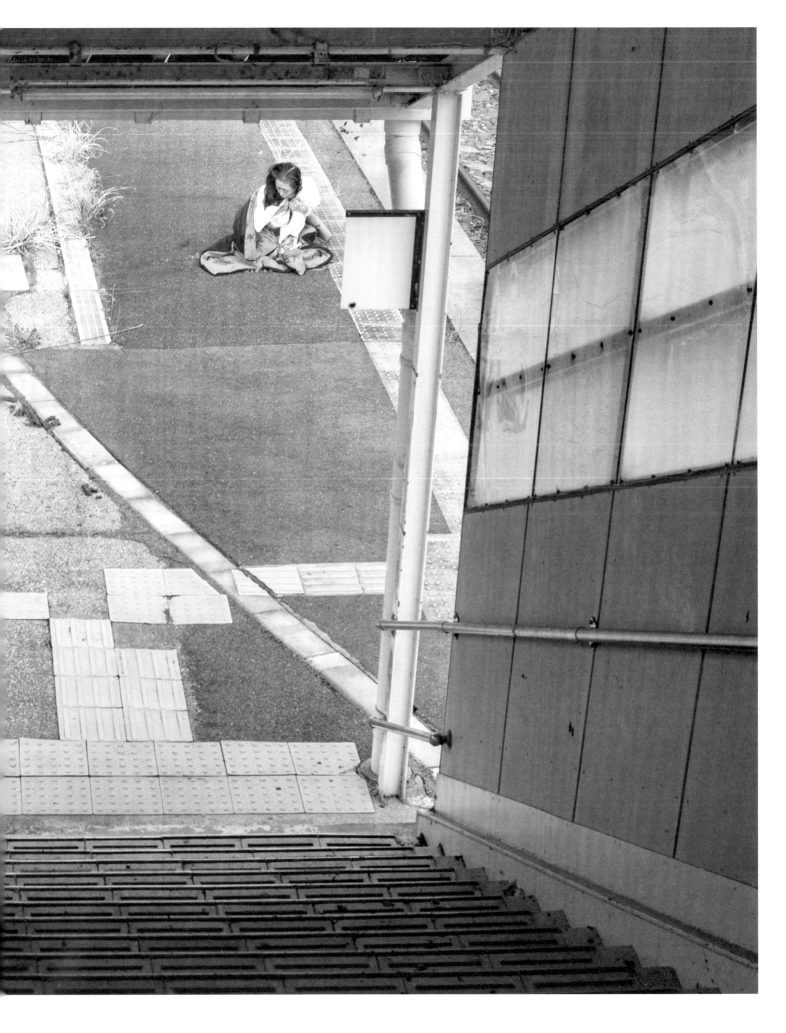

MOMOUCHI STATION 桃内駅

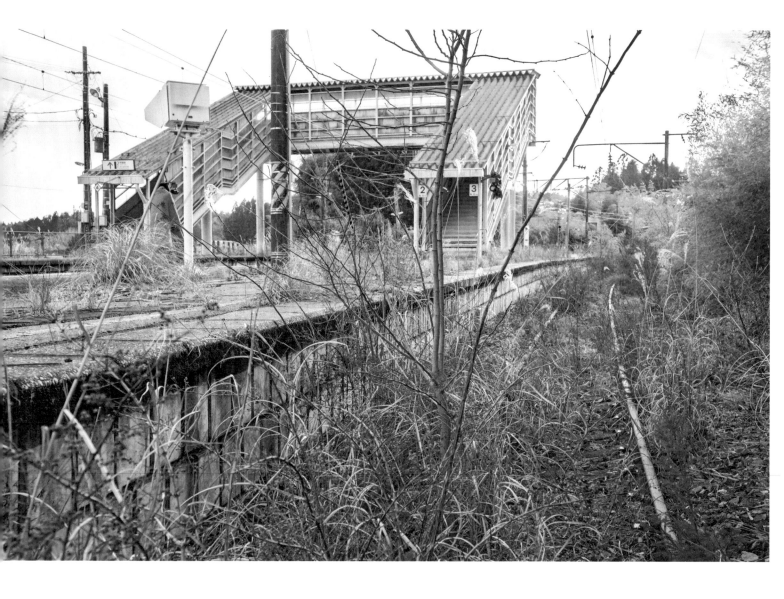

When we first visited in January 2014, Momouchi station, located 7.6 mi. (12.2 km.) northwest of the Fukushima Daiichi reactors, the tracks were overgrown with vines and trees had started to grow between the rails and on the platform itself (pages 53, 58–59); kudzu had invaded the telephone booth (page 75). By July 2014, the vines and other plants were flourishing (pages 120–23). This station had first opened in 1948 at the request of the local community and was largely built with voluntary labor and donated materials. It officially reopened in March 2020, but a passenger train went through the station while we were visiting in December 2019.

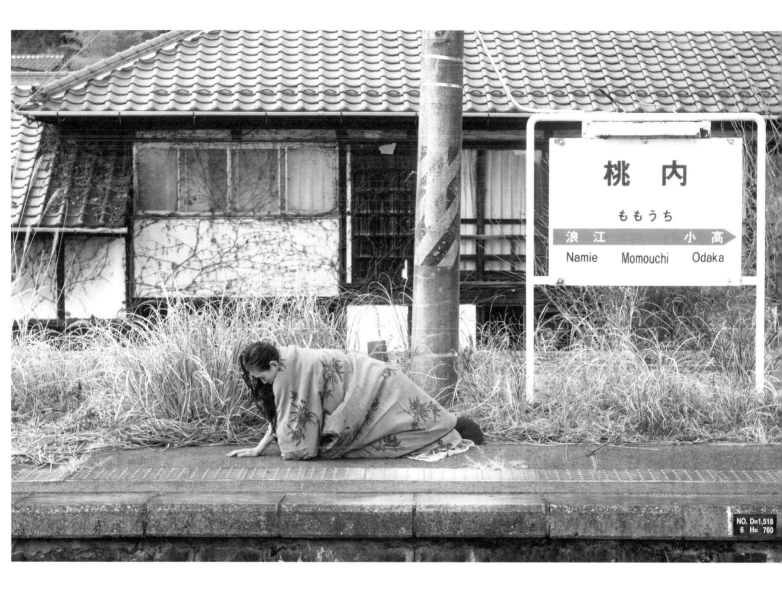

MOMOUCHI STATION 桃内駅

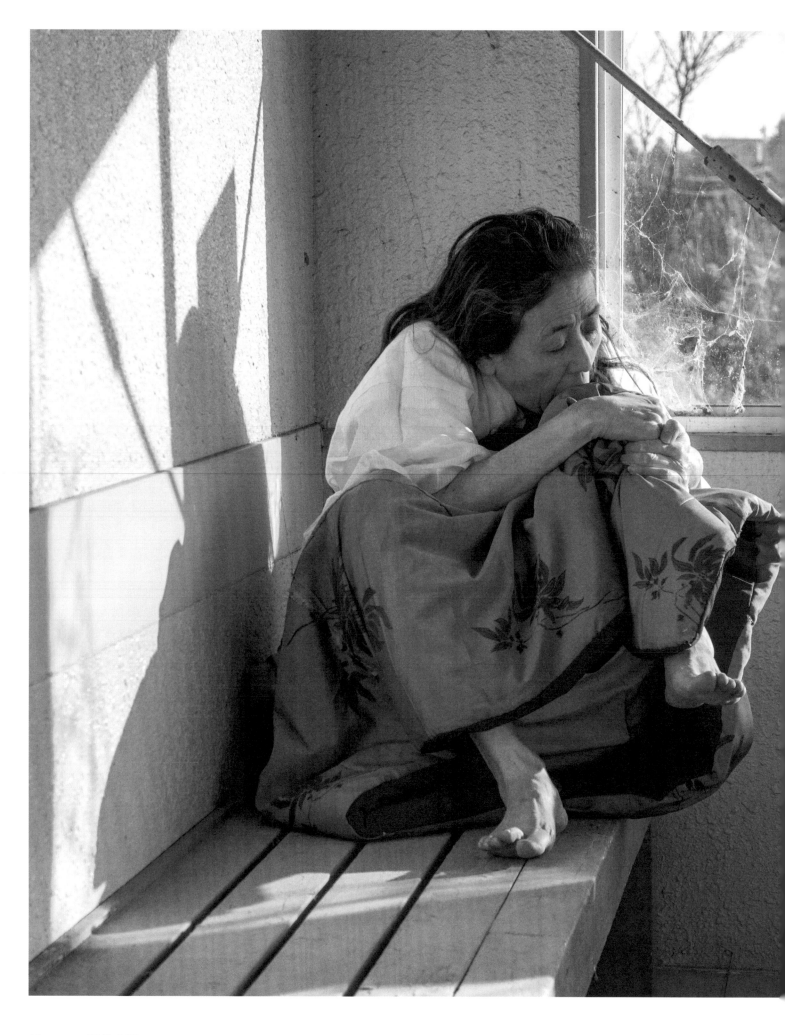

JR相馬駅長

　　　　　KOMAGAMINE STATION　駒ヶ嶺駅

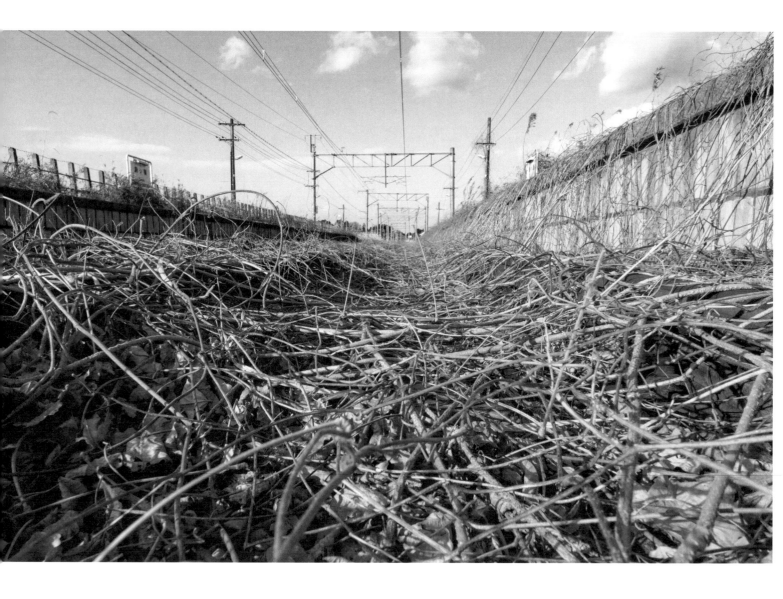

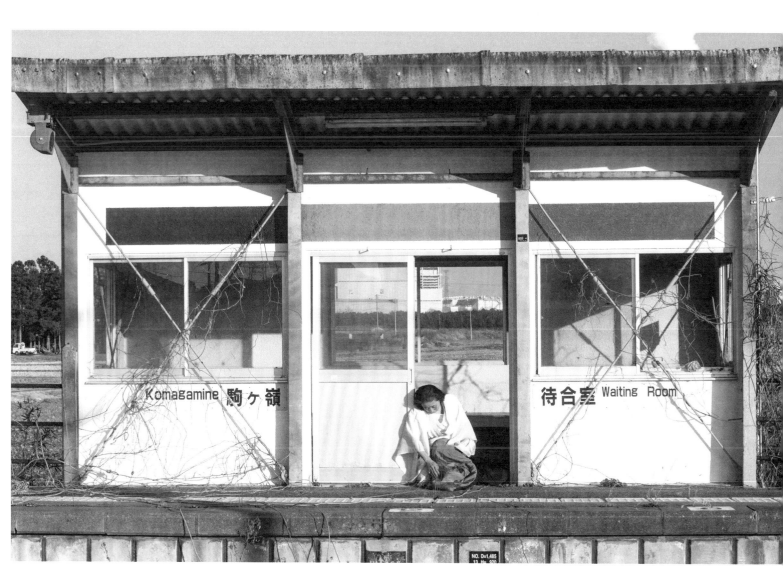

Komagamine 駒ヶ嶺　　待合室 Waiting Room

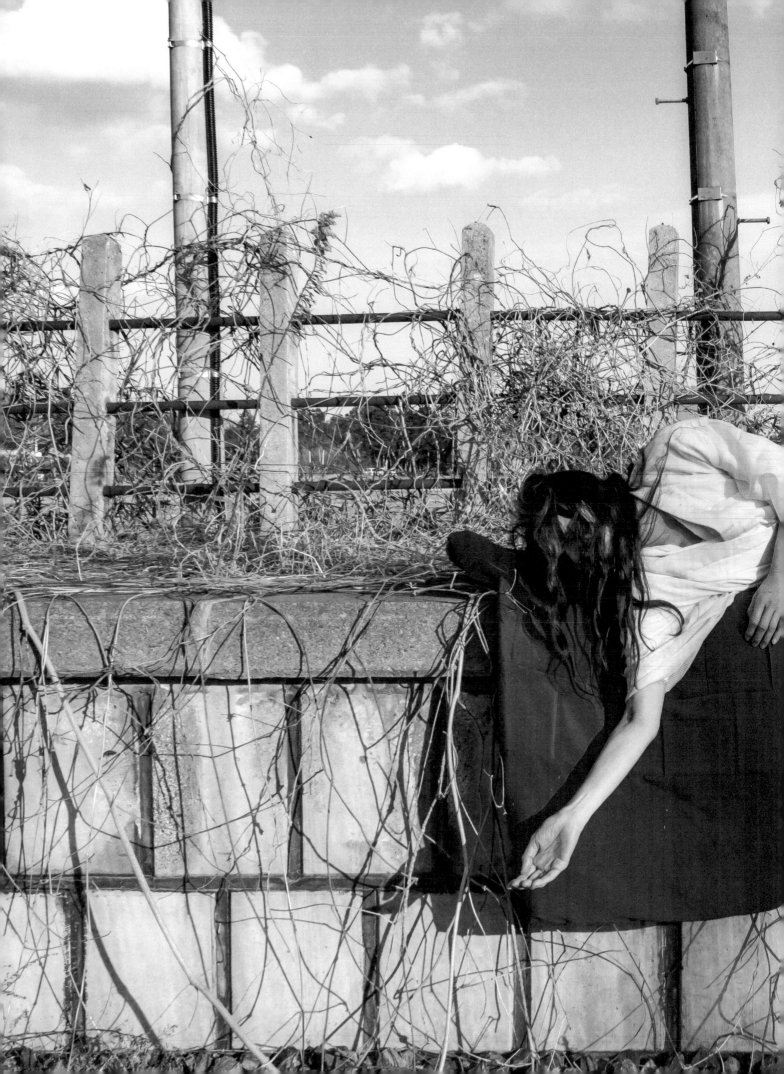

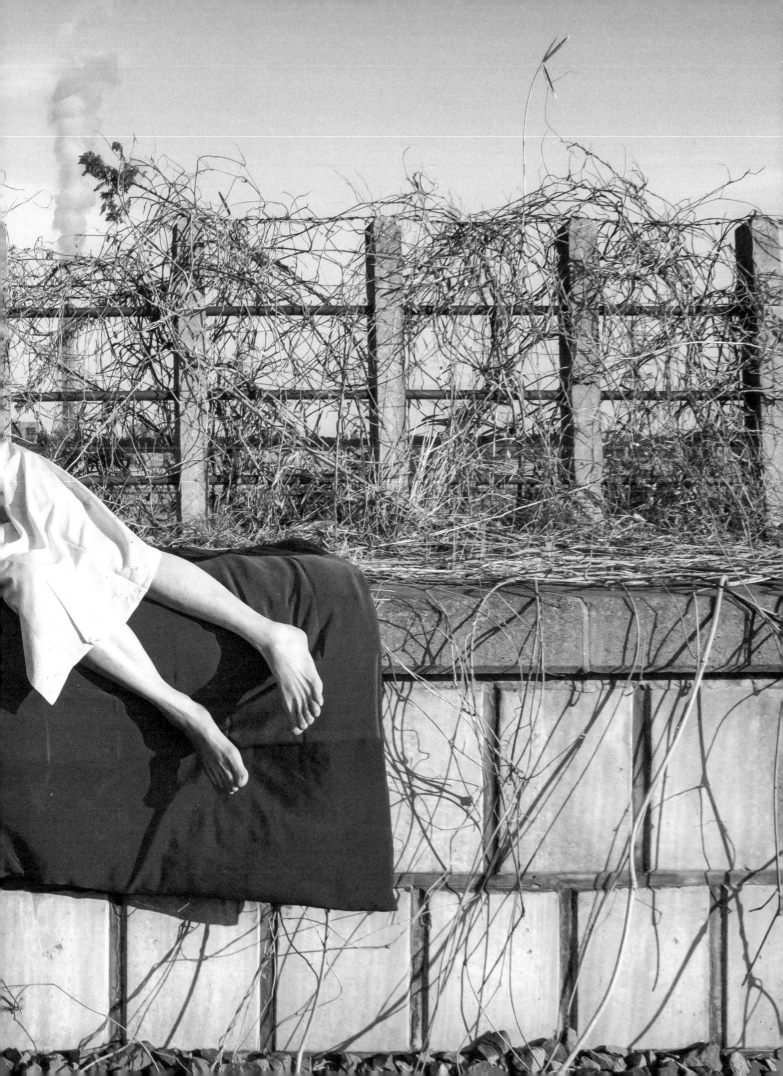

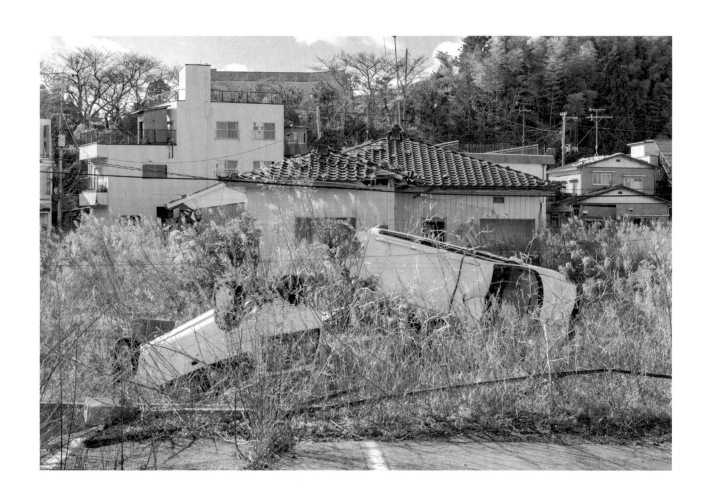

Tomioka train station was 6.6 mi. (10.6 km.) southwest of the Fukushima Daiichi reactors. The town of Tomioka had a population of nearly 16,000 on March 11, 2011. That afternoon the tsunami, which reached nearly 70 feet at the Tomioka coastline, swept across the fishing port, beach, and station, reaching well into the town. The following day, the ongoing melt-downs required the evacuation of the entire community. High radiation levels later discouraged most previous residents from returning to live there. On our first visit, the town around the station still stood much as it had been left in 2011—a mess

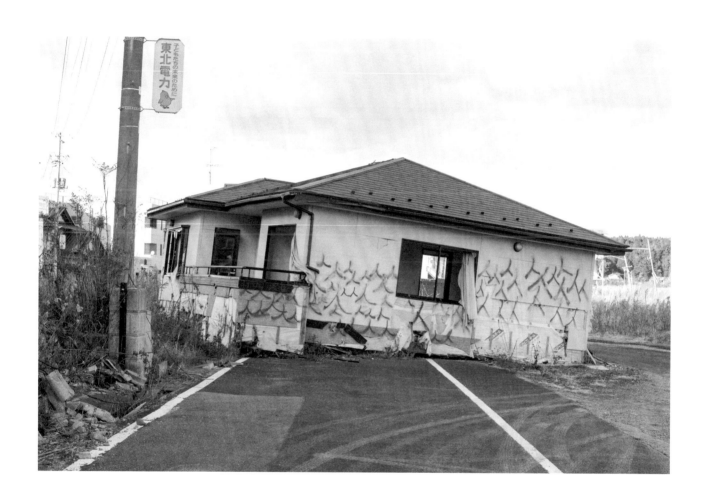

where clocks had stopped at 2:46 p.m., the moment the earthquake had struck. Cars remained where the tsunami dropped them next to the station and a house sat on the main road south from the station (pages 66–67). A team of performance artists had painted the character for person (*hito*) in red across the house.

In 2017, the station was being rebuilt and most of the town around the station had disappeared, replaced by an enormous parking lot (pages 172–73, 204). That year only 215 former residents had returned to live in Tomioka. In 2019, although the station had been rebuilt, construction continued around it (pages 225–27).

This is a memorial to one or more persons who died in the tsunami at Sakamoto. Everything is carefully placed. The three bamboo vases on the left are for flowers. The can of Asahi Beer is an offering of a favorite drink to the dead. There is a funerary tablet (*sotoba*) with a Sanskrit inscription signifying sky, wind, fire, water, and earth. The diagonally cut bamboo vases in front of the tablet also are for flowers; the flat-cut bamboo in front of them is an incense burner. This was a place of memory and devotion, often visited at a recent time in the past. The coin placed on the tile in the lower center of the image was a five-yen (*go-en* in Japanese) piece, signifying a karmic bond (*goen*). The piece of a computer on front of the yellow, pebbled guide for the blind suggests that the deceased had an interest in computers. The grey stocking cap on the right edge might have belonged to the deceased, offered to keep the head warm on the journey to the next world.

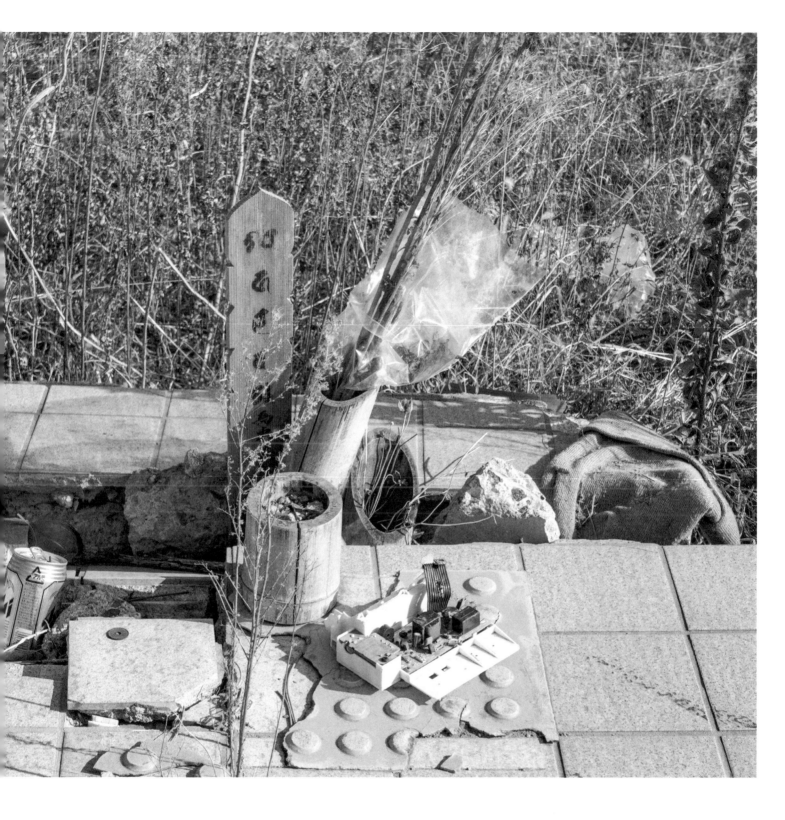

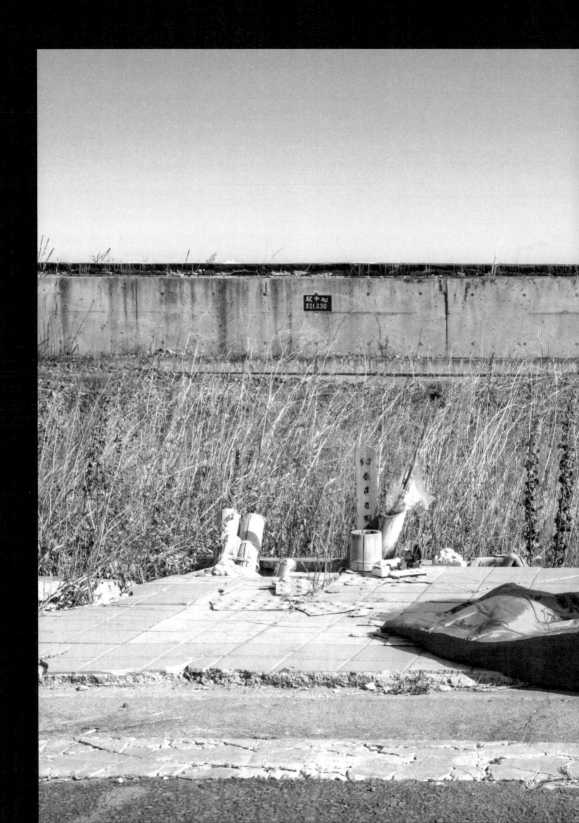

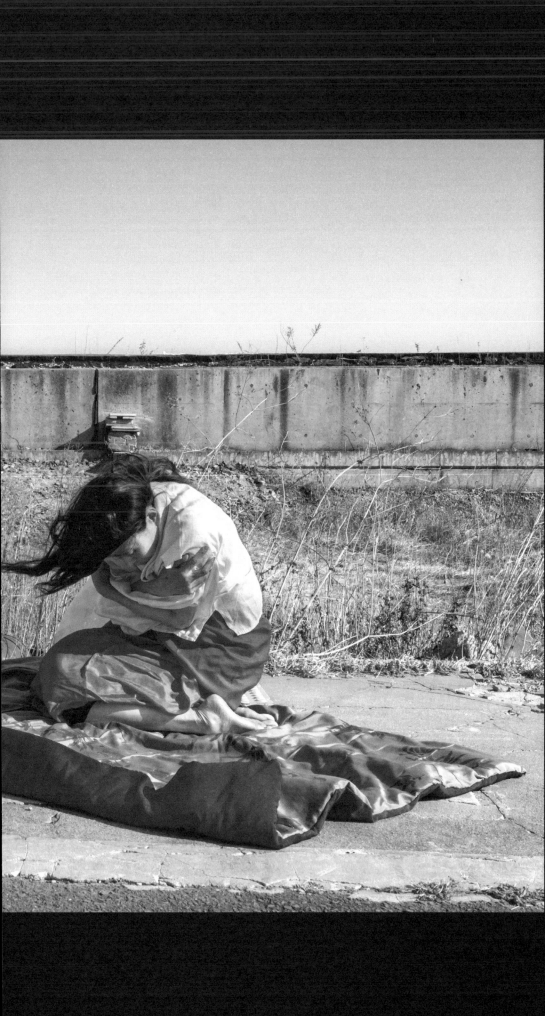

SAKAMOTO STATION 坂元駅

BEING IN FUKUSHIMA

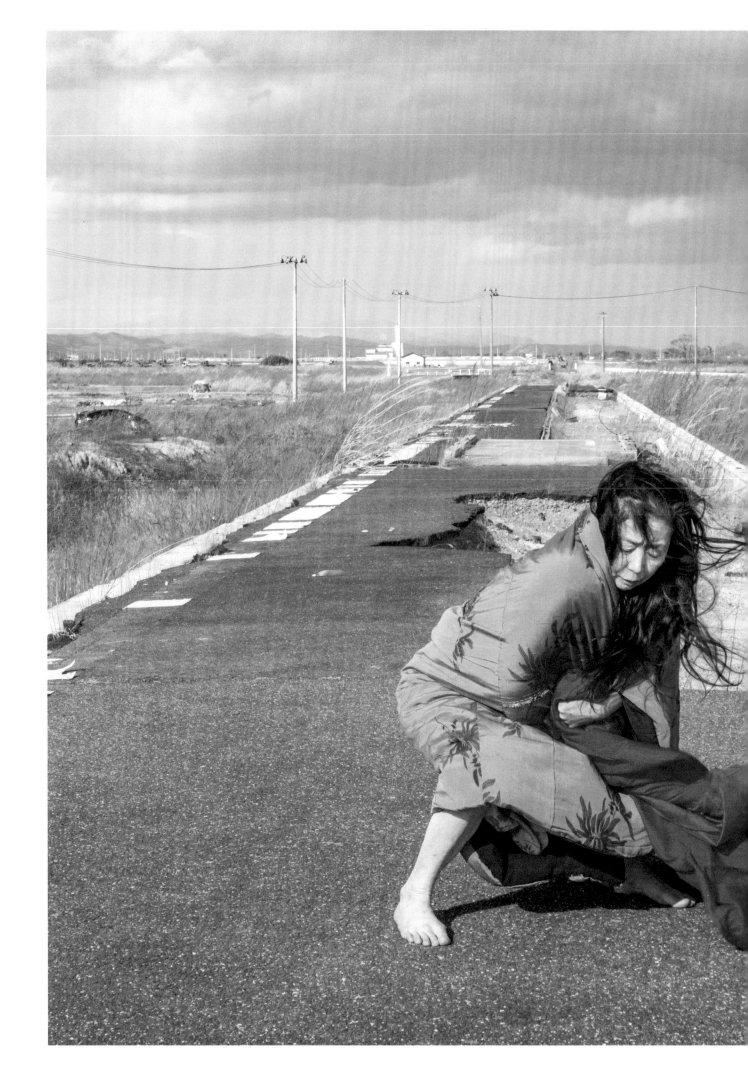

JANUARY 16, 2014. NOBODY CAN STAY OVERNIGHT IN THE EXCLUSION zone. Bill and I stay in lodgings that were quickly built right outside of the boundary for people who commute to work in the exclusion zone. Curious about a white person fluent in Japanese with an aged Japanese woman, many of the all-male and mostly young workers tell us their stories.

A middle-aged engineer who oversees the production of tanks to store contaminated water tells us of his dilemma: If he orders tanks to be made with welded bolts, there will not be enough tanks; if he orders workers to skip welding the bolts, tanks will be built faster, but they will leak. Either way, he figures, it is impossible to contain the contaminated water that grows daily by a huge volume. And nobody knows what to do with it once it is stored. He suspects that no matter how hard his team works, the contaminated water will have to be released into the sea. For many reasons, he is stressed. He has not seen his family for four months.

A young man buys us sake from a vending machine but challenges us, "Oh, you guys come for a week and go back to your safety." True. But I ask myself: *Is it really better that I don't come at all?* Walking around the high-radiation area, however short a time, I myself wonder often, *What am I doing here?* Surely, I'm not contributing in a way that makes this situation less of a disaster. These questions linger as we work in Fukushima.

Throughout my life, I have traveled a lot. There are things I can learn only by being in a particular place. Being in Fukushima is very different from just reading about it, or even from remembering having been here.

In the Fukushima evacuation zone, I am at a loss. I am stunned by how upset my body feels. I cannot help asking, *How has this come about? Where is this going?*

No answer.

I was here before. In 2011, I came to Fukushima because I instinctively felt I had to. I have always felt there are certain places where it is necessary to visit—to smell, feel, and remember. People forget things, so each of us decides and puts efforts into what we want not to forget. I came to Fukushima because I did not want to see the Fukushima disaster only on TV. Seeing these terrible things at home on media, I can go to the bathroom or have a snack. That makes me know I am at a safer distance. I wanted to change the feeling of that distance.

Now that I am here with a photographer, I do not know what I am to do. But I know I will remember this fear, and the shiver. *I will NOT forget this. If I forget this, I will no longer be me.*

I am here just to be here. It is necessary.

I sit, not able to move. My body tenses. Tears. Bill has gone out of sight to photograph the area. *I want to go home.* Finally I stand up. I talk to myself: *I will not leave the area crying. I asked Bill to come to photograph me here. I have come here to perform.* I reluctantly choose costumes for this place, mainly for a color I want to add to the scene. I take off my shoes and have a moment of hesitation. *Radiation levels are high. I am barefoot. And I am going to lie down.* I am aware that radiation among the dried weeds covering the ground is much higher than what is shown by a dosimeter placed five feet above the ground.

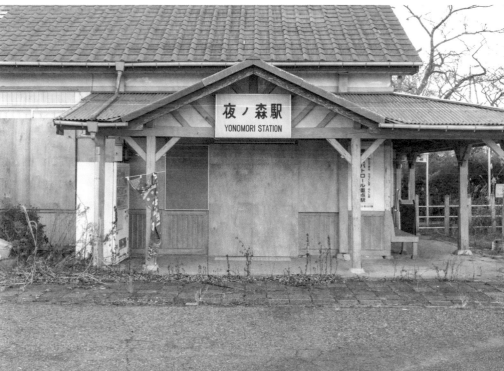

Tsunami-swept, irradiated Fukushima is unusual in Japanese landscapes. For generations Japanese people have utilized every usable space for farming, foresting, housing, and making things. But Fukushima near the coast is now desolate. Damaged houses barely standing. Disappeared houses. *No one here. Absolutely no one around.*

Dancing in Fukushima is a very naked experience. Yet, this emptiness carries so much residue of the people who had lived here, who had died here, and who had to flee. I see such residue in piled futons, discarded shoes, and broken bathroom tiles. I have brought old kimonos, so I let my body mingle with the residues of Fukushima's past.

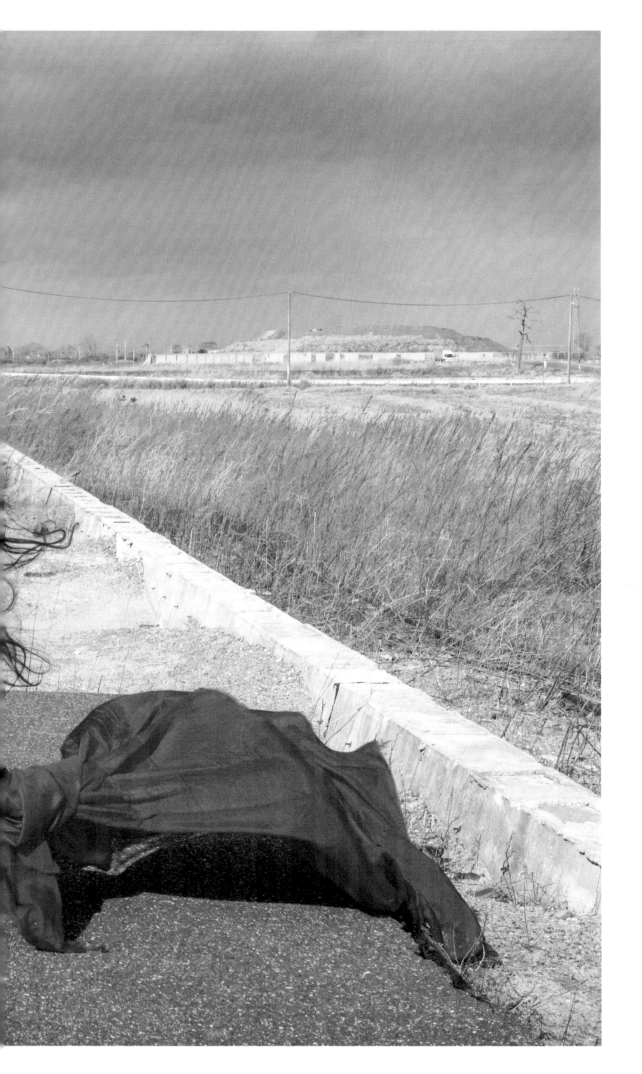

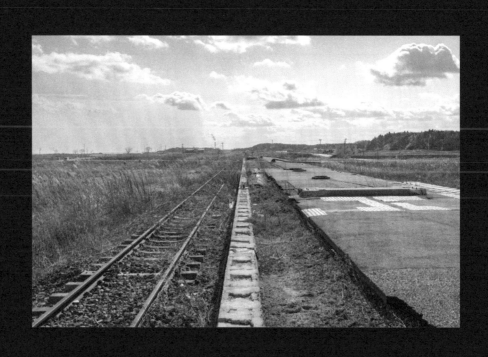

MOVEMENT

IT IS NOT ONLY A BODY THAT MOVES, BUT EVERYTHING ELSE TOO. OUR mind flutters and thoughts gush. A virus spreads. A flower blooms and withers. A thing is built and broken. We get deeply moved by a story, visible growth of a child, or an artwork. We also get bored and yawn. Movements of a body and a mind. A social movement swells, dwindles, and reignites. The Manhattan Project and the development of nuclear technologies, as well as antinuclear activism, are also movements. In recent years we are moving for Black Lives Matter.

In both individual and collective movements, momentum becomes a crucial force. Yet momentum is often dangerous, carrying us to where we never knew we were going and where we might not be prepared to be. Momentum makes risk-taking both a pleasure and moral dilemma.

In my dancing, I have swayed between wanting to keep fueling myself and noticing my hesitation about the speed and the force.

Being a contemporary artist means that one *grapples* with today's world. But *grappling* takes a little bit of commotion. And I have to *swallow* my own regrets. Grapple and swallow are movements. Maybe that is why I like to present a body and mind that are "not quite right."

I once wrote, "I want to stay miserable." Thinking I had chosen the wrong word, my friend Sam crossed it out and wrote "vulnerable." I crossed out his correction and re-wrote "miserable." I am well aware that museums and theaters are not a place where people expect to see something miserable. But being vulnerable doesn't take determination, because we are all vulnerable. I want to be existentially miserable.

I carry with me the memories of visiting Fukushima.

I perform. It is my way of knowing. I make more decisions when I perform. It is through making decisions that I observe and remember—however minor such decisions might be—where to stand, what to wear, and how to bend my body.

Looking at myself in Bill's photographs, I realize again a body that is dancing holds nothing useful or practical. It is playing with air. A dancing hand does not brush teeth, or write a clear statement, or attack and harm other beings. It is not ready to do such things.

The uselessness of dancing is human.

I want it to subvert and sabotage technology and productivity. I do not want to join a chorus praising dynamic creativity. Such can be too costly for our survival. I want to hold a hesitant gaze, though my body is almost always tipped forward.

Dancing is prayer.

I will return to Fukushima. Going to Fukushima is a choreography. Traveling there is a movement. Walking, crying, and sighing are movements. Wind moves leaves, weeds, waves, broken curtains, and my costumes. Time moves.

When I go to Fukushima, my distance to Fukushima changes even after I return. Seeing me in these pictures, I hope the reader's sense of their own distance to Fukushima might also change.

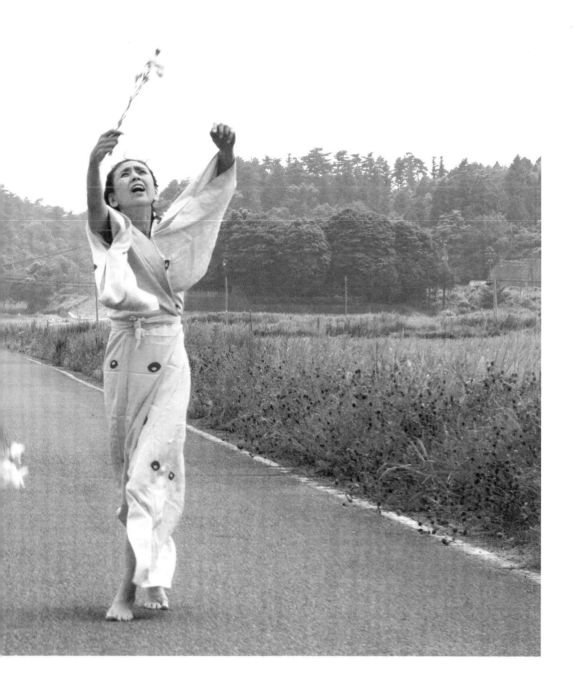

YABUREMACHI 破町

TRIP TWO

前原 MAEBARA

富岡町 TOMIOKA TOWN

富岡漁港 TOMIOKA FISHING HARBOR

新舞子浜 SHINMAIKO BEACH

破町 YABUREMACHI

夜ノ森 YONOMORI

桃内駅 MOMOUCHI STATION

坂元駅 SAKAMOTO STATION

JULY 2014

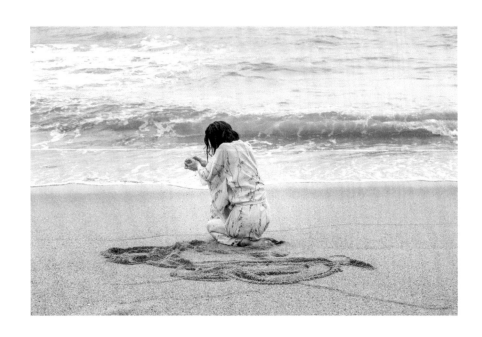

SHINMAIKO BEACH 新舞子浜 (above, and next page)

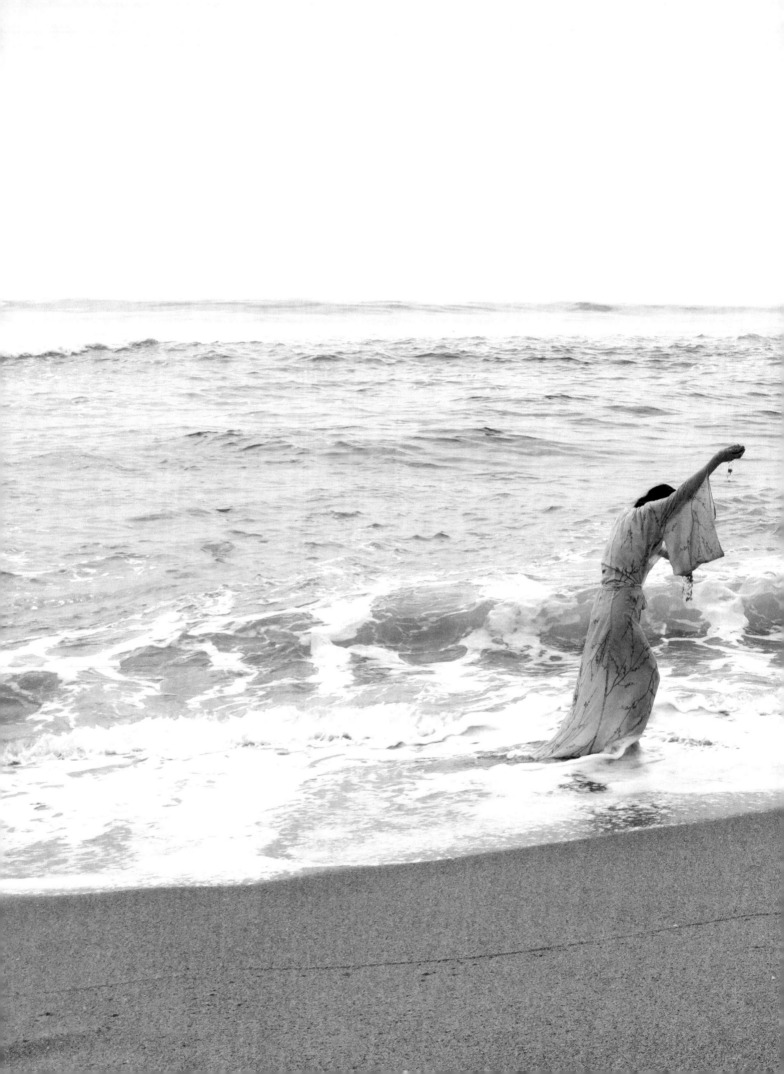

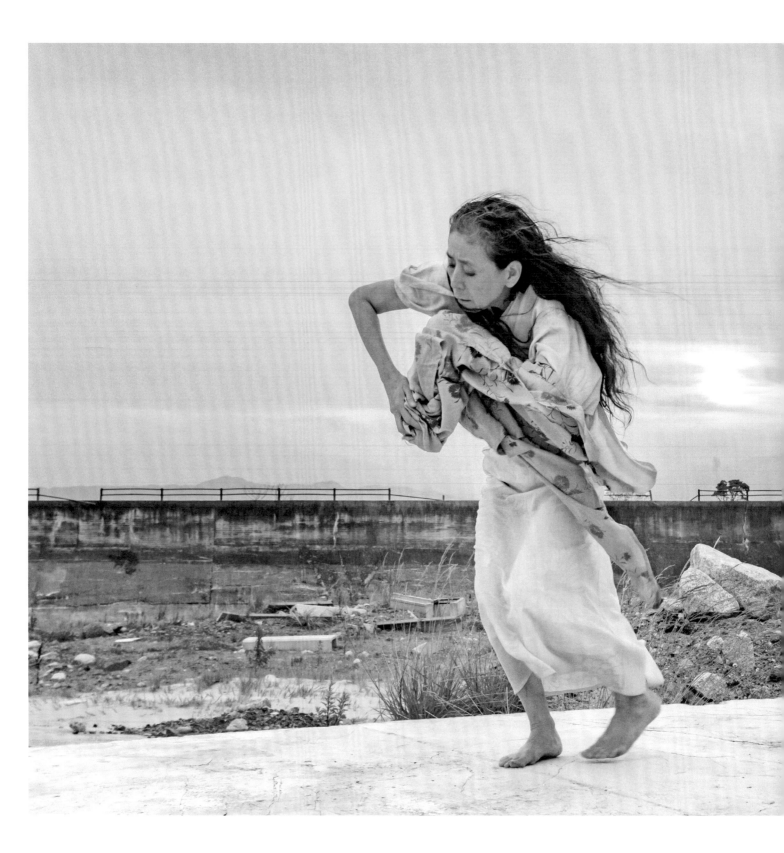

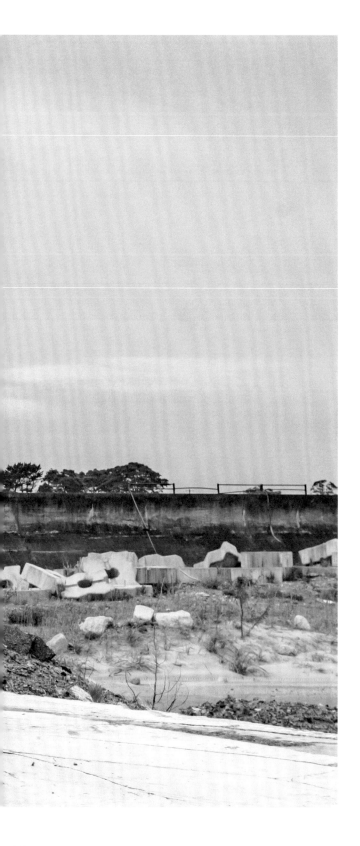

TOMIOKA FISHING HARBOR　富岡漁港　(above, and next page)

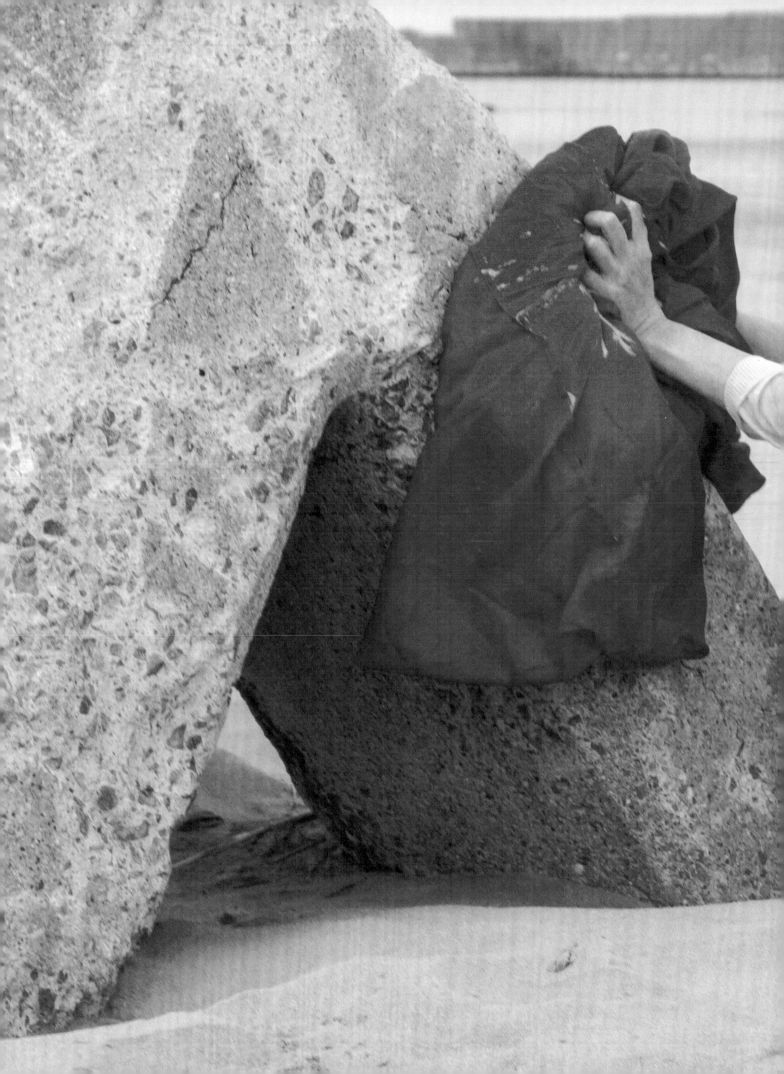

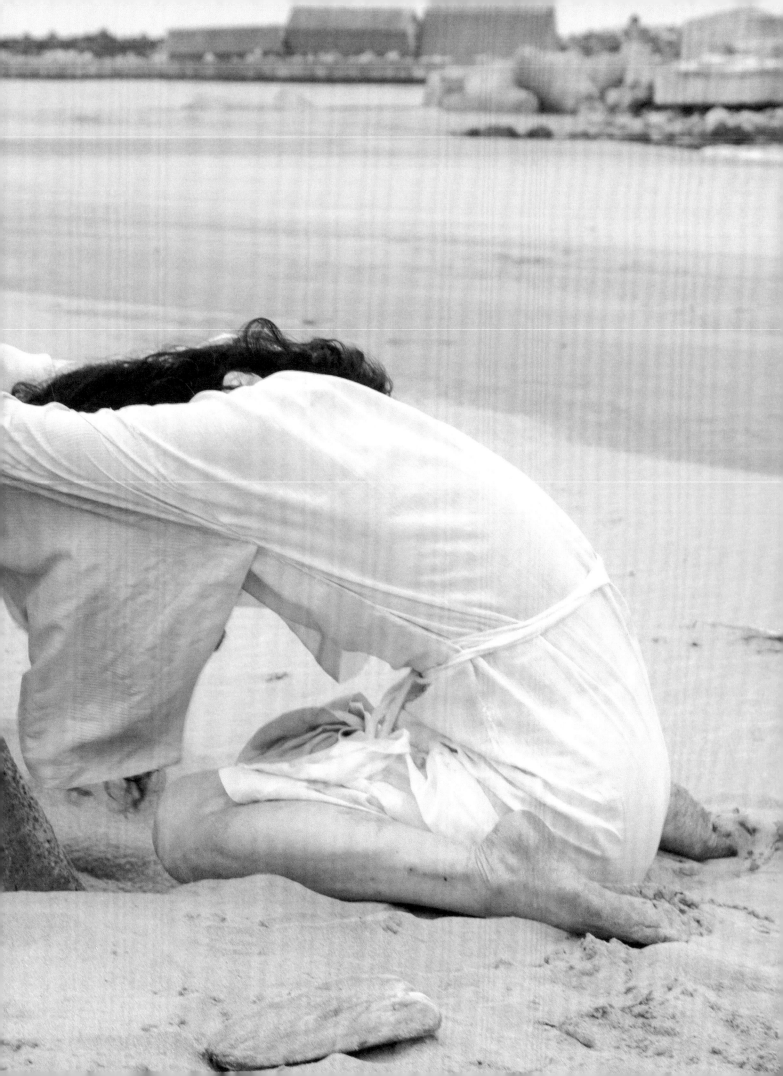

At Tomioka fishing harbor, 6 mi. (9.6 km.) south of the Fukushima Daiichi reactors, the tsunami on March 11, 2011 reached nearly 70 feet, higher here than any place else in Fukushima; it was one of the three highest inundation levels on the coast. It crashed over the harbor, destroying fishing boats, the Tomioka Fishing Cooperative building, much of the sea wall that separated the harbor from the rest of the town, and a major bridge. The harbor area had been inaccessible in January 2014, but in July Eiko danced on top of pieces of the broken seawall, on the beach, inside the twisted remains of the Fishing Cooperative building (pages 3, 29, 88–91, 95, 98–99, 100–103).

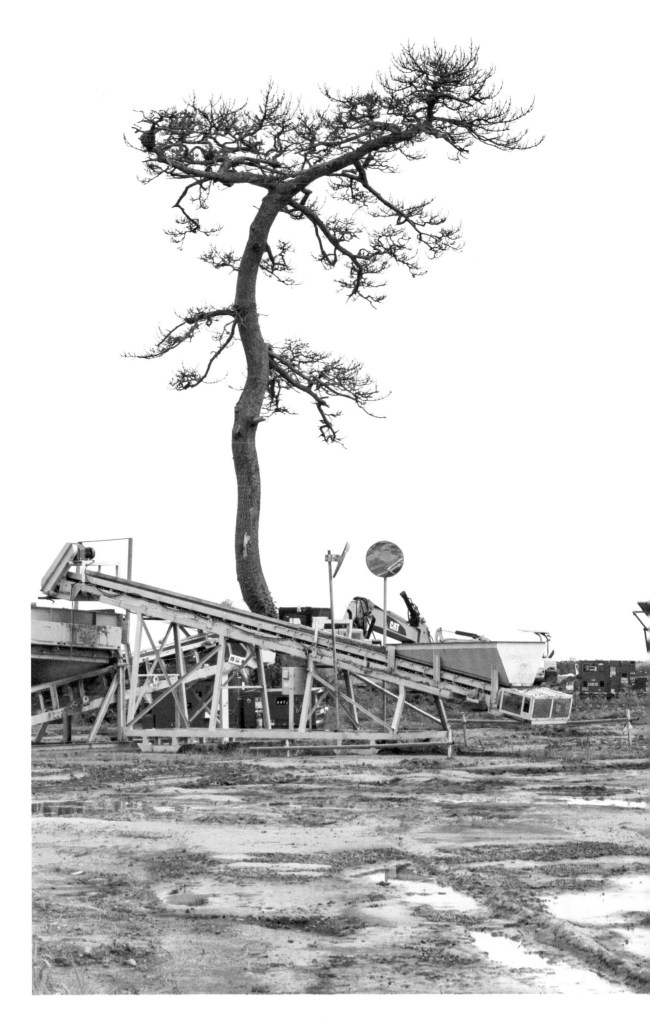

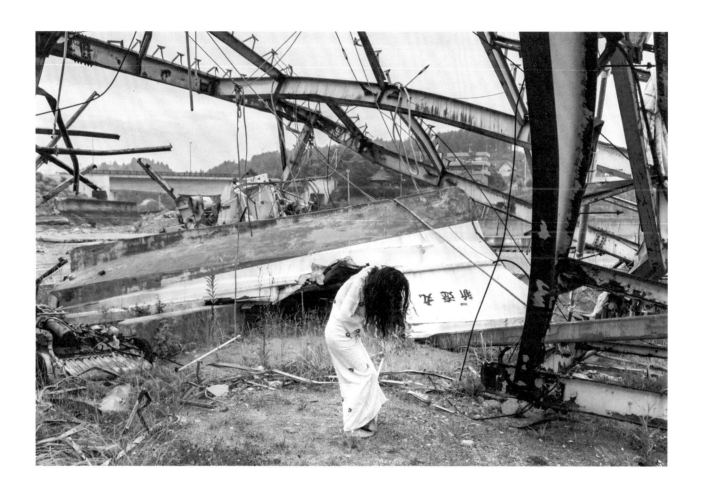

A broken road parallel to the sea-
wall led toward the Fukushima Daini
(Number Two) nuclear reactors,
which narrowly missed melting down.
Eiko performed on this road during
four visits (pages 29, 96–97, 236–39).

By 2019, new Fishing Cooperative
buildings had been completed,
ready for the day in an indefinite
future when the Fukushima Daiichi
no longer pours radioactive ground
water into the sea.

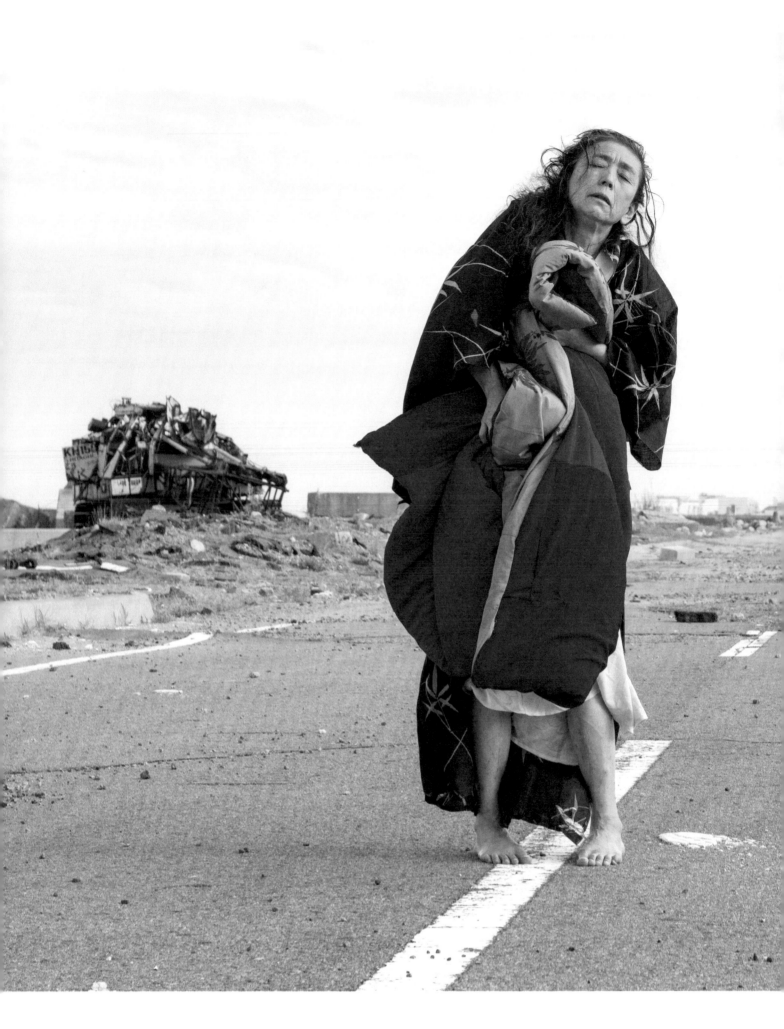

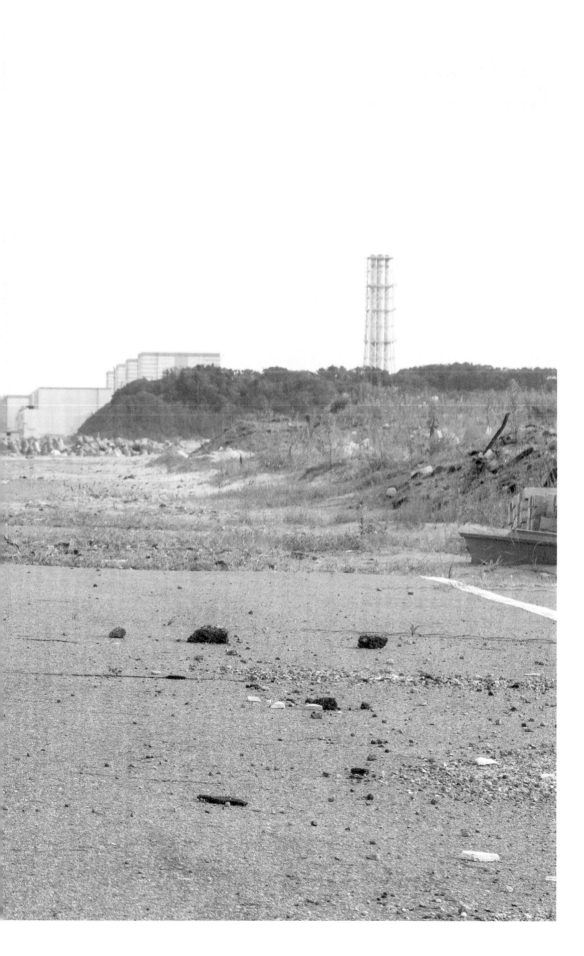

TOMIOKA FISHING HARBOR 富岡漁港

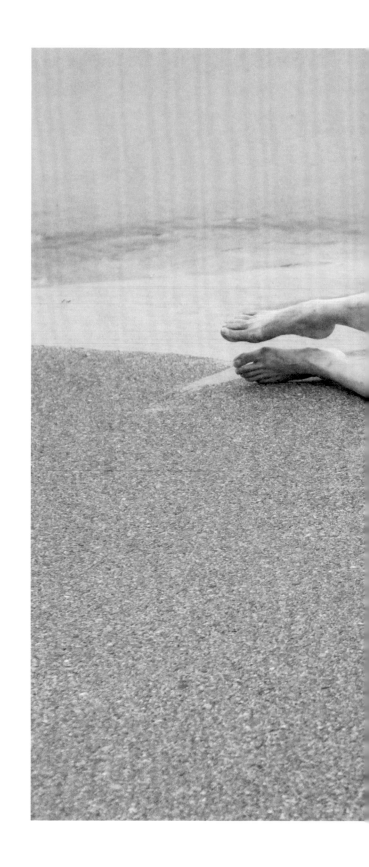

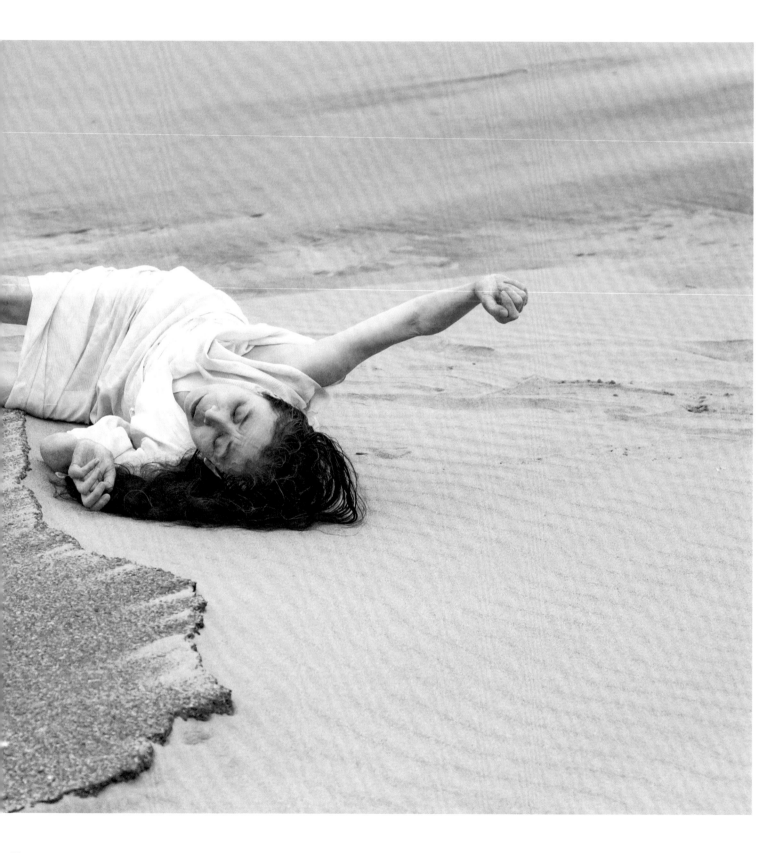

TOMIOKA FISHING HARBOR 富岡漁港 (above, and next page)

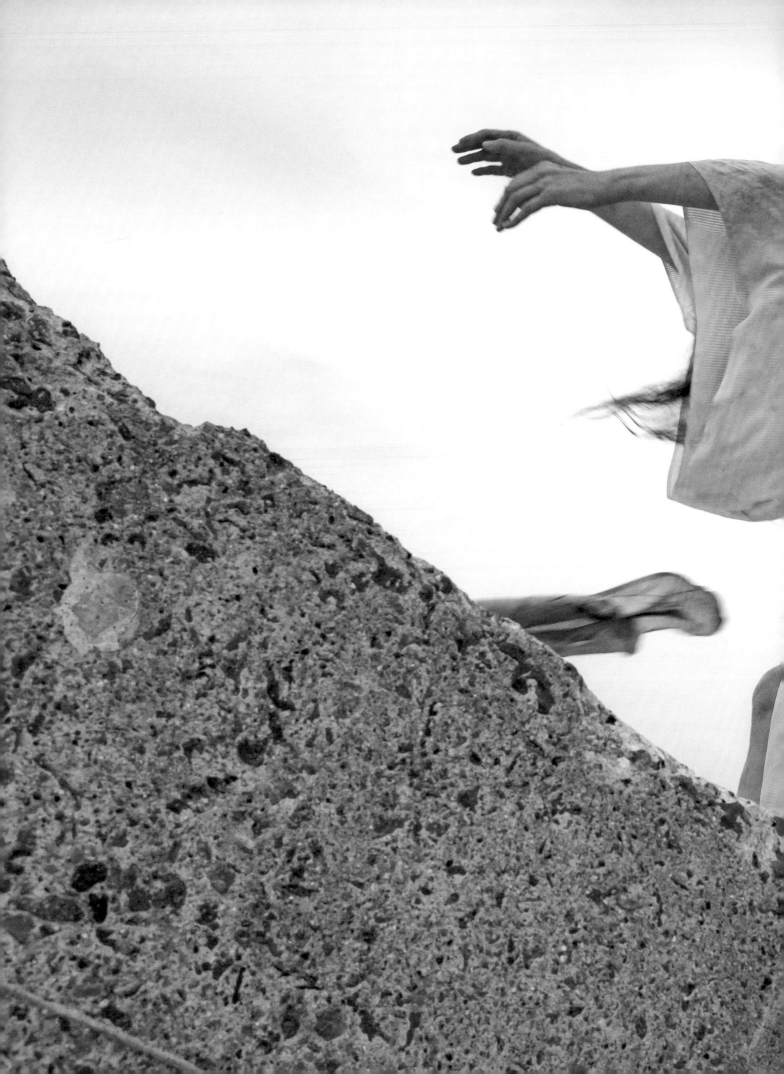

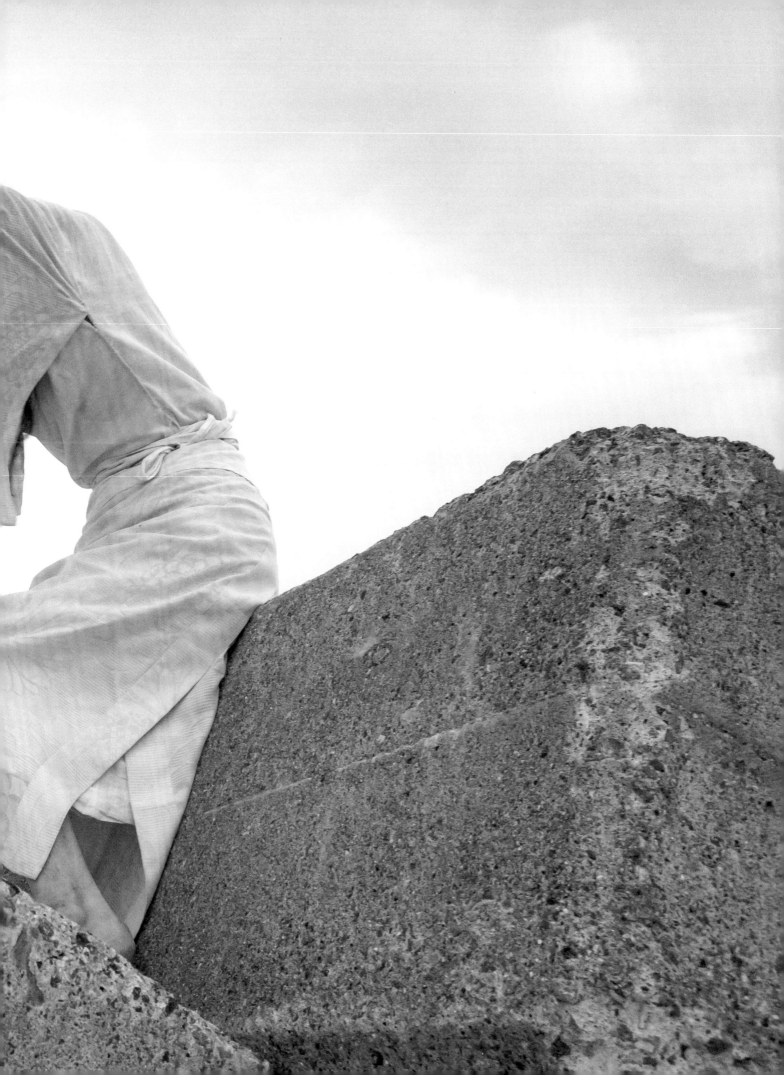

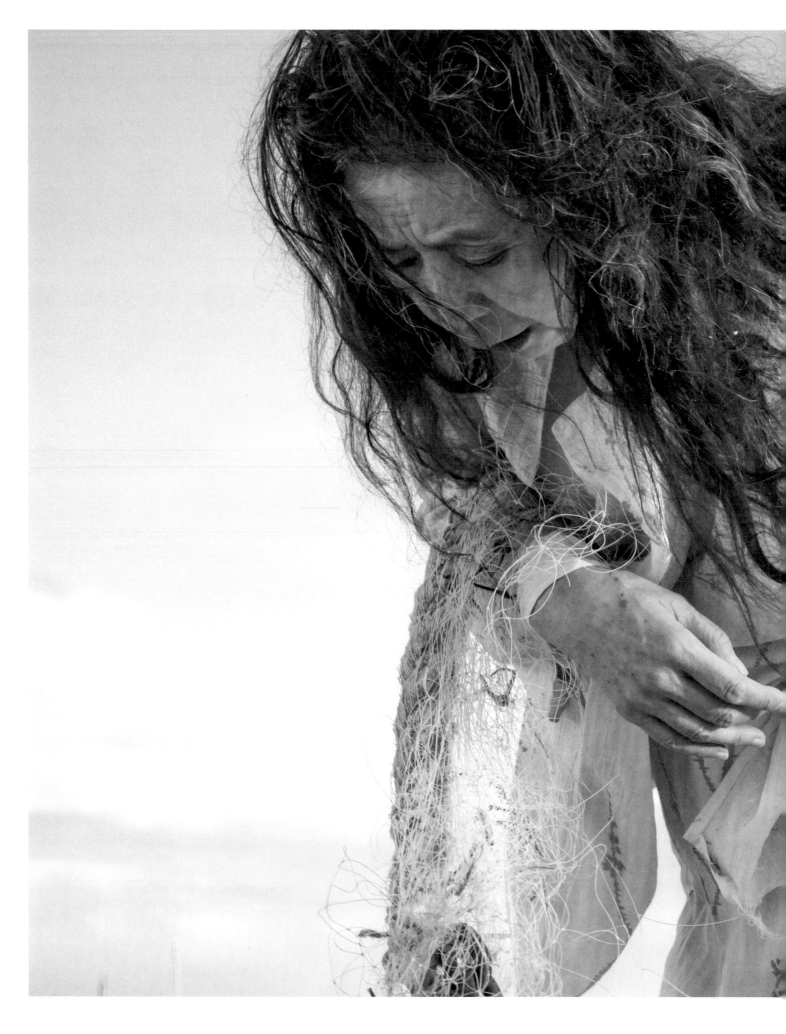

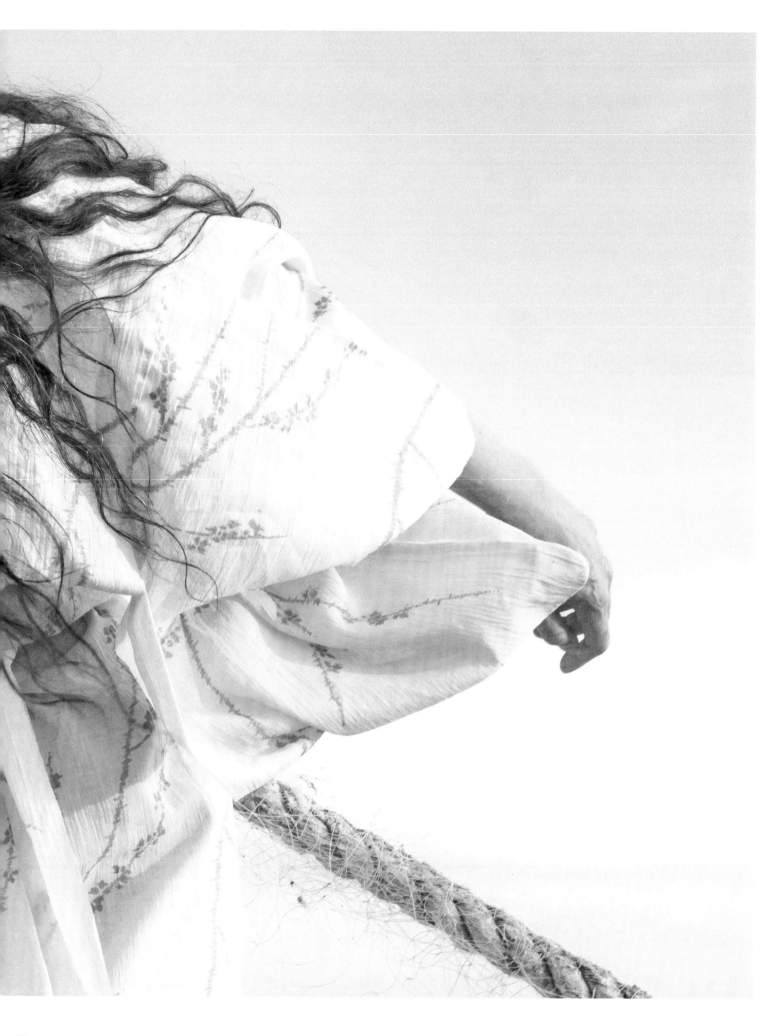

TOMIOKA FISHING HARBOR 富岡漁港

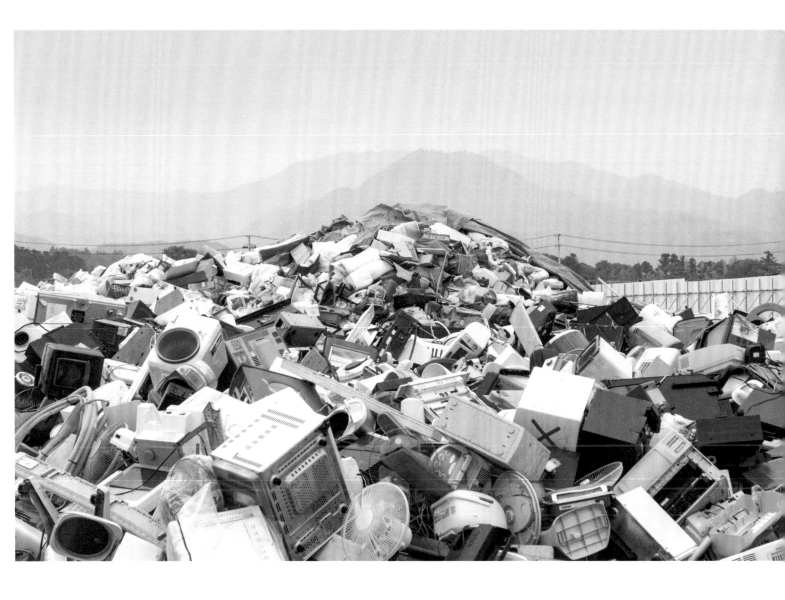

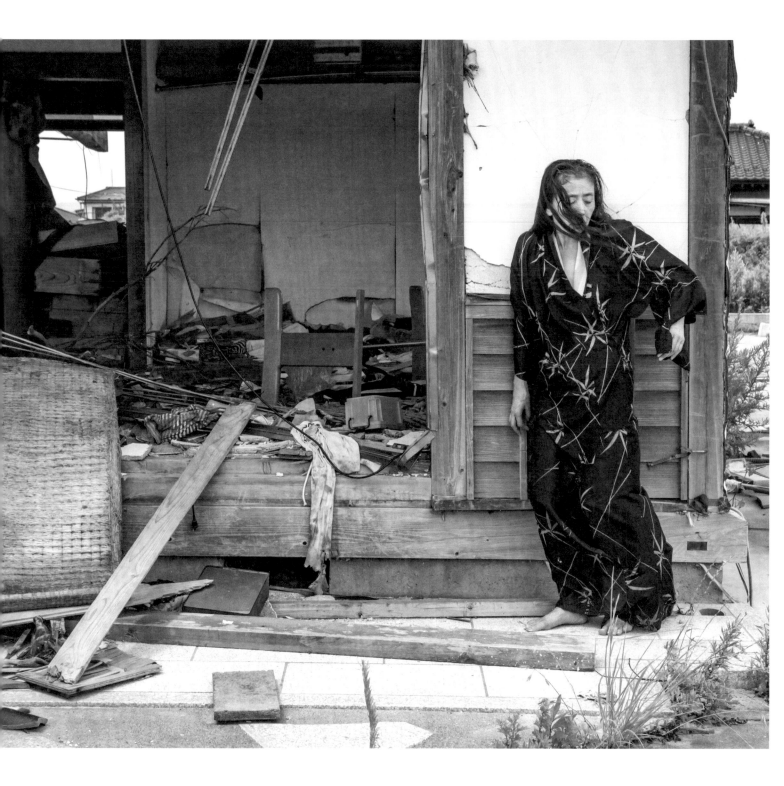

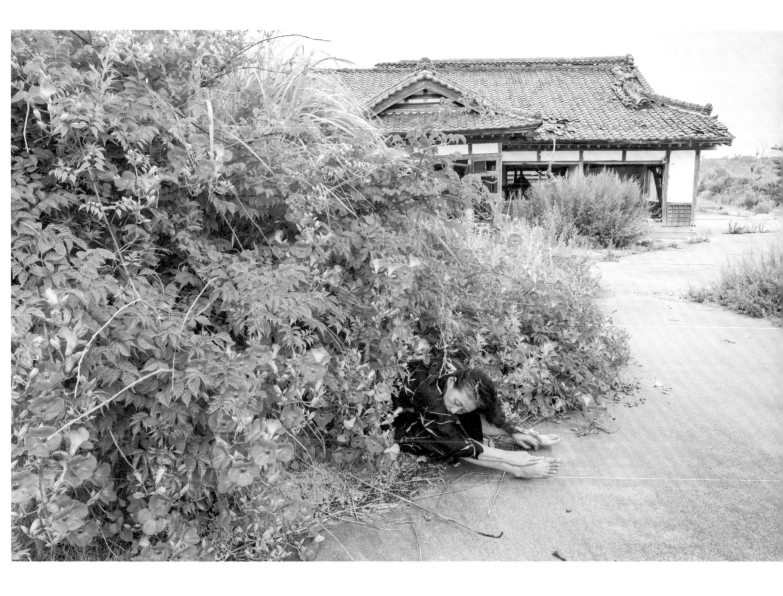

　　　　　　　　YABUREMACHI　破町

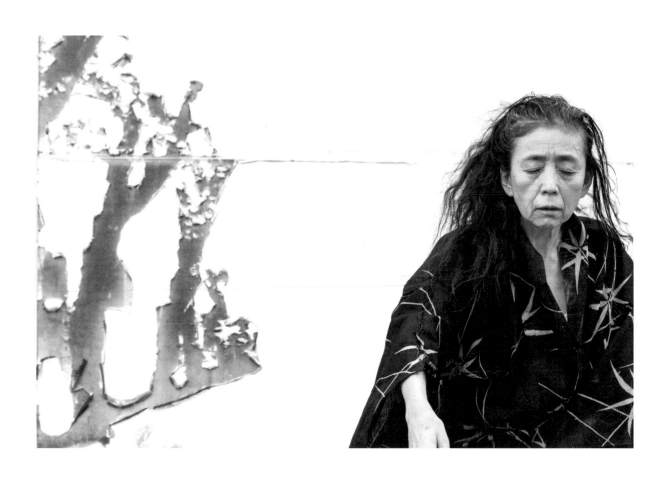

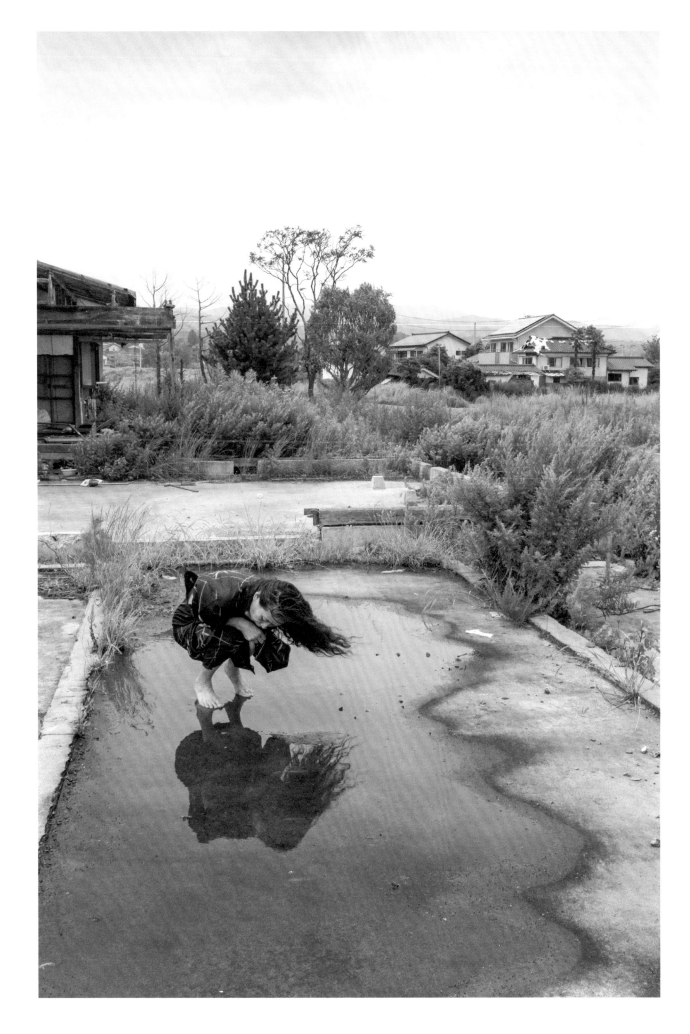

YONOMORI 夜ノ森 (left), YABUREMACHI 破町 (right)

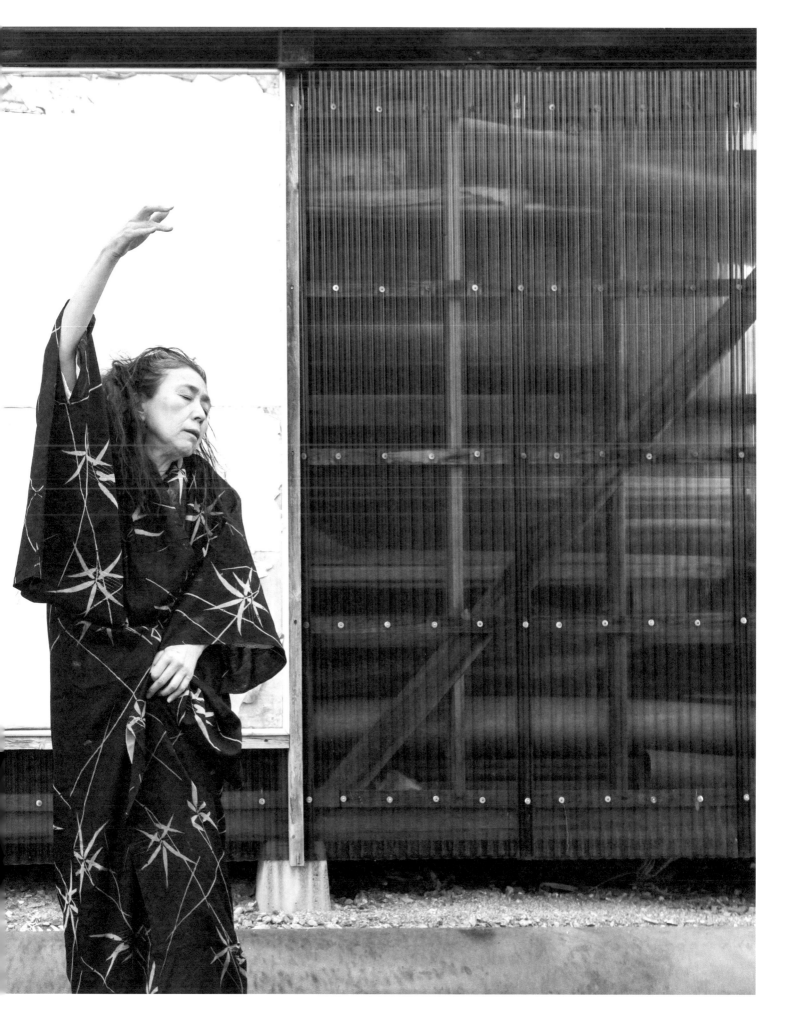

YONOMORI 夜ノ森

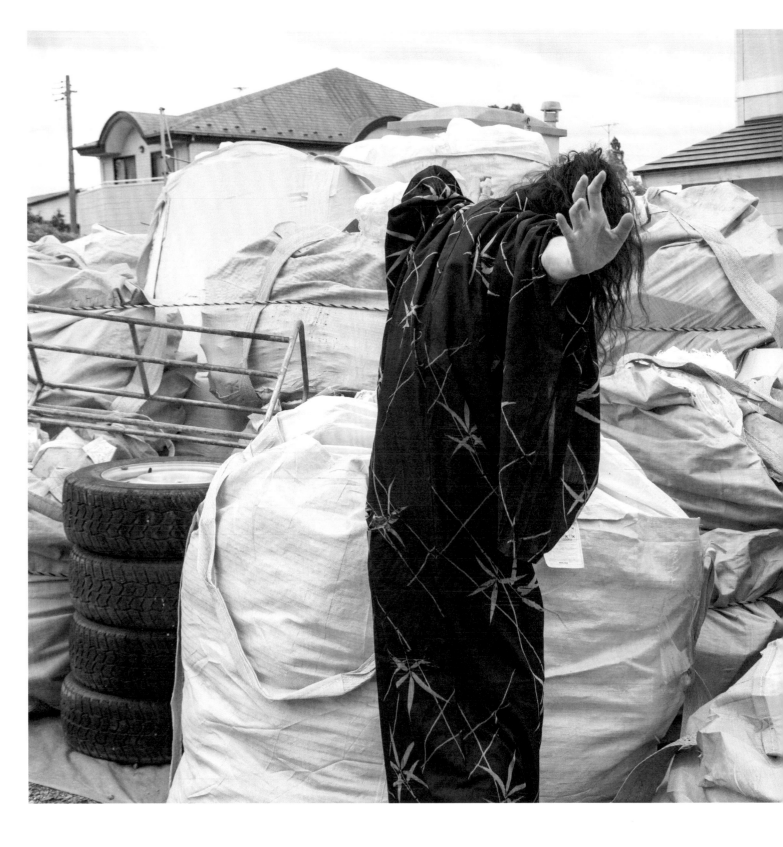

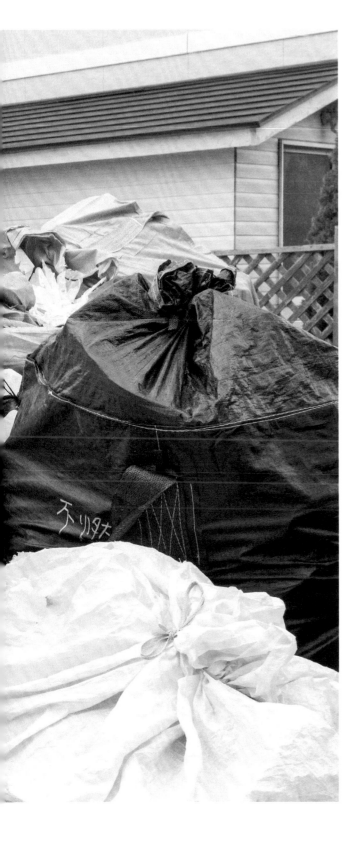

YONOMORI 夜ノ森

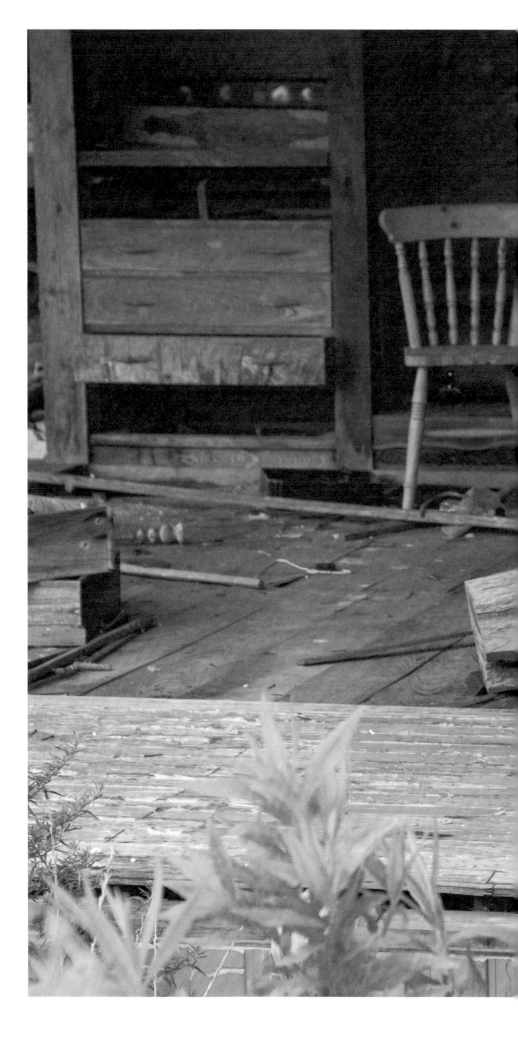

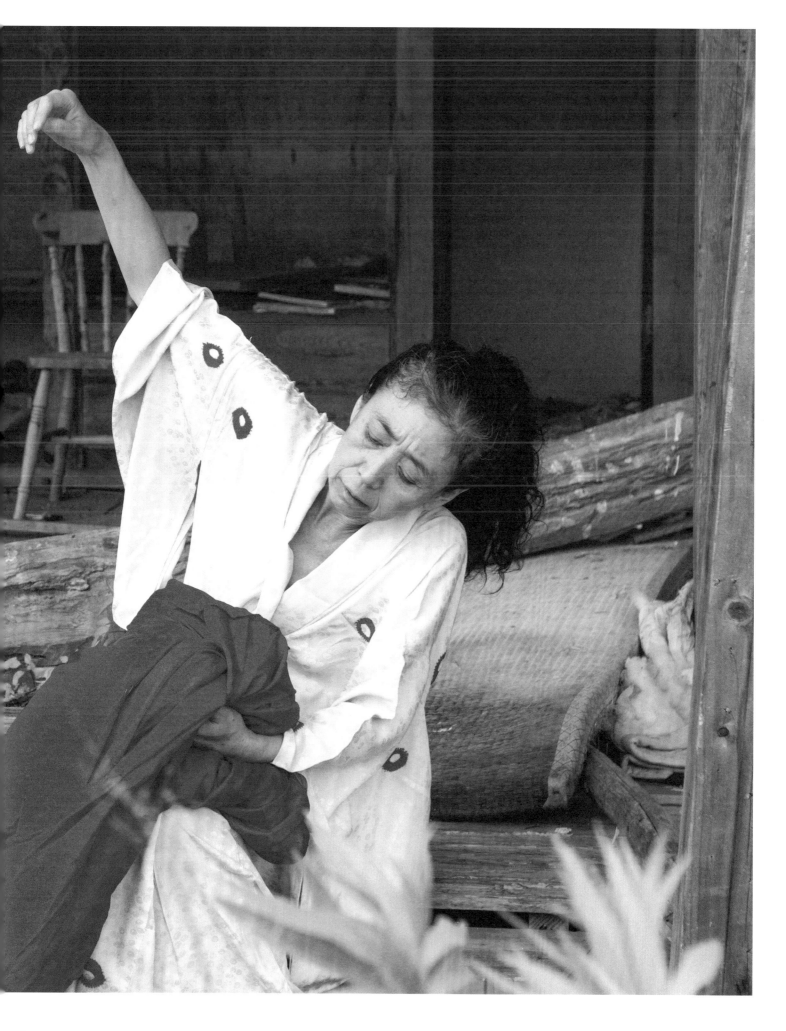

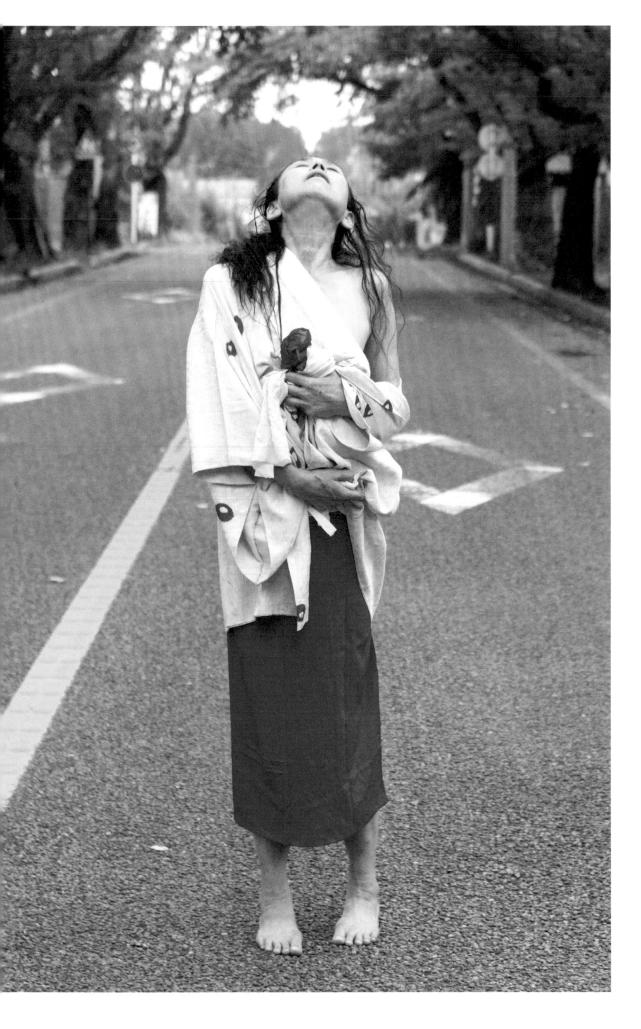

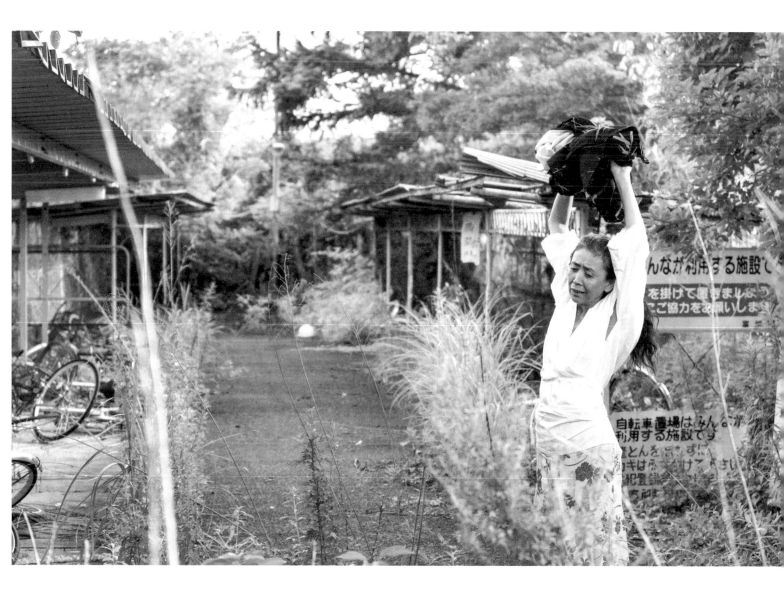

Yonomori, situated 4.5 mi. (7.2 km.) southwest of the Fukushima Daiichi reactors, was famous for its main street lined with over 1,500 cherry trees (pages 33, 116) and hundreds of azalea bushes surrounding the train station. Before 2011, people from all over Japan came for the cherry blossom festival in April. After the meltdowns, high levels of radiation required that large parts of the community, including the railroad station, be placed in the exclusion zone, closed to visitors. In January 2014 we entered that area, and returned again in July (pages 116–19). On our second visit we measured the radiation with a portable dosimeter; when it went past 13 millisieverts per hour and kept rising we quickly left. Although the damage from the earthquake was not severe and the tsunami did not reach there, the radiation made it uninhabitable. Yonomori railway station (page 75), built in 1920, was dismantled in 2019 and replaced with a new building although the area remained highly radioactive.

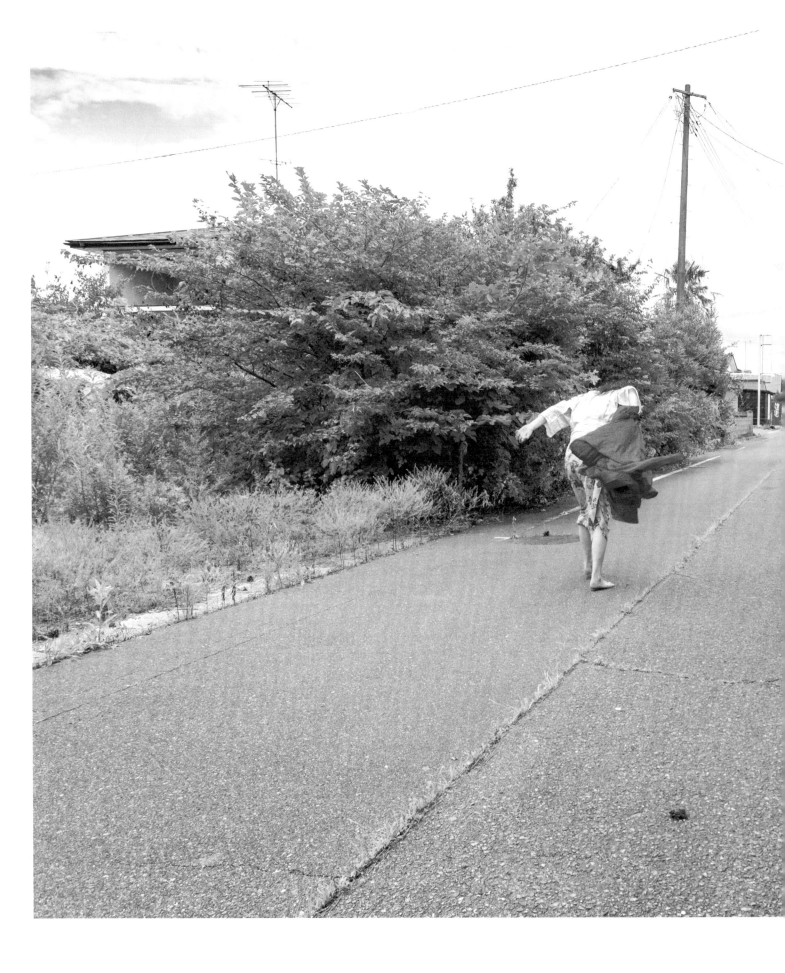

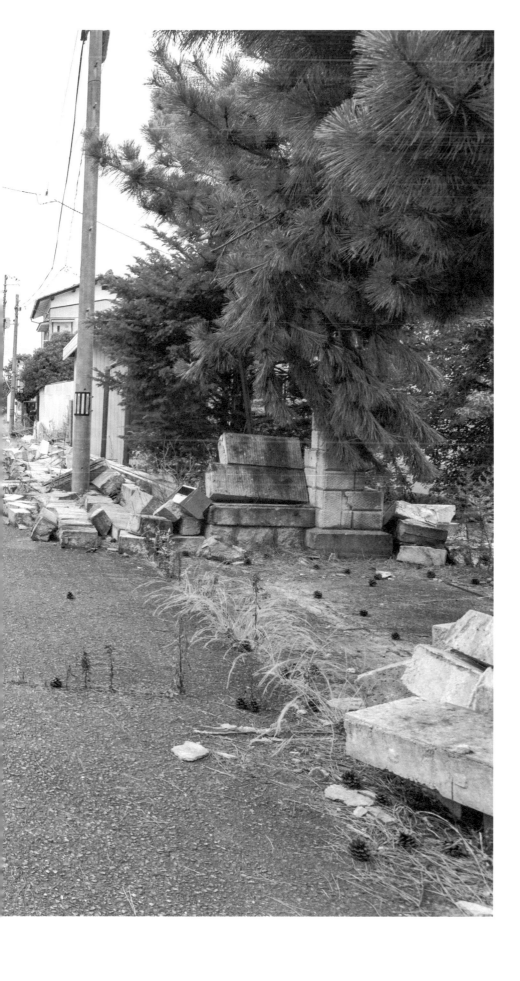

YONOMORI 夜ノ森

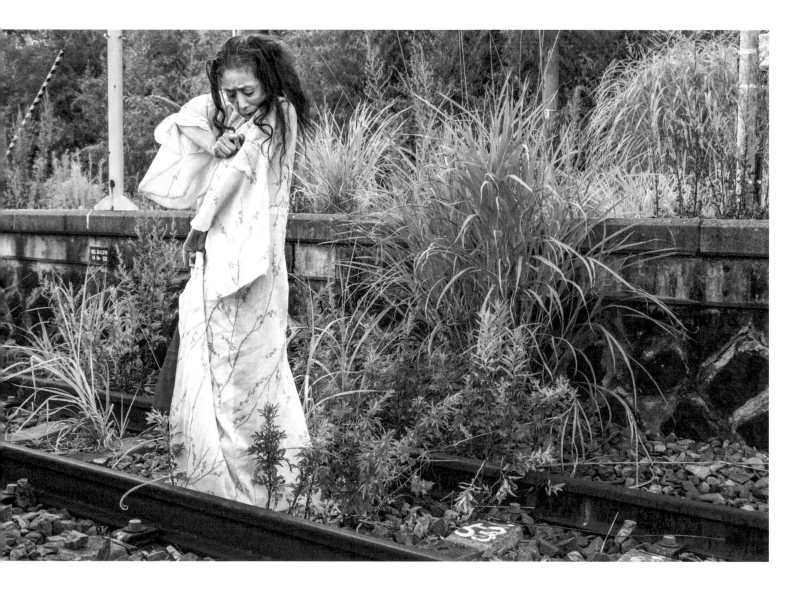

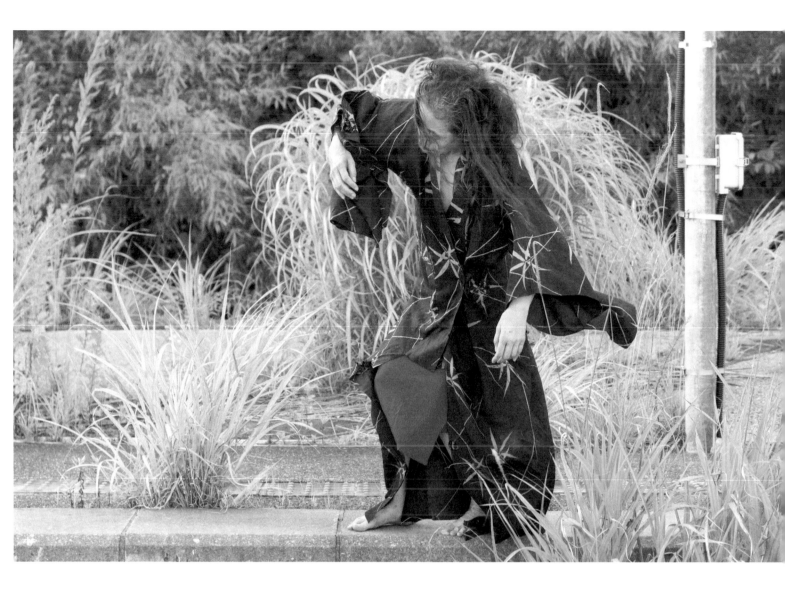

MOMOUCHI STATION 桃内駅 (left, above, and next page)

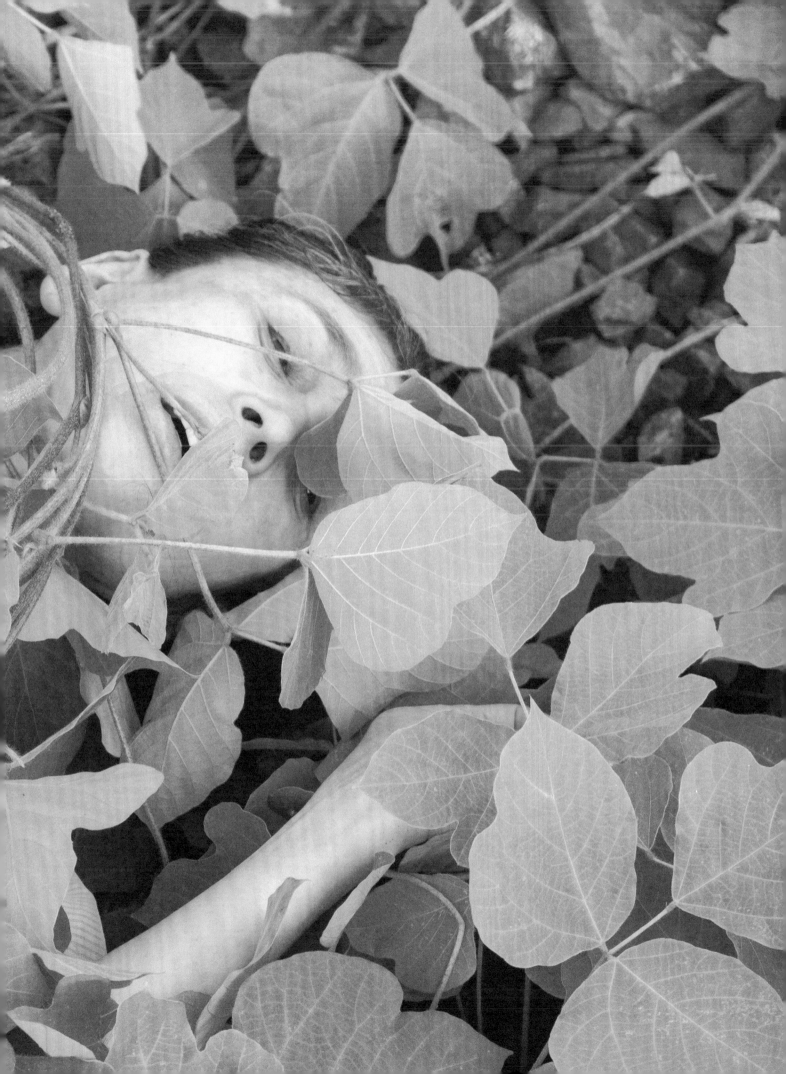

When we visited Fukushima the first time, the northernmost station we planned to visit was Shinchi station. Yet when we got to Shinchi there was nothing resembling even the ruins of a station. The tsunami had obliterated everything. We ventured north to the next station, which was Sakamoto, just across the Fukushima border in Miyagi Prefecture, 35 mi. (56.3 km.) north of the Fukushima Daiichi reactors. The tsunami swept over the station, folded steel street light poles parallel to the ground, and destroyed the station building. All that remained in 2014 was the platform (pages 20, 24, 68–71, 73, 77).

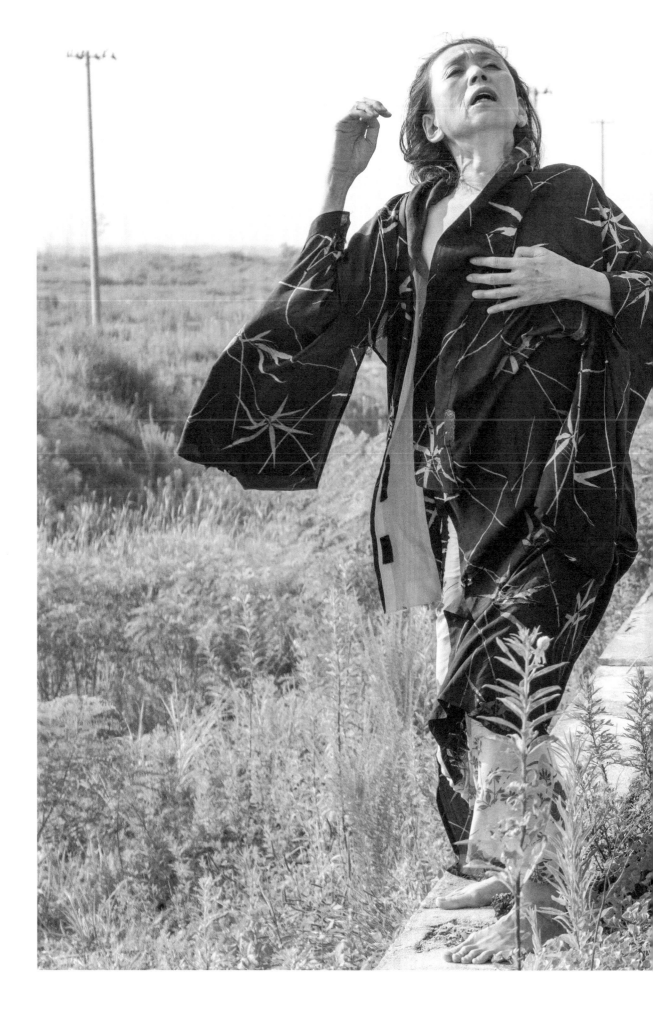

SAKAMOTO STATION　坂元駅

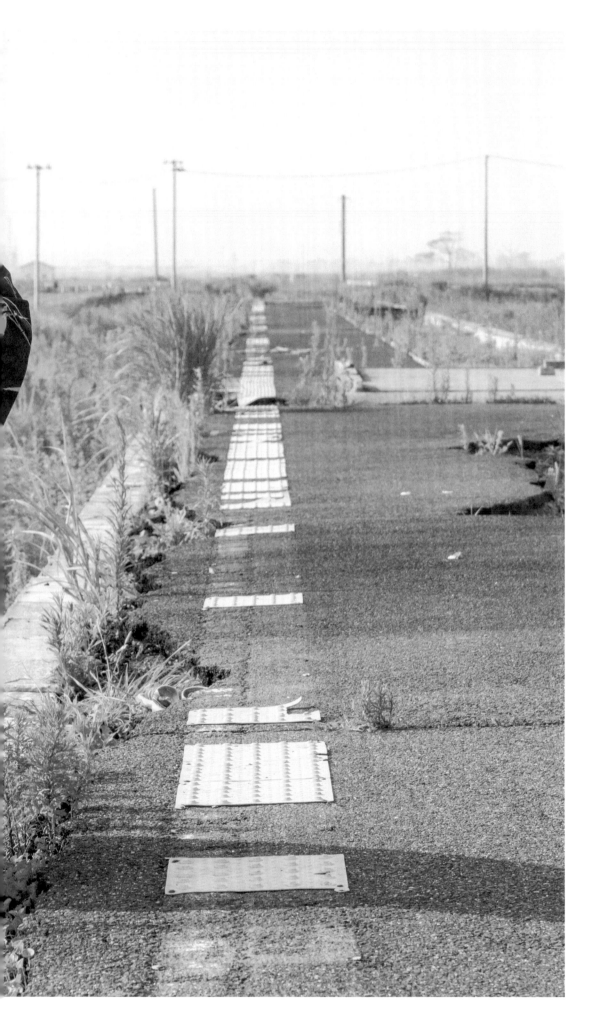

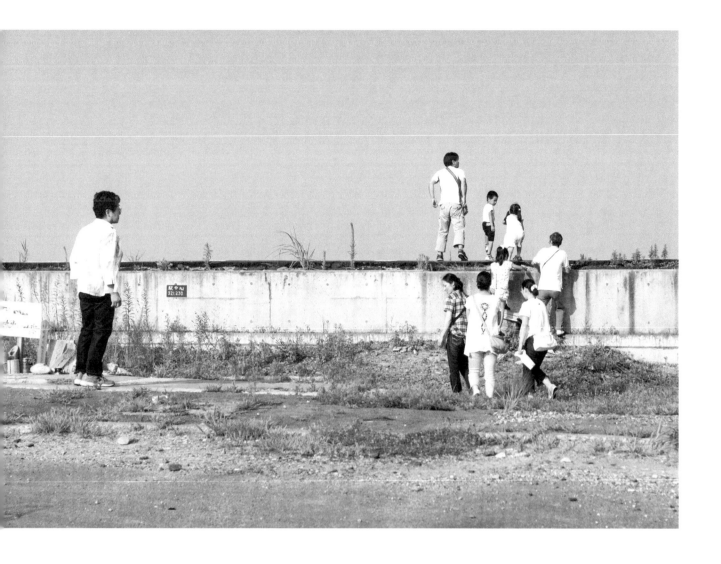

When we reached Sakamoto in July 2014, the barren landscape had become verdant with weeds (pages 125–26). People from the former community had planted a flower garden in front of the former station. Sunflowers were thought to remove radiation from the ground (pages 128–29). A family, including several children—a rare sight at that time—visited the memorial to the dead and the platform (page 127). By the summer of 2016, the entire platform at Sakamoto Station had been removed, along with the commu-

nity gardens and the memorials to those who had died there (pages 140–43). It seemed like a desecration. We mourned the loss as the ongoing cleanup and decontamination processes transformed the landscape more than the tsunami itself had done. In 2017, a new station had opened, several miles inland from the old one, seemingly to avoid destruction by future tsunami (page 199).

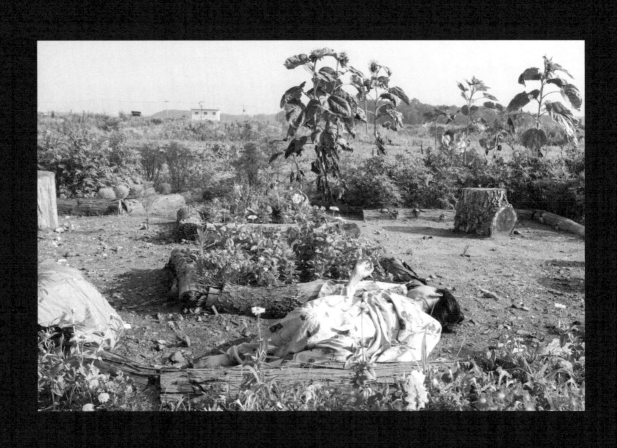

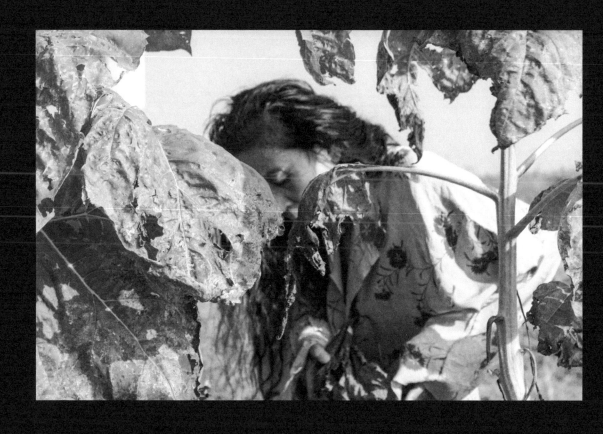

RED SILK CLOTH

Sagamihara City, Japan. For several days in a row,
my mother and I sew together pieces of red silk
fabric that used to line my grandmother's and my
mother's kimonos. My ninety-year-old mother
has almost no short-term memory, so it is hard to
have a conversation, but she can still sew by
hand very well. Her small hands move diligently,
creating small straight stitches on a particular
shade of red. The cloth is very old silk, with very old
red dye. If I cry on the cloth, or if the cloth gets wet,
the dye stains everything it touches.

The worn-out silk is already fragile, so if I stretch
it carelessly, the cloth rips easily. That affects how
I move and handle this cloth. At first, I am careful
and hesitant. But while dancing, my emotions
get stronger, as if toughened by resistance, and at
some point my movements override my hesitation.

So the cloth gets torn. A Fukushima tear.

Back at home my mother and I sew
the linings back together by hand, each
of us with very different memories of these
pieces of old red silk.

WORKING WITH EIKO

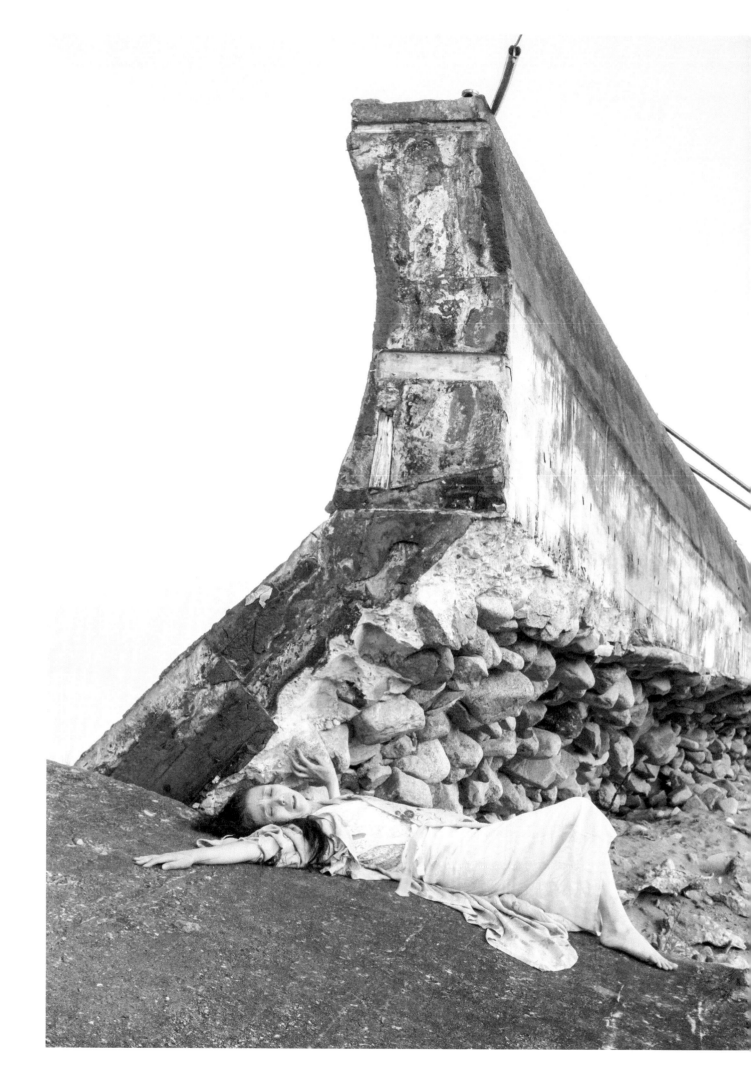

EVEN AFTER WORKING FOR YEARS AS A COLLABORATOR WITH EIKO, both as classroom instructors and as artists in the making of the photographic series *A Body in Places*, her performances remain a mystery. I've watched Eiko perform in front of many different audiences, from sophisticated New York dance aficionados to students in the classroom to street-fair goers in rural Massachusetts. Above all, I love to watch children mesmerized by a performer unlike anyone they have seen before. They watch without expectation and full of wonder.

Eiko's performances have a knack for showing audience members their unspoken and often unrealized assumptions, the ideas that determine how we react in certain situations. She does this by creating a space that activates those assumptions while challenging viewers to think about how those assumptions are out of place. She creates an emotional nakedness that takes courage to accept. Some people find this uncomfortable. Others find it enthralling. Children, of course, carry around fewer assumptions than do most adults. Their ideational baggage is lighter. As a consequence, children can often see that Eiko is penetrating emotional depths, exploring places of wonder that our ideas obscure.

It has been my goal to create in photographic images the feelings of mystery and the emotional depths that Eiko created in her live performances. Could I make the photograph itself a performance which brings resonances of Eiko's body straight to the viewer?

As we drove around Fukushima, we became acquainted in ways that made collaboration instinctive. While I walked around neighborhoods looking for possible locations, Eiko would be doing the same, but moving as though she felt the place in her hands, her feet, her arms, allowing it to speak to the world through her body. Specific places also spoke to me. Some reminded me of clearcut forests or mountains and valleys destroyed for coal.

Often, places felt the same way to both of us. This became obvious on our first day of shooting in Fukushima during the winter of 2014. We drove toward the ocean and parked the car in what looked like a neighborhood frozen in time. Earthquake and tsunami damage had remained unrepaired for over three years because of high radiation levels. Immediately, Eiko and I both knew that her plan of making a "Body in Stations" series had become a "Body in Places."

A once-stately old house in a place called Yaburemachi (破町), literally meaning "Broken Town," became the starting point. My intention was to frame Eiko's body in the place so that both received equal attention. That night, after a long day of shooting, we looked through the images together. We used the day's images as a springboard for the next day's work. Eiko created threads of continuity using costumes, especially the large piece of red silk and the purple and bronze futon that appear in so many images, not only during the first trip to Fukushima but also in many that followed. This established our daily working pattern. While at times we would discuss technical points regarding camera angle, placement of Eiko's body, use of motion, light and shade, more often we would talk about the places themselves, what we had felt and observed during the day. Those conversations fueled the next day's work.

The experience of working together in our January 2014 trip to Fukushima compelled a return visit in July of that year. My pace of shooting picked up, and I made more images of Eiko spontaneously. On numerous

occasions, Eiko would take a break but then begin moving part of her body. In response, I would begin photographing what her body was expressing, and she would be in performance mode once again.

Over the course of multiple trips to Fukushima we found that we said little after agreeing to work in a particular place. Sometimes Eiko might ask about her costume, or I might suggest something, but otherwise the dialogue between site, body, and image would unfold with the place, the voice of the locale, taking the lead. In some places we made only a few frames; in others we made several hundred. Sometimes a micro-narrative would emerge, such as when, reminiscent of the shaman in *Rashomon*, Eiko seemed to link heaven and earth (pages 46–47). In another (pages 64–65), the image of Eiko was transformed into a *pietà*, but one in which her body was being held by the earth rather than by another human.

We learned to depend less on each other and to listen more closely to what the place was saying. The neglected and damaged surfaces, corners, columns, and windows, the broken and shattered fragments of buildings and lives all called for attention. While deciding where and how to position herself, Eiko often hummed or sang softly to herself. On occasion it seemed as if an ethereal music permeated the forms and colors that held us in that place. It did not seem that Eiko was performing to the music. The melody, sometimes distinct, sometimes only the faintest of notes spaced far apart, was more the voice of the structures, the branches, the shadows and highlights, than of Eiko.

Each place was different. Some sang of loneliness and separation; some of grief and mourning; some of being lost, without moorings in a changing world where the familiar had become the strange. The Fukushima that had evolved over centuries had been destroyed. Over the course of a few hours, the land was shaken violently in an earthquake, flooded in an enormous tsunami, and immersed in the invisible and odorless clouds of radioactive toxins from the three meltdowns. The houses and neighborhoods that have been "decontaminated" since then are still not as safe as before March 11, 2011. Eiko, performing in areas that we knew were unsafe, or in areas that were declared safe but based more on good intentions than knowledge, became one with those who found themselves living or working in these places. This is the body we see in the photographs of Eiko in Fukushima.

Working with Eiko has been, above all, an act of witnessing. My goal in making photographs with Eiko is to give that experience to others. There were many places where we felt overwhelmed, isolated, crushed, drowned, helpless, utterly miserable. I cannot find words to express my feelings; they appear in our photographs.

TOMIOKA FISHING HARBOR 富岡漁港 (previous page)

TRIP THREE

福島稲荷神社 FUKUSHIMA INARI SHRINE

坂元 SAKAMOTO

八沢 YASAWA

浪江町 NAMIE TOWN

富岡漁港 TOMIOKA FISHING HARBOR

破町 YABUREMACHI

絹布根神社 KINUNONE SHRINE

波立弁天 HATTACHI BENTEN

田人 TABITO

AUGUST 2016

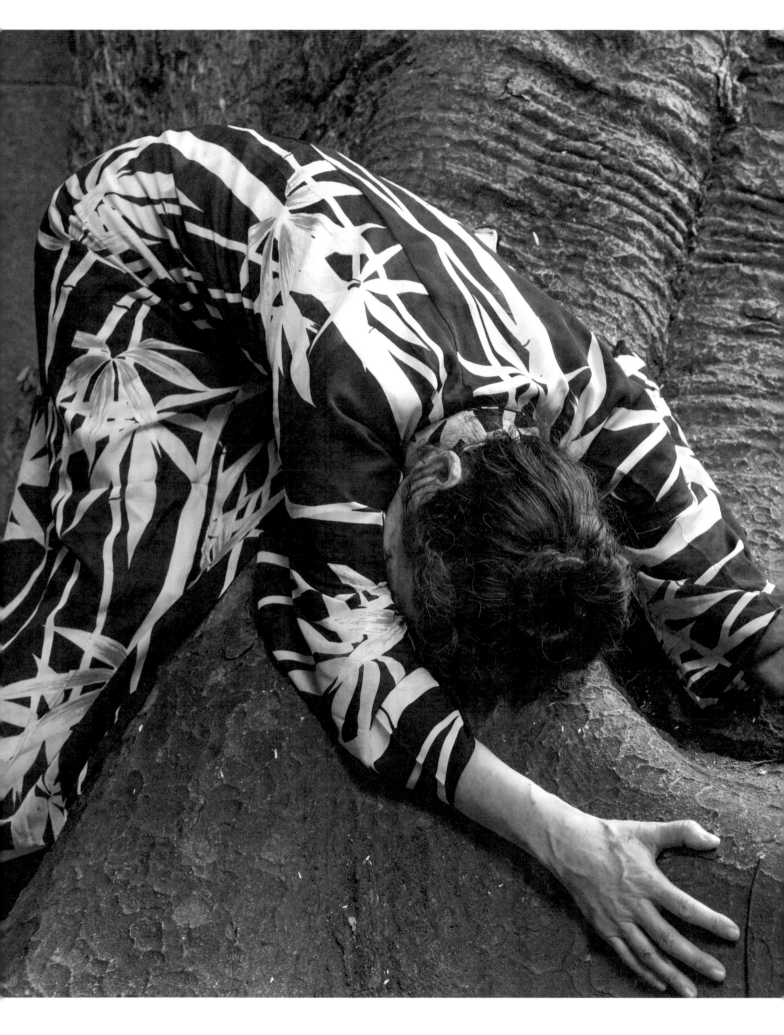

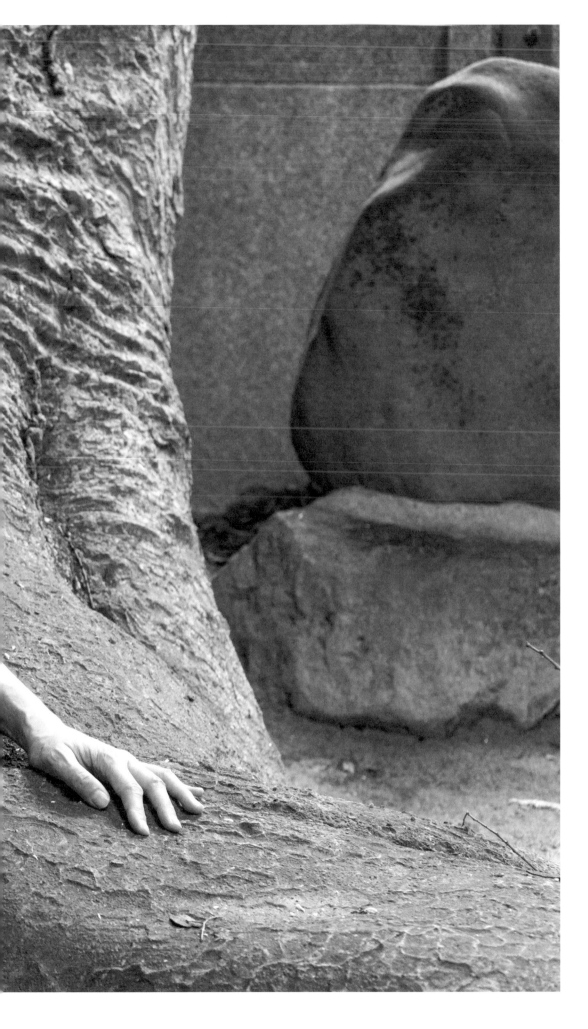

FUKUSHIMA INARI SHRINE　福島稲荷神社

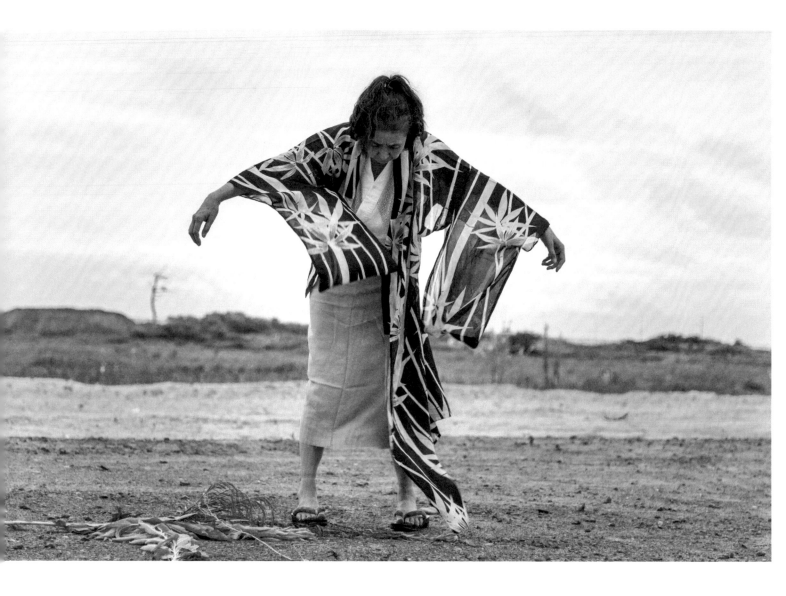

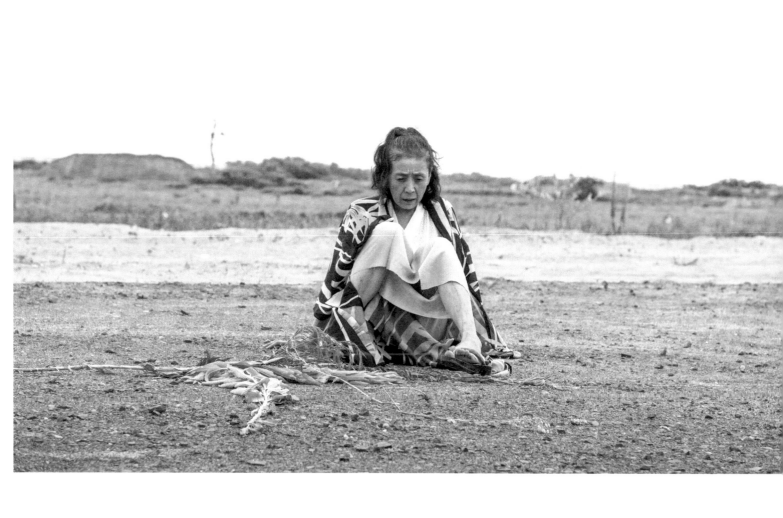

SAKAMOTO 坂元 (left, above, and next page)

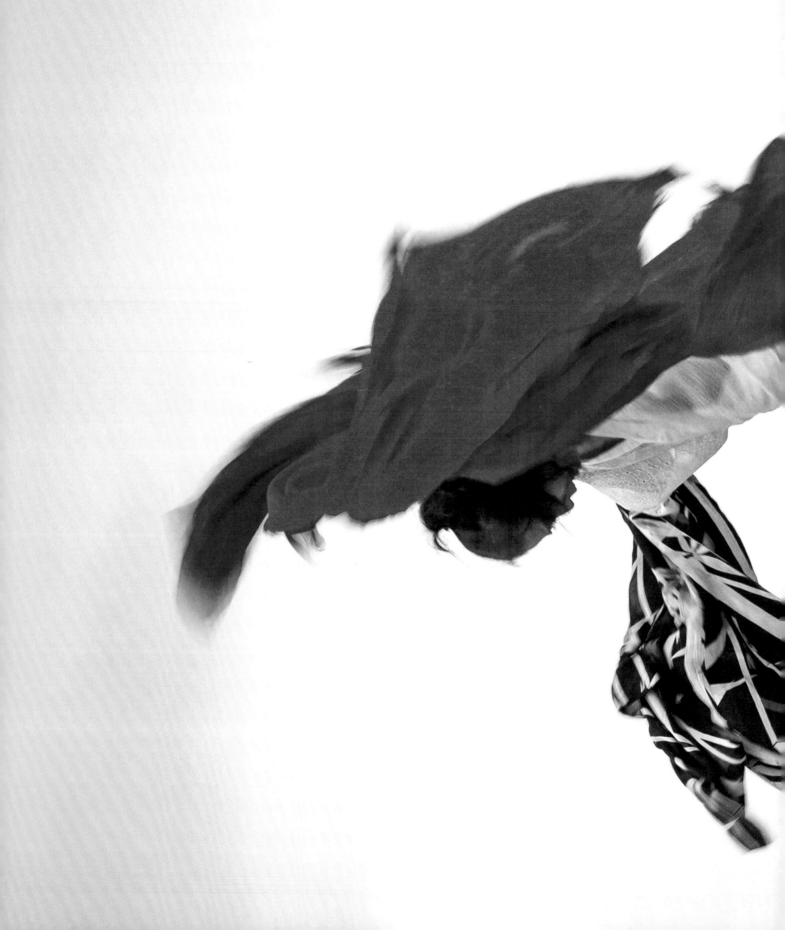

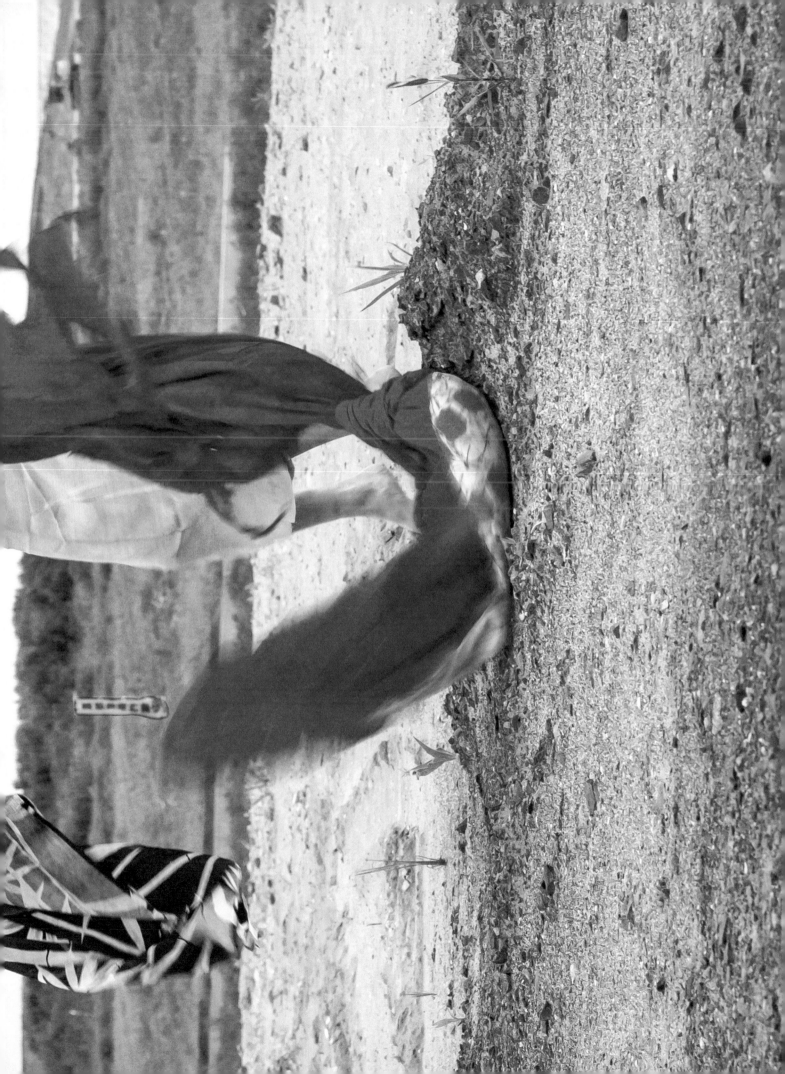

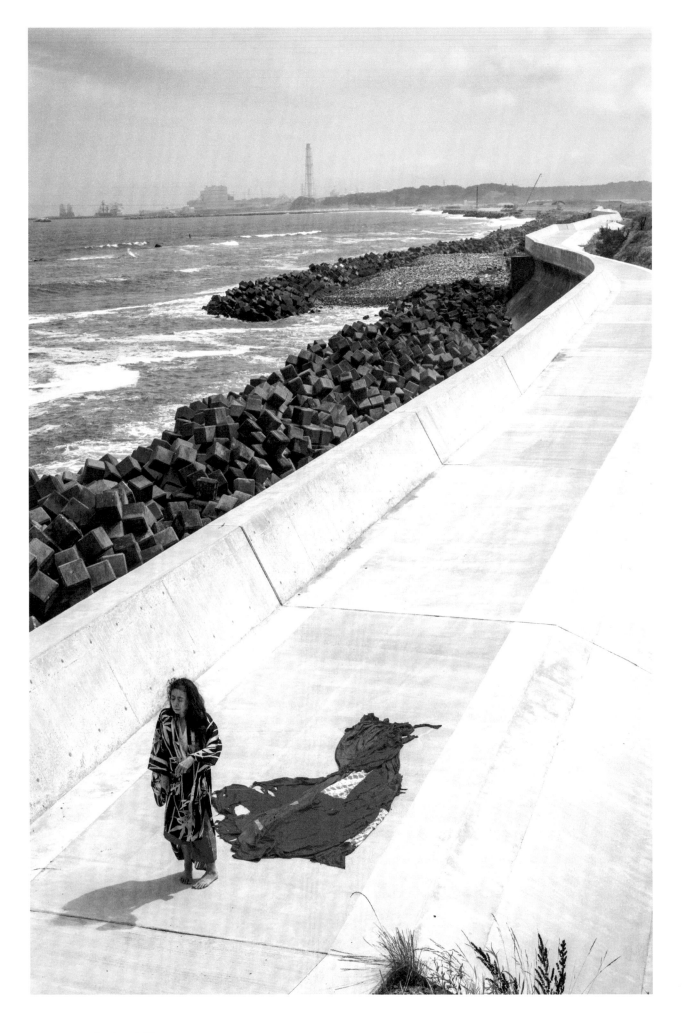

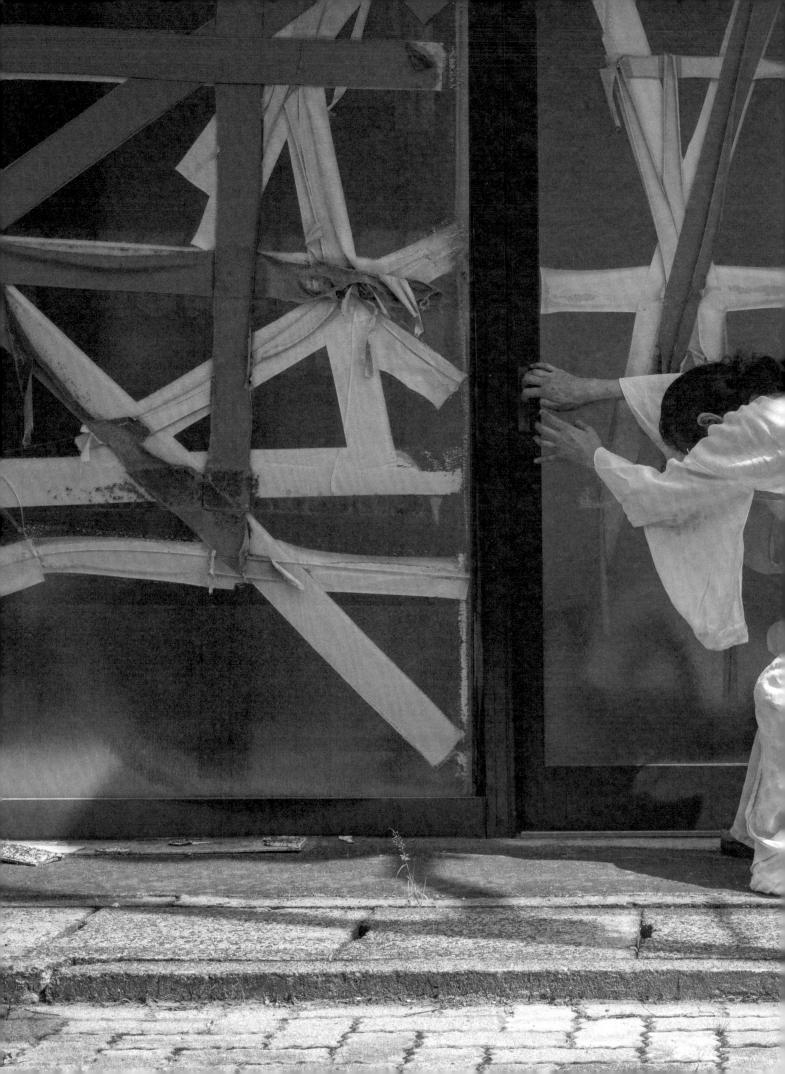

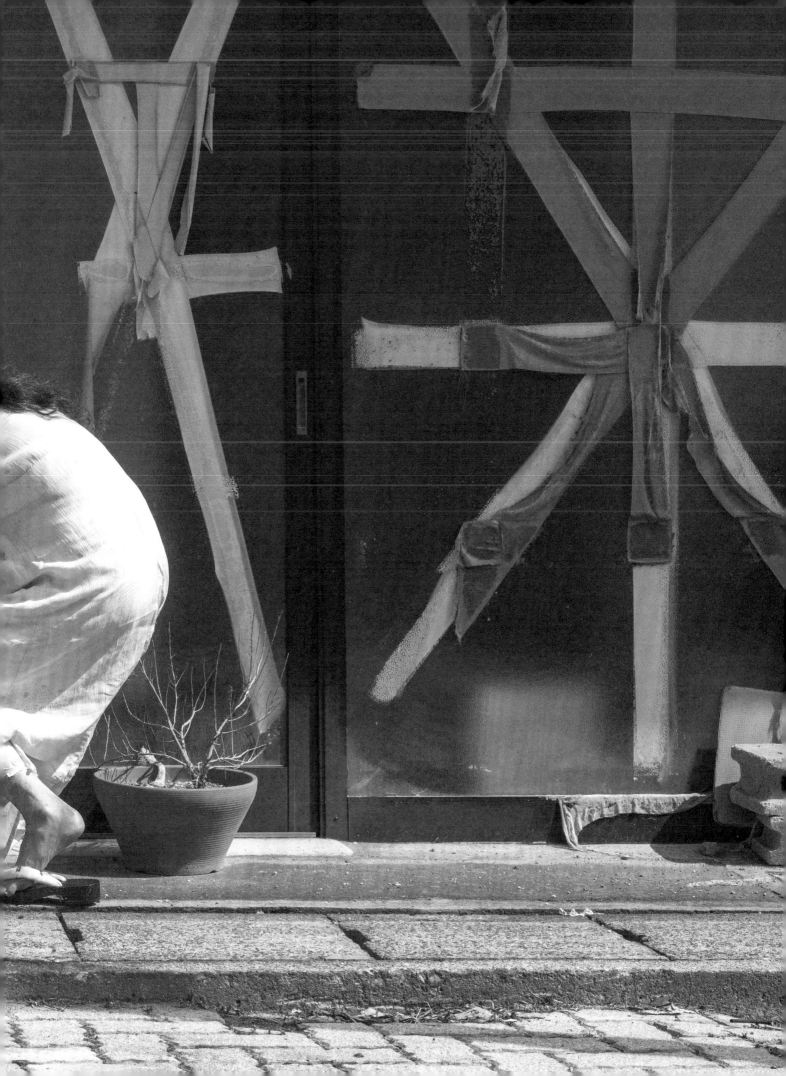

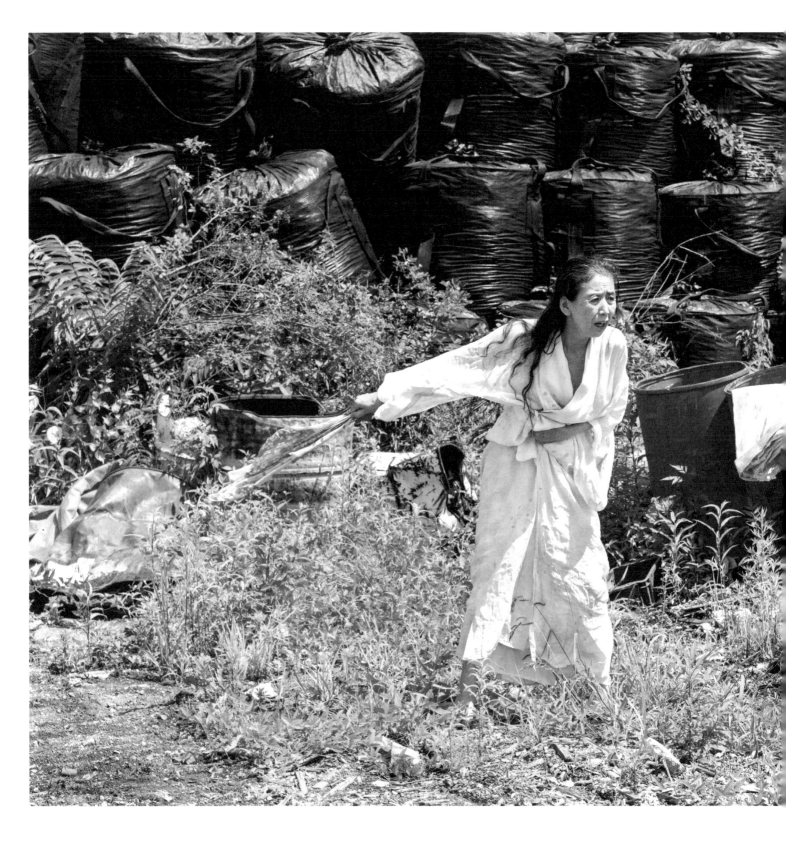

The area around the town of Namie, 5.2 mi. (8.4 km.) northwest of the Fukushima Daiichi reactors, had been settled for more than two millennia. Tumulus mounds created between 300 and 500 CE, similar to the one where Eiko performed in Kido (pages 174–77, 218–19), dot the landscape. The town was created in 1889, an amalgamation of several small villages. The railway station opened in 1905. Namie was primarily an agricultural community until the 1960s, when electrical appliance and tool companies built factories, and construction on the Fukushima Daiichi reactors began. By the 1980s, industry, agriculture, fishing, and production of electrical

NAMIE TOWN 浪江町 (previous, above, and next page)

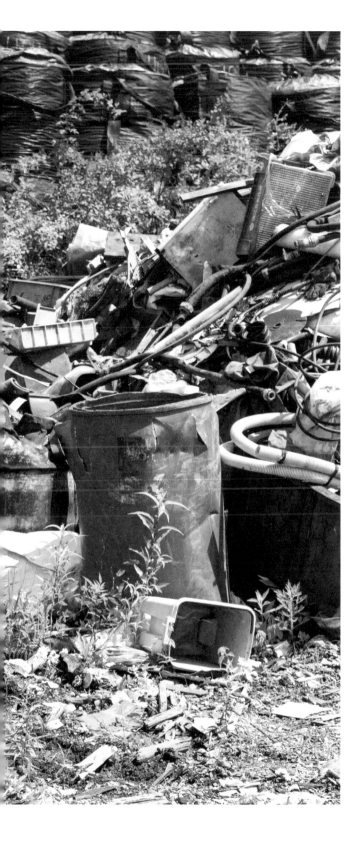

energy had given the town relative prosperity. After the reactor meltdowns in 2011, radiation levels made Namie off-limits, inside the exclusion zone, where we first visited in 2014. The town's population of 20,905 evacuated and dispersed widely across Japan. By 2016, Namie was opened for short visits by former inhabitants and decontam- ination workers, although many "hot spots" remained. Namie was a ghost town but virtually unchanged five years after the earthquake, since the tsunami did not reach this far inland. Mounds of one-ton plastic bags filled with radioactive debris towered over neighborhoods (pages 146–53, 245–49).

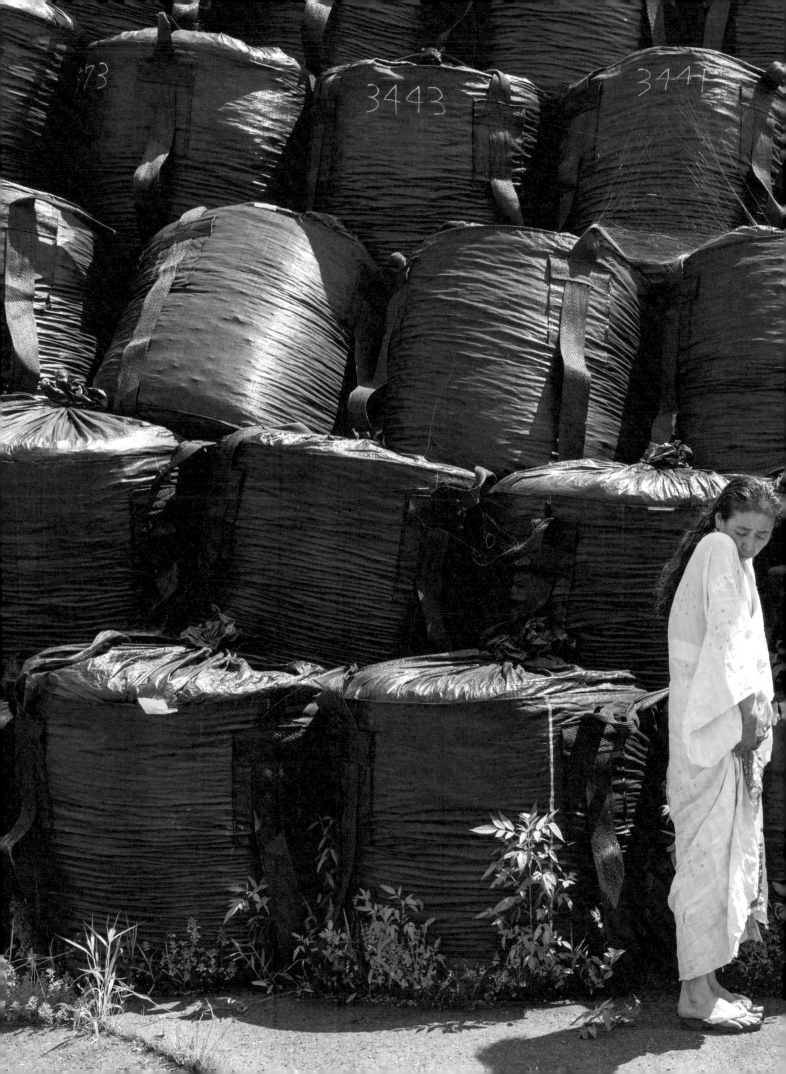

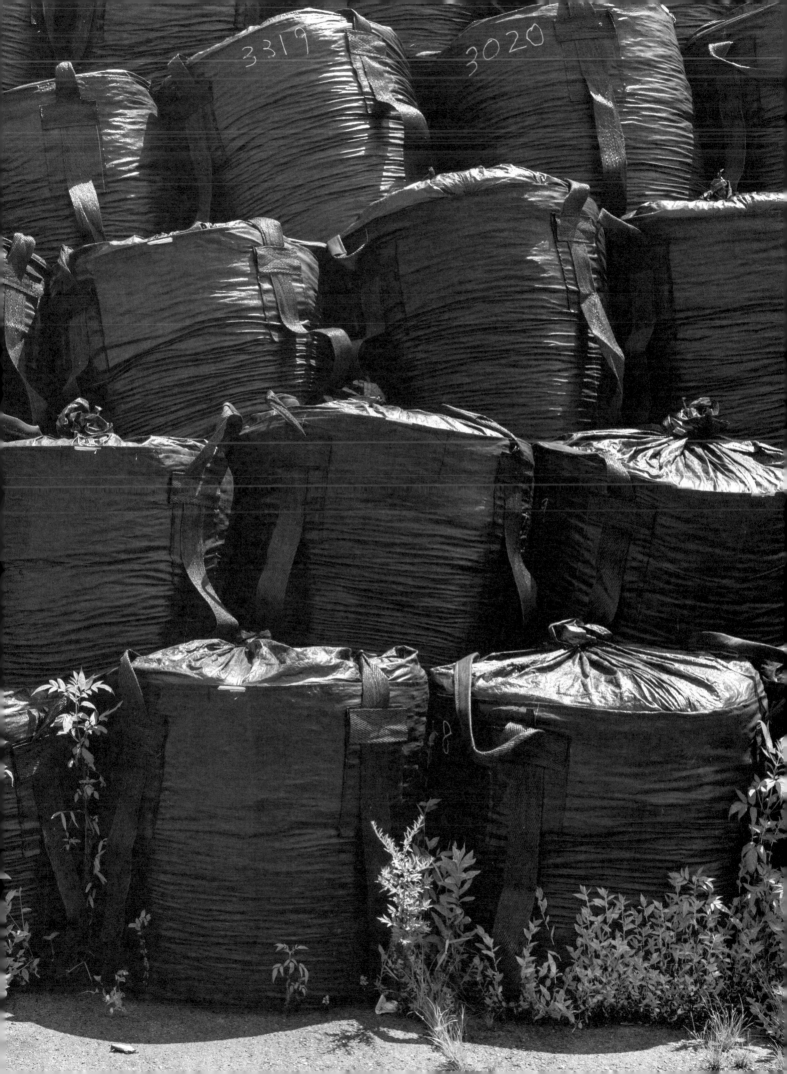

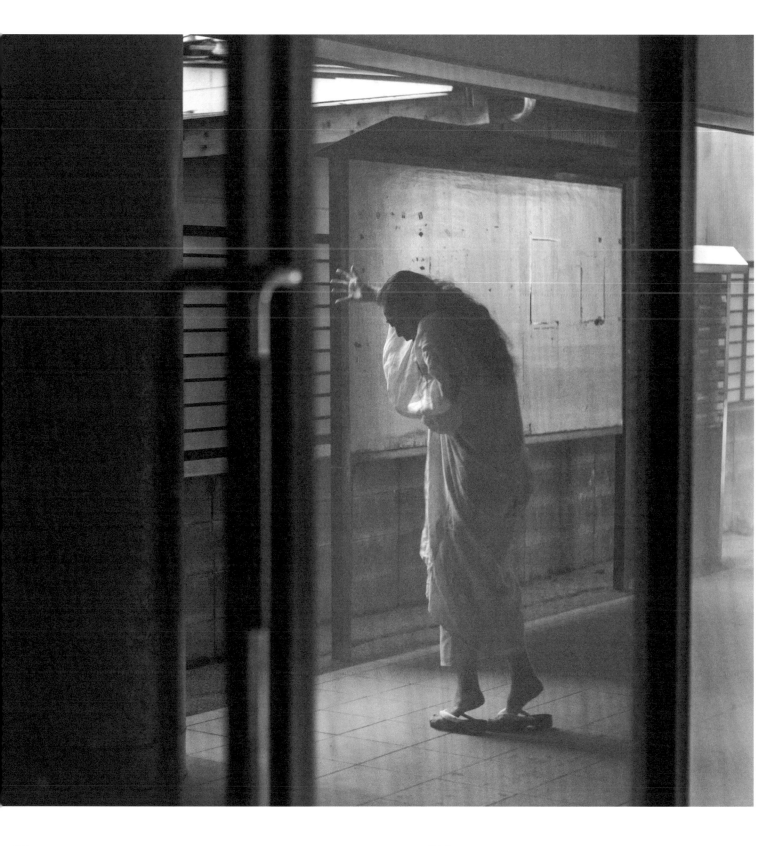

NAMIE TOWN 浪江町

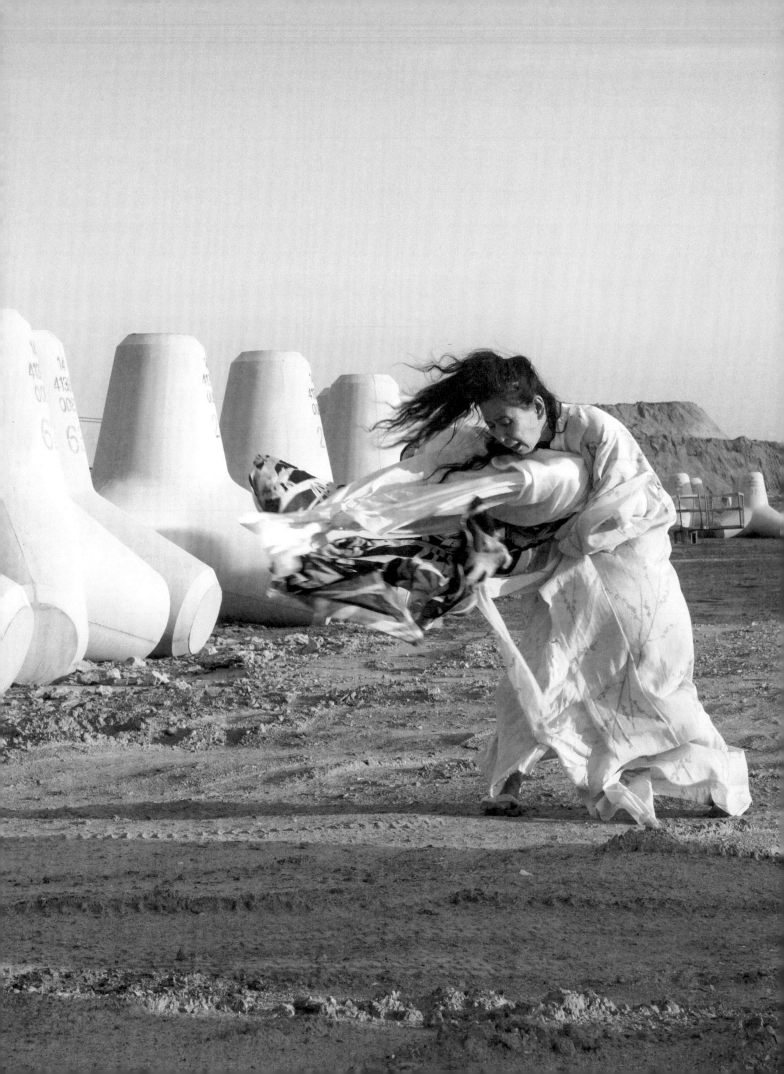

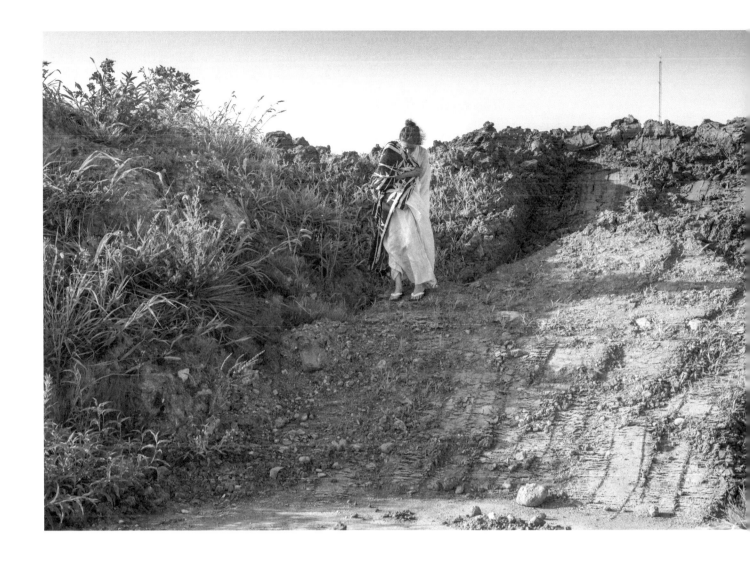

TOMIOKA FISHING HARBOR 富岡漁港 (left), YABUREMACHI 破町 (above, and next page)

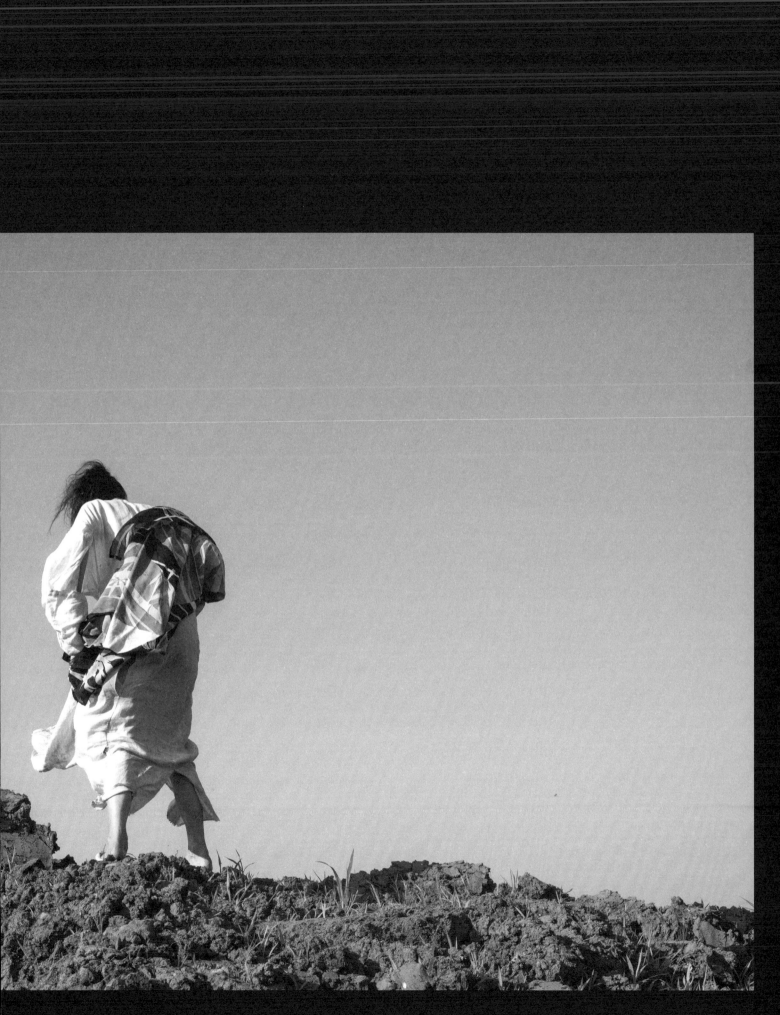

DIGNITY

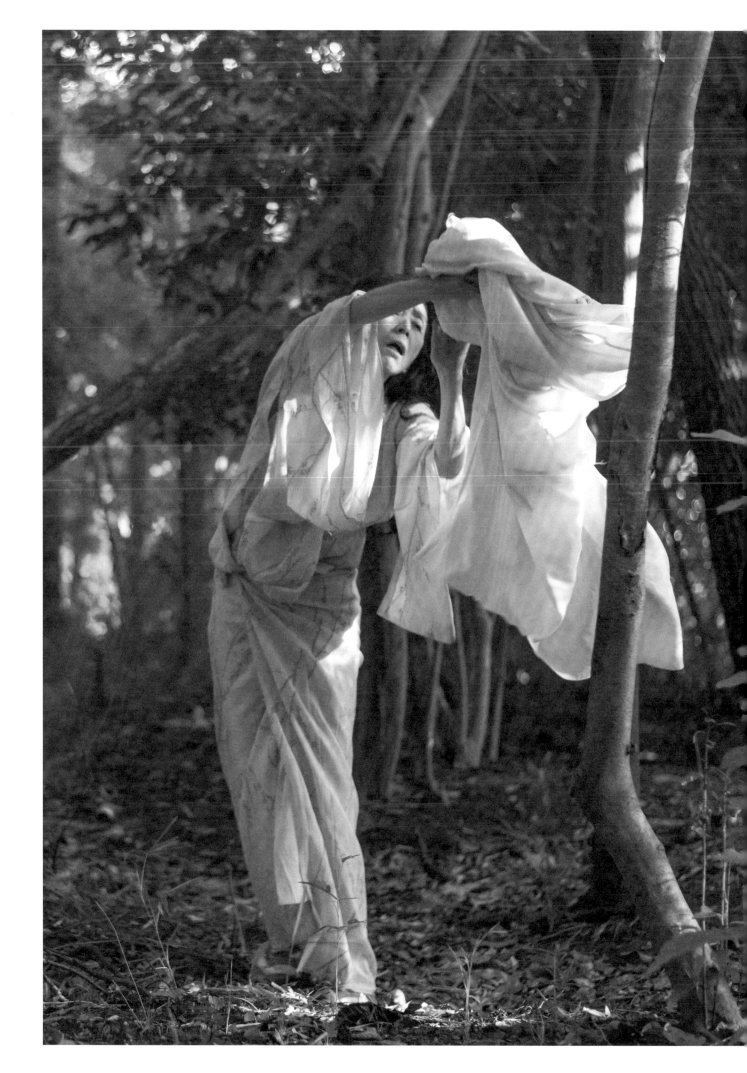

FOR A LONG TIME, I THOUGHT DIGNITY WAS AN ESSENTIALLY HUMAN attribute, a constructed idea about humans created by humans.

In 2014 in the irradiated Fukushima evacuation zones, I found a quiet insistence in the torn houses and broken furniture that survived the tsunami. Some colors, shapes, and functions were gone but I sensed dignity in the things that were left. Broken, but holding time. Forgotten, but holding memories of loss and traces of the days when people used these things.

Each time we went back to Fukushima, we revisited places we had previously photographed and found them changed. Some were hardly recognizable. "Decontamination" and "reconstruction" have become new industries. Trucks, bulldozers, and dust erase the memories of the people who had lived there. Weeds grow over the remains, and the makeshift memorials that marked deaths have also gone.

However shrines, temples, and graves often stand unchanged. Bulldozers regularly work around the sacred areas, many of which have been protected for centuries. These places hold a special magnetic feeling that had originally attracted the people with their prayers.

Behind the shrines and temples are forests. They are irradiated, as is everything that grows here, but I might not even feel it if I did not know what had happened. Forests cannot be decontaminated. They stay irradiated. They stay hurt. Forests do not walk away as humans do.

The morning light in the forest is achingly beautiful. Rays of light shine with intricately different shades of green. Then when the dusk approaches, we hear more sounds. Shadows become longer before they become fainter. With mountains to the west, dusk moves fast in this part of Fukushima.

The sense of awe I felt in this forest made me realize for the first time that dignity does not originate with humans. Long before people could name what they saw, our ancestors found dignity in forests, rivers, mountains, and seas. They wanted to transmit that dignity into humans. But we humans now hurt the very places from which we have learned beauty and dignity.

What humans create imitates humans.

Humans often fail in ways no one knows how to fix.

How have we not learned hesitation? Humans are so capable producing, but at the same time we remain utterly destructive. Trembling with fear but also with beauty, I say this.

Dignity is being.

Persevering and precarious.

AHH, AH, AH, AH

A LETTER TO KYOKO HAYASHI

"Bodies I saw on August 9th in
Nagasaki had no outlines. You might
explore that in your dancing."
Kyoko Hayashi

Dear Hayashi san,

You were pronounced dead on February 19, 2017. Soon your bones and ashes will perhaps be brought into a grave according to Japanese custom or to the sea. But the birth of a baby takes nearly nine months. So a death, too, cannot happen at one moment. The death of a person one knows deeply takes a long time to complete, perhaps never in one's lifetime.

Hayashi san, your words, voice, and gestures are so deeply imprinted in me that you will keep both living and dying while my thinking lasts. You might laugh at me, but you knew this is true. Because of what I learned from your writing and from our long conversations, I have thought, worked, and lived differently.

I began studying atomic bomb literature in 2002, and soon discovered your work. We met, talked, and corresponded. I loved your handwritten letters! With your encouragement, I translated and published your book From Trinity to Trinity. *After I began to teach your work, you always enjoyed hearing how my students responded to it.*

After the Fukushima meltdowns our talk intensified, with both of us so angry. When I visited Fukushima in August 2011, you asked me, "Now you want to be a hibakusha *too? It was not enough for you to follow me? You wanted to be the one with radiation." I am still thinking about these questions. Though it was not my intention to harm myself, there is some truth in that. I wanted to feel the places where radiation was a real threat.*

It was to you that Bill and I first showed the photographs we created during our initial visit to Fukushima. We went directly to your home in Zushi. On the train I selected ten pictures to show you. I was nervous. Looking at our photos on my computer for a long time, you said, "Because you are in these pictures, I look at each scene much longer than otherwise. I then see more details. I see each photograph, wondering why Otake-san is here, how you decided to place your body here." Your words articulated our wish, which we had not yet said ourselves. Your words gave us motivation to go back to Fukushima and to present photo exhibitions.

Hayashi-san, you often told me that people killed in the atomic bombings were deprived of their own personal deaths. You taught me what massive violence does. When I was at a loss with what to do after being invited to perform in New York with the Hiroshima Panels *created by Iri and Toshi Maruki, you said, "Bodies I saw on August 9th in Nagasaki had no outlines. You might want to think about that in your dancing." You gave me the challenge I needed. I am still thinking about that kind of body.*

For the past six months, we had a photo exhibition of our A Body in Fukushima *in the nave of the Cathedral of St. John the Divine in New York. So on March 11 this year, I produced a four-hour event at the cathedral titled* Remembering Fukushima: Art and Conversations. *I told you about the twenty-four-hour event and exhibition I presented on March 11 last year at St. Mark's Church in downtown Manhattan. It was to acknowledge the fifth-year anniversary of the Fukushima disasters. Many people being in the same place at the same time for the same purpose was a powerful and bonding experience.*

I thought that if no one commemorates the sixth anniversary, nothing may happen until the tenth year, so once again I wanted to offer an occasion in which audiences and participants could gain knowledge, experience art, and reflect on the meanings of the Fukushima meltdowns. I wanted to create a new experience, a particular time and space, the

memories of which would make people feel closer to Fukushima.
With those young people who do not have the same memories as we do,
we cannot ask them not to forget. But we can create a new experience
in which we spend time together, learning and remembering. We then
can begin resisting our forgetfulness.

You told me how you marked your life after 1945 with the annual
August 9 memorial. Every year as that day approached, you remembered
all the people you knew who died, one by one. For days before and in hours
prior to the memorial you counted the time, feeling tense. You continued to
realize "They were still alive" until finally 11:02 a.m., the time the Nagasaki
atomic bomb exploded, was minutes away. They would be killed in the next
3 then 2 then 1 minute. Finally, the time is 11:02; they die and you become
a hibakusha.

As a Japanese person, I grew up seeing the Hiroshima memorial on
TV (the Nagasaki memorial was not nationally broadcast in my childhood),
but until you told me this story, I had not thought of a person at the memo-
rial, re-living the time approaching 11:02 on August 9.

The March 11 event at the Cathedral of St. John the Divine provided
many ways to commemorate what happened in Fukushima: in words,
in poetry, in song, in photographs and video, in instrumental music, and in
dance, and by inviting audience members to place origami *cranes on stage*
in a communal ritual of remembrance. The people of Fukushima were also
present through their poems and videos, which illuminated the mountains
and sea of their homeland.

I no longer can call you. I almost hear your voice, but I cannot con-
verse with you. So I talk to people about you, your work, and your death so
they can learn to think about Fukushima from your perspective.

These were the words I spoke to the audience at the memorial:

I am dedicating today's program to Kyoko Hayashi. My close friend who died
last month. Many of my students and audience members who are here today
know how deeply I respect Kyoko Hayashi and her work.

Early in our friendship, overwhelmed by Hayashi's stories, I said what many
people might say to atomic bomb victims, "I can't even imagine." She looked
at me eye to eye and said, "Are you that stupid? Do you need to experience the
blast and radiation sickness to understand the Atomic Bomb? For what have
I written so much about August 9th?"

Since then I have prohibited myself and my students from uttering this
phrase, "I can't even imagine." Instead, I ask: How can we imagine other people's
experiences? How can we change the sense of distance between here and
there?

Those of you, who have never experienced Hayashi's work, please imagine
a fourteen-year-old girl in 1945 in Nagasaki, who was exposed to the atomic
bombing near the epicenter. She suffered acute radiation sickness, and
even after regaining her strength, feared that her child would be affected by
radiation.

Twenty-two years after the war, she began to write about her own and
other people's experiences of the atomic bomb. Fifty-four years after the war,
Hayashi visited the Trinity site in the New Mexico desert, where the atomic
bomb was tested before being exploded in Hiroshima and Nagasaki. Please
imagine this sixty-nine-year-old woman standing in New Mexico in 1999,

realizing that the first atomic bomb victims were the plains and hills there. Imagine how she felt, watching the Fukushima nuclear plants explode in 2011. She was eighty years old.

Hayashi lamented to me, "When the nuclear radiation from Fukushima had become very clearly dangerous, the government told people to stay in their houses, shut windows tight, and wash their hair. I shivered with anger upon hearing this. I remember being told the same thing in 1945. After sixty-six years, if the people who were exposed to the radiation were only told again, 'Stay in the house and wash your hair,' if that's all that the government is capable of telling the people, how could it allow nuclear plants to be built? I now feel I have lived the life of a *hibakusha* in vain.

"It is as if we, the atomic bomb survivors, did not exist. It is as if the experiences of the atomic bomb survivors have never counted for anything. Though so many friends died because of the atomic bombings and suffered from radiation, Japan as a nation never learned anything about radiation. I am heartbroken."

Japan often claims to be the only nation to have experienced the atomic bomb. But it was not Japan the nation but the people of Hiroshima and Nagasaki who were exposed to the atomic bombing. And now, the people of Fukushima are the ones who have been exposed to high levels of radiation and cannot return home or farm their land. And it is the land of Fukushima that has been irradiated.

Hayashi wrote in *From Trinity to Trinity*, "Nature is not all gentle but it is never malicious. A river may swallow towns and carry people away, but it has no good or bad intentions."

It was not the tsunami but the self-interest and negligence of people that caused long-lasting damage in Fukushima. Hayashi recognized and announced that every nuclear explosion is first and foremost an environmental disaster caused by humans.

Hayashi spoke quietly, but in 2013 she wrote, "On my last day, I'll cry out loud, 'Ahh, ah, ah, ah,' pouring my heart out to the world as I leave it, and have done with it."

Hayashi-san, I said this "Ahh, ah, ah, ah," loudly as you had instructed. I remember you told me, "I want to die crying out loud Ahh, ah, ah, ah . . . *The character for this cry is not the one with three water drops* (泣く) *but with two big open mouths like a dog howling* (哭く). *Do you get it?"*

Thank you Hayashi-san for all of your work, provocations, and friendship. As an artist and a friend, you were incredibly eloquent and unafraid. Thank you for inspiring the many young people with whom I have shared your work. I will continue to do so. Though I can no longer hear your new stories, I will continue to imagine your last, very loud cry. If your cry ever becomes faint, I will join you in crying loudly.

I miss you,
Eiko Otake

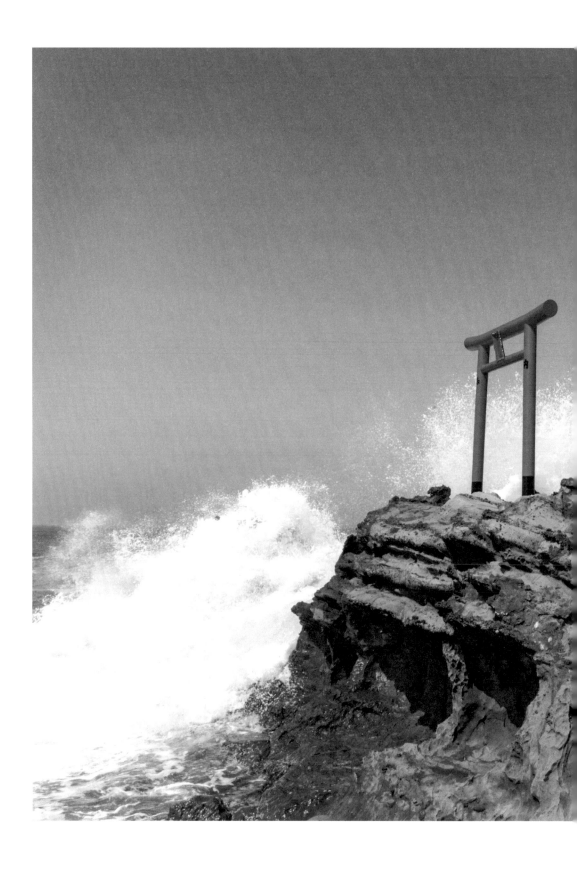

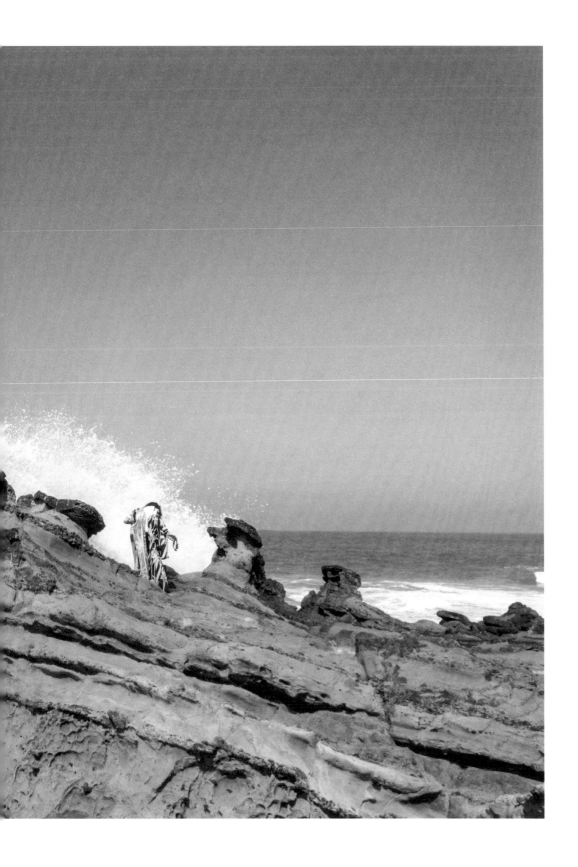

HATTACHI BENTEN 波立弁天

TRIP FOUR

久之浜漁港 HISANOHAMA FISHING HARBOR

富岡駅 TOMIOKA STATION

木戸古墳神社 KIDO KOFUN SHRINE

富岡し尿処理施設 TOMIOKA SANITATION PLANT

塩釜神社 SHIOGAMA SHRINE

波倉稲荷神社 NAMIGURA INARI SHRINE

小浜 KOBAMA

請戸海岸 UKEDO BEACH

谷地畑 YACHIHATA

坂元駅 SAKAMOTO STATION

相馬市街 SOMA CITY

JUNE 2017

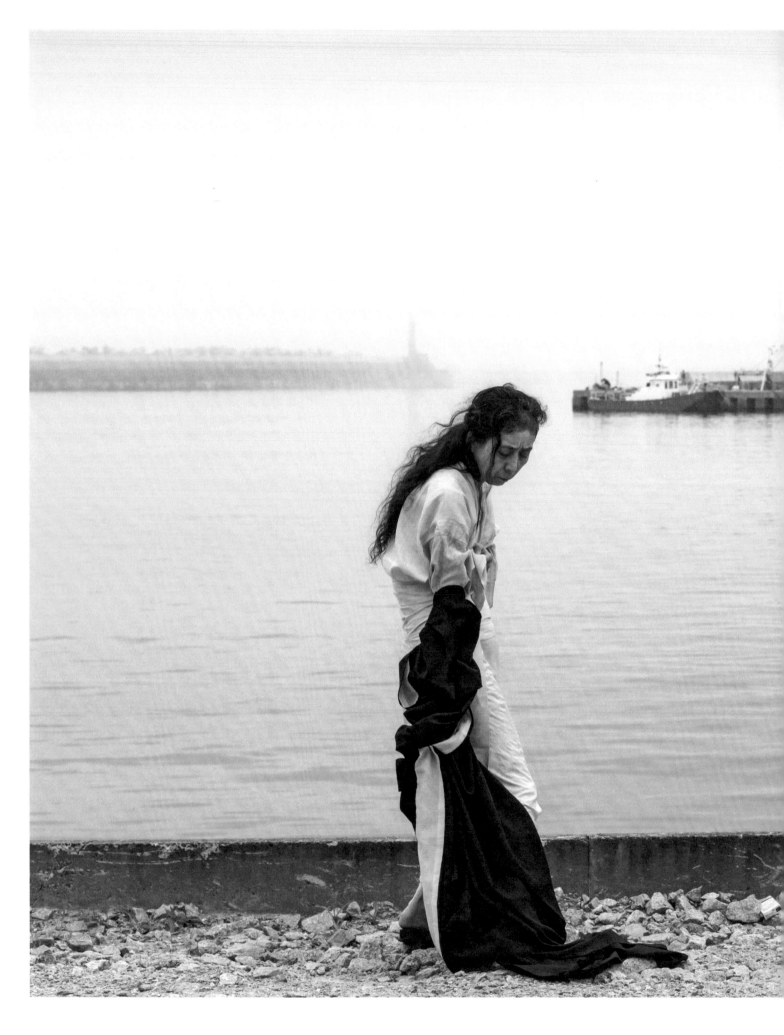

HISANOHAMA FISHING HARBOR 久之浜漁港

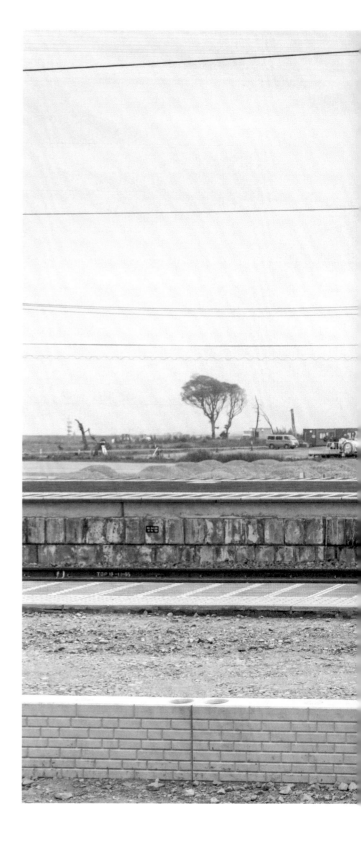

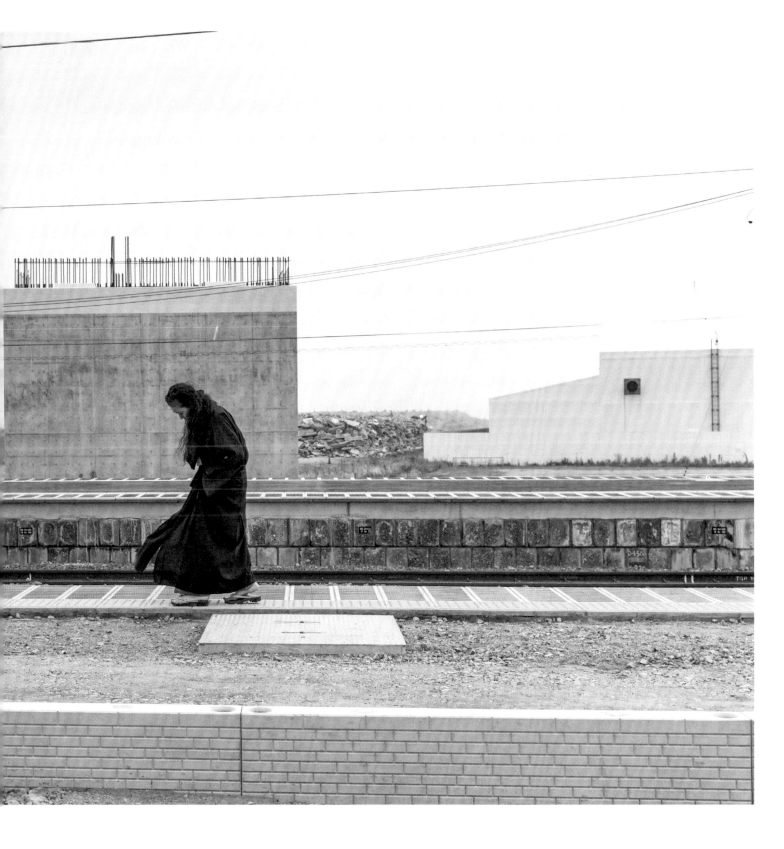

TOMIOKA STATION 富岡駅

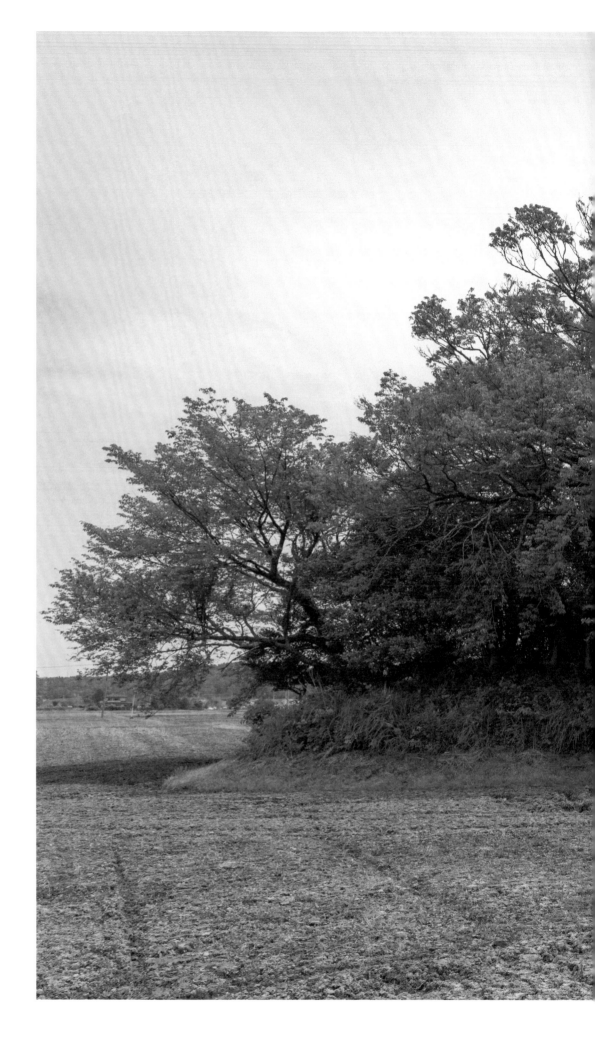

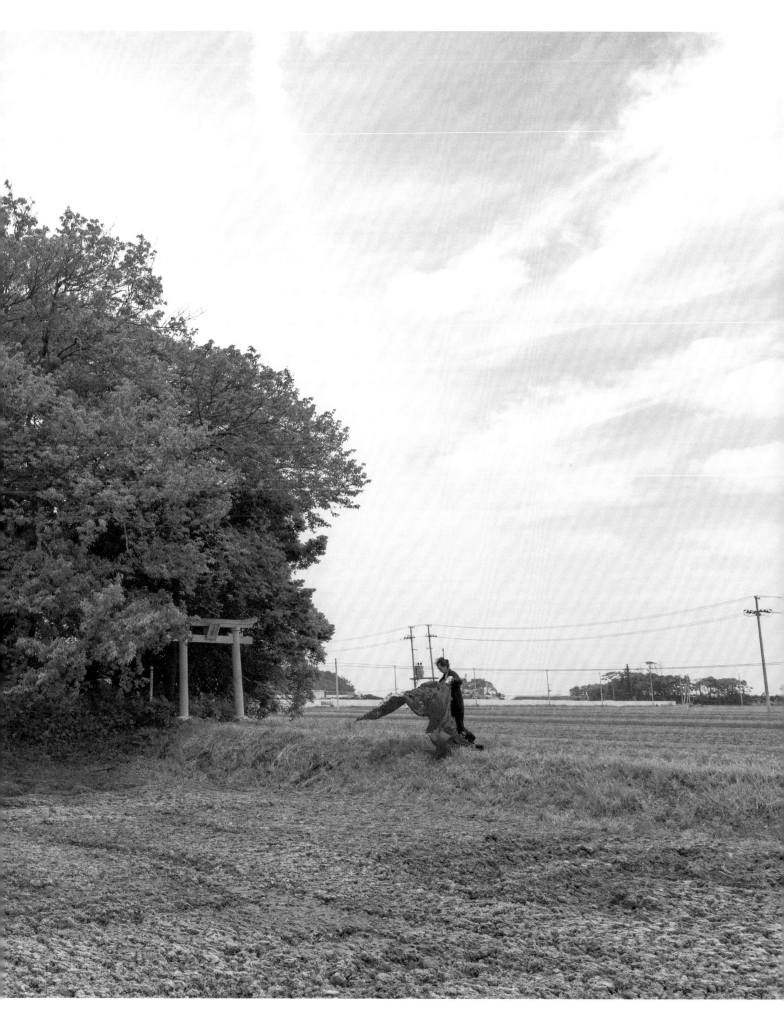

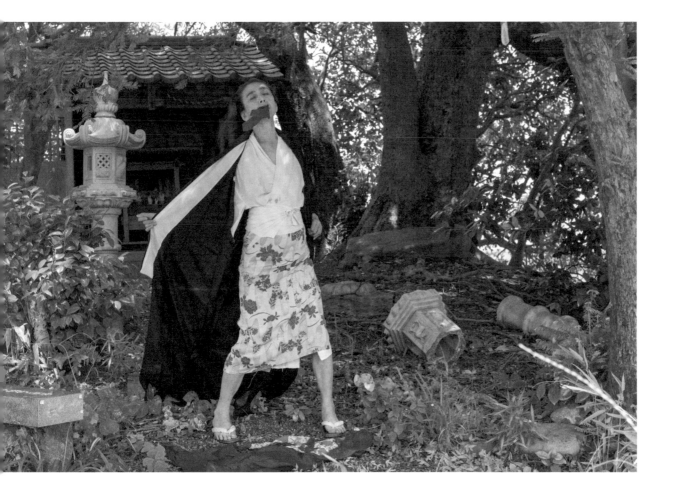

KIDO KOFUN SHRINE　木戸古墳神社

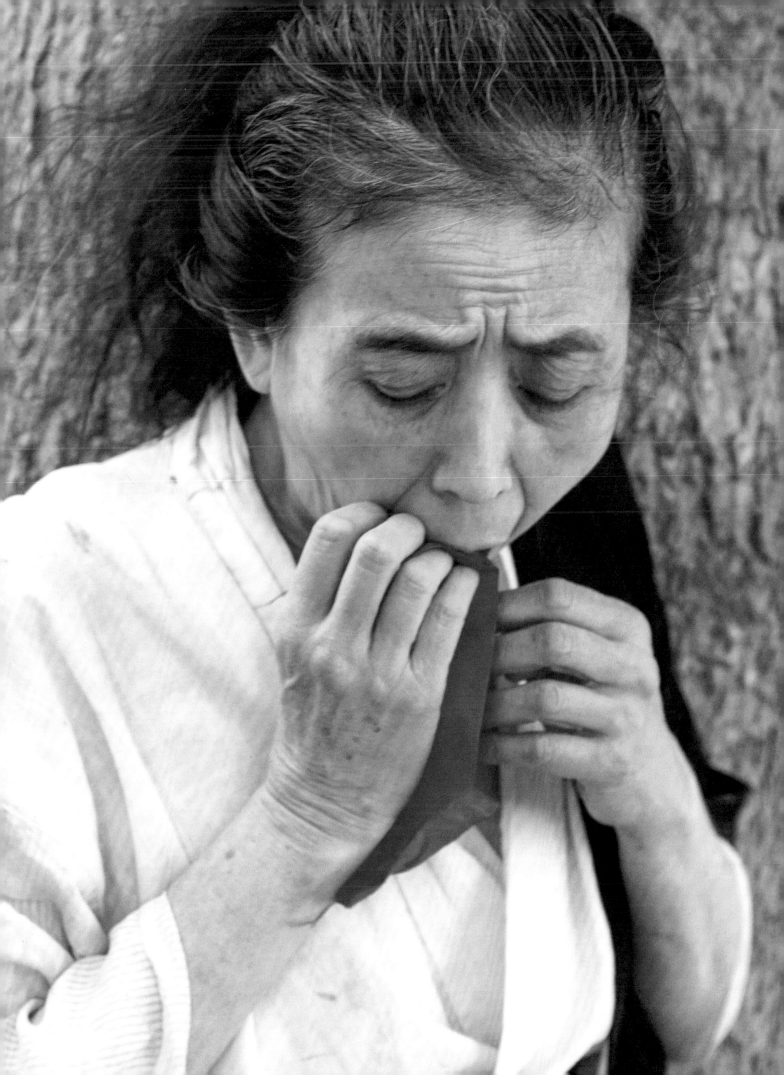

Chance led us to many of the places where Eiko performed for the camera. We drove around the area in a rental car, and stopped to examine places that looked compelling. The Tomioka Sanitation Plant was one of those places. Taking a back road we drove by the gate. It was open but nobody was there; everything seemed to remain in 2017 just as it had been after the earthquake in 2011. A dormitory facing the coast had been built on a precipice and was dangerously tilted into it. Huge, pink hoses wound around an outdoor storage site (pages 180–81). It seemed as though it would resume operation at any time (pages 178–79, 182). Yet when we returned in 2019, all of the buildings and equipment had disappeared. Concrete rubble, twisted iron reinforcement bars, and a toxic, green pool of water were all that remained (pages 243–45).

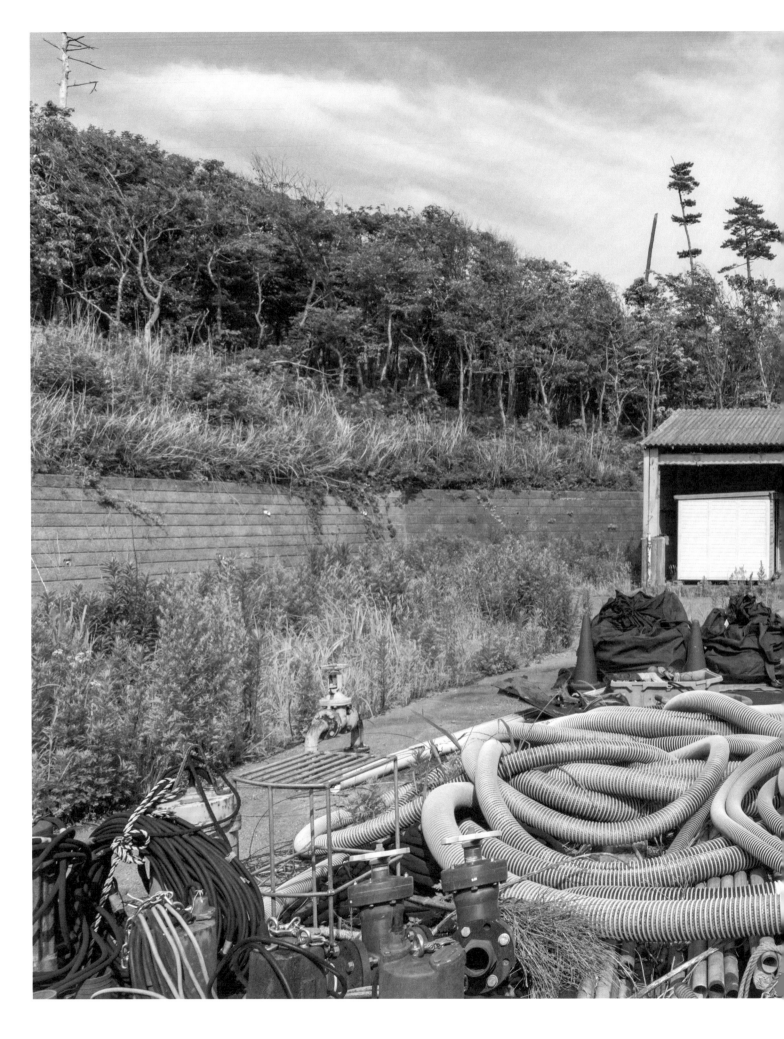

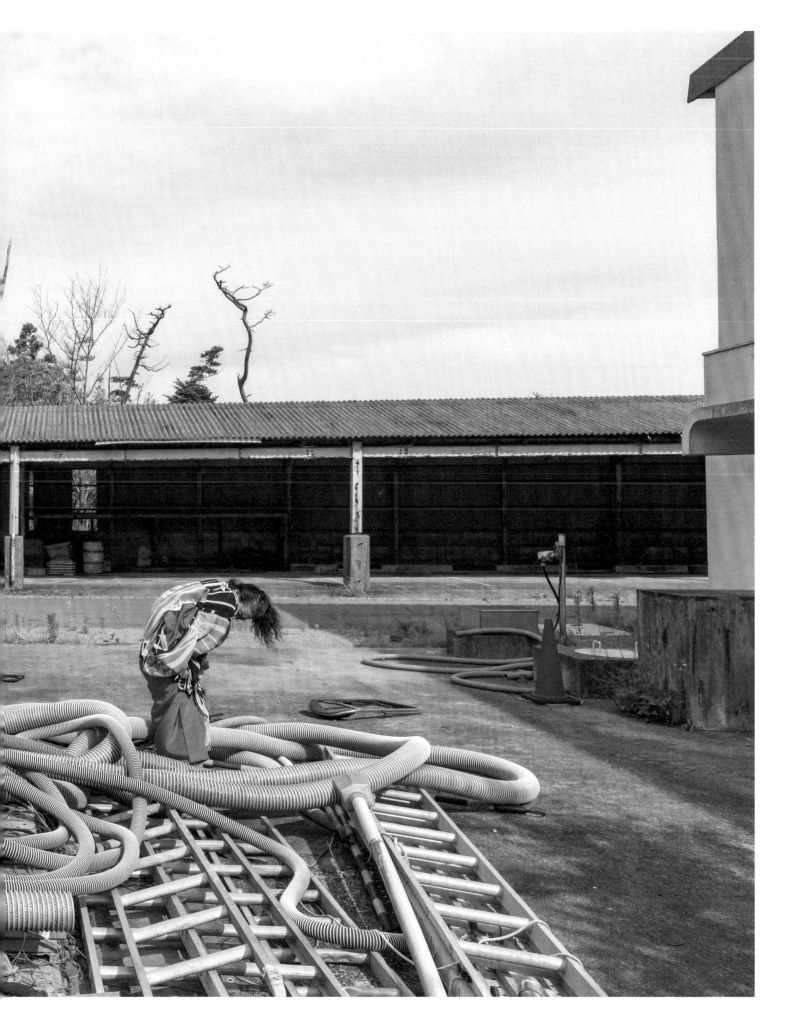

TOMIOKA SANITATION PLANT 富岡し尿処理施設

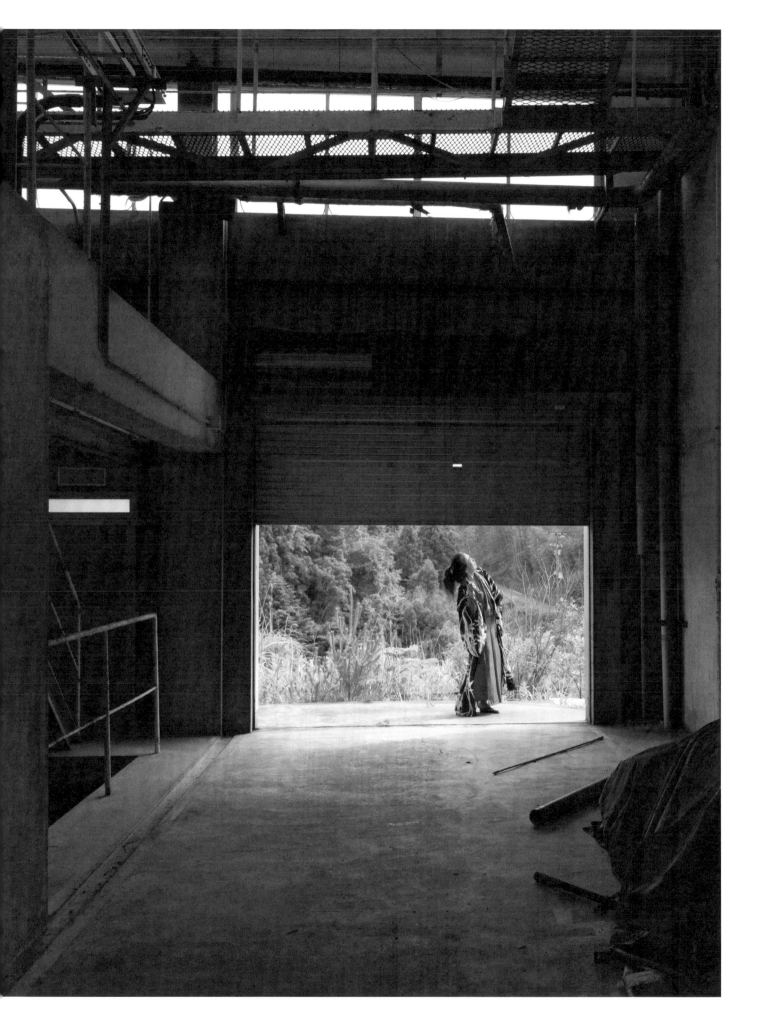

TOMIOKA SANITATION PLANT 富岡し尿処理施設

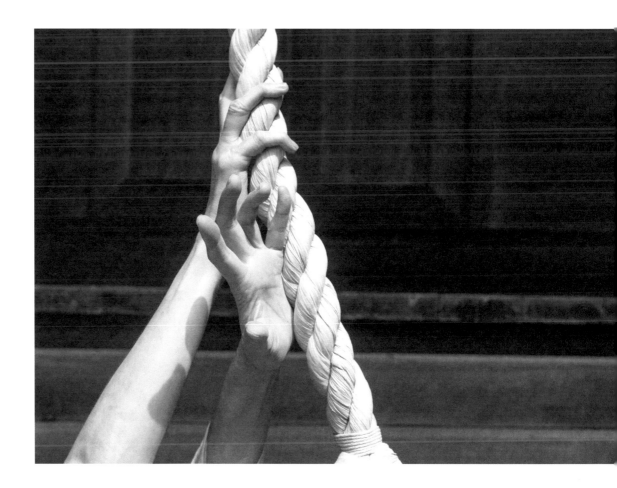

SHIOGAMA SHRINE 塩釜神社

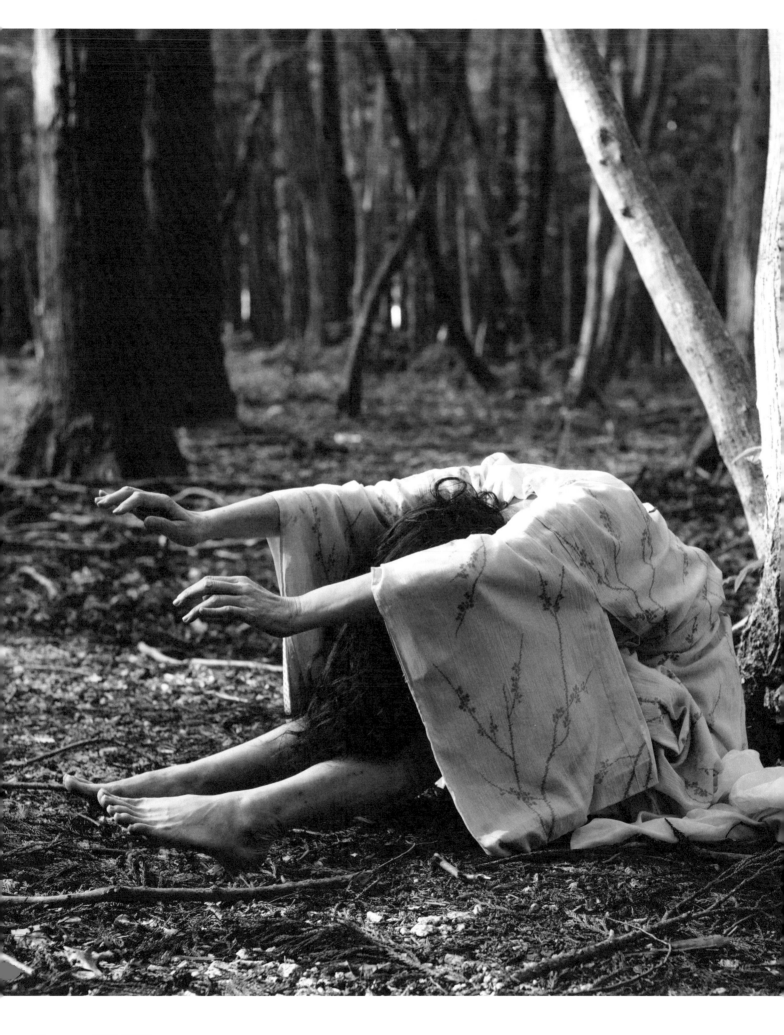

KOBAMA 小浜

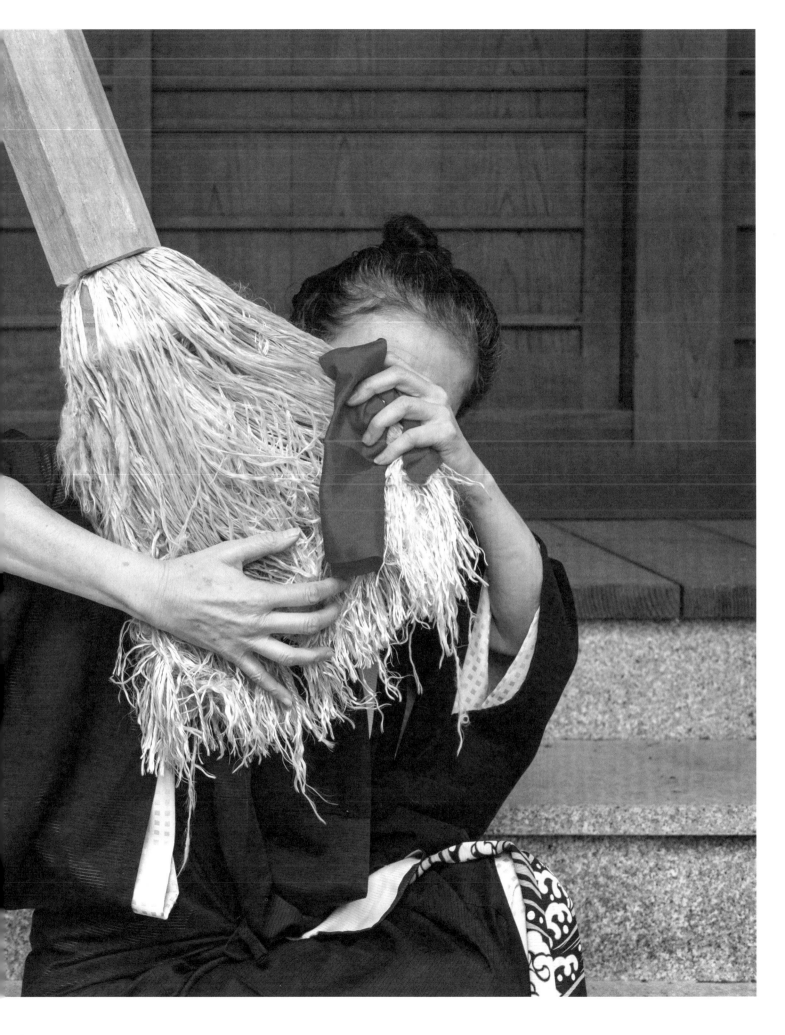

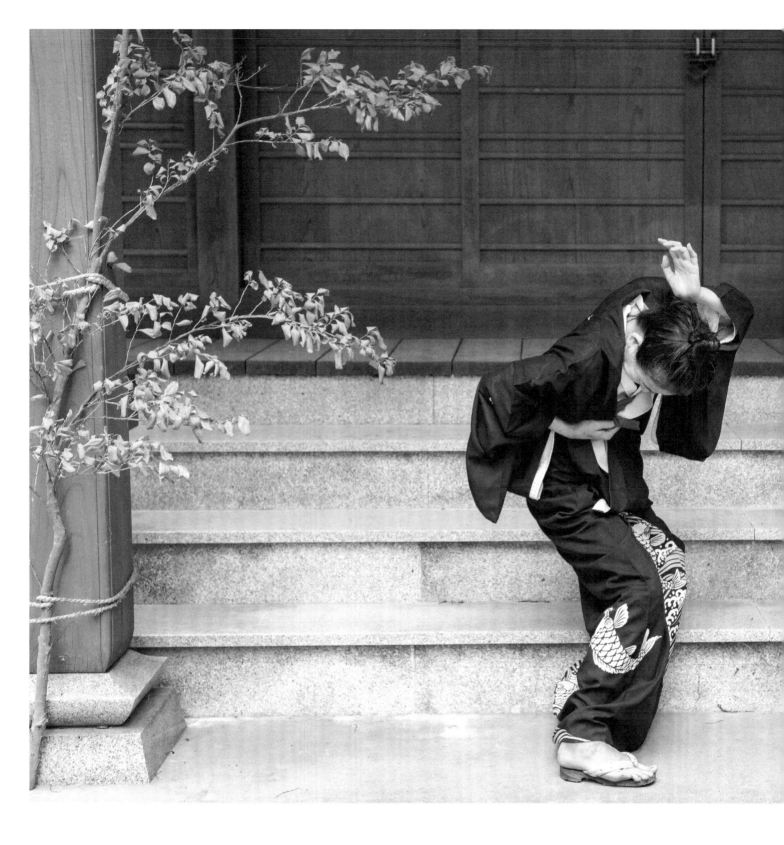

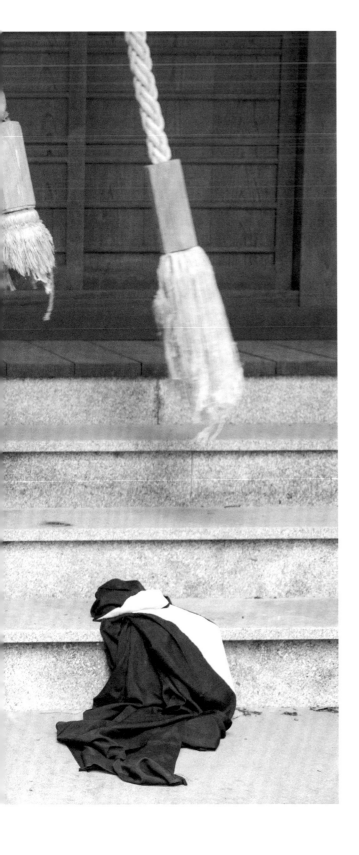

NAMIGURA INARI SHRINE 波倉稲荷神社

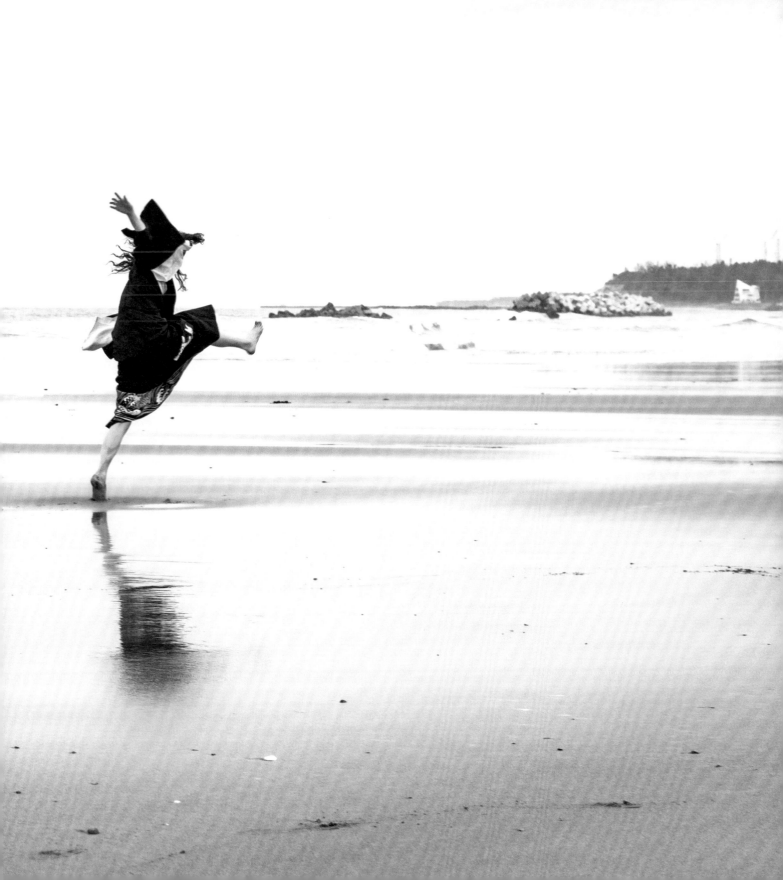

Ukedo Beach, 4 mi. (6.4 km.) north of the Fukushima Daiichi reactors, was as close as we came to the site of the meltdowns. Until 1953, Ukedo had been an independent village, but in that year was absorbed into the town of Namie. The town was famous for its fishing harbor, until 2011 one of the most active in Fukushima, and for the broad beach popular among bathers, swimmers, and surfers. On March 11, 2011, the tsunami flowed across the beach and reached far into the town. All through the next day rescuers worked hard to reach persons trapped in houses that the tsunami had damaged; they could hear the cries for help but had to leave when it got dark as they lacked the heavy equipment for rescue operations. That evening, they were told that they could not return to rescue the trapped because of the radioactive cloud that was spreading over the area.

UKEDO BEACH 請戸海岸 (previous page, and right)

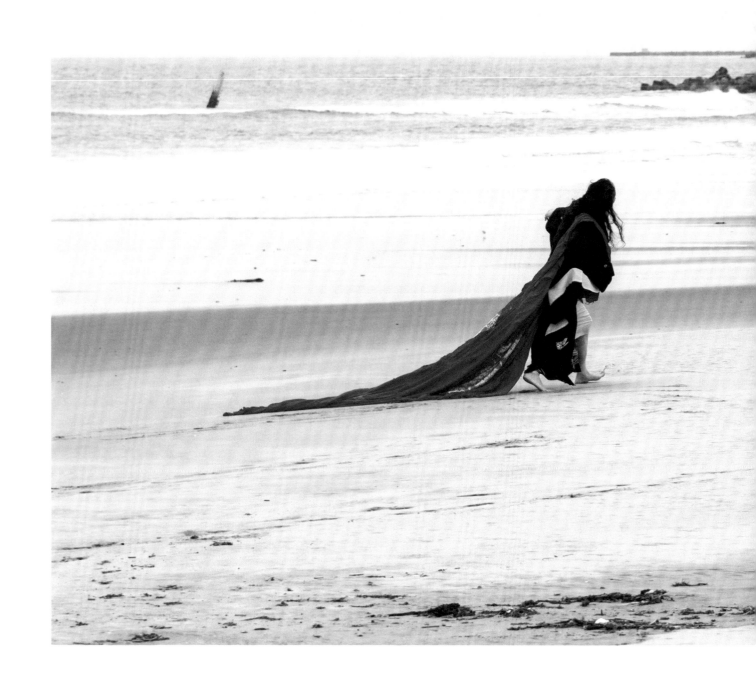

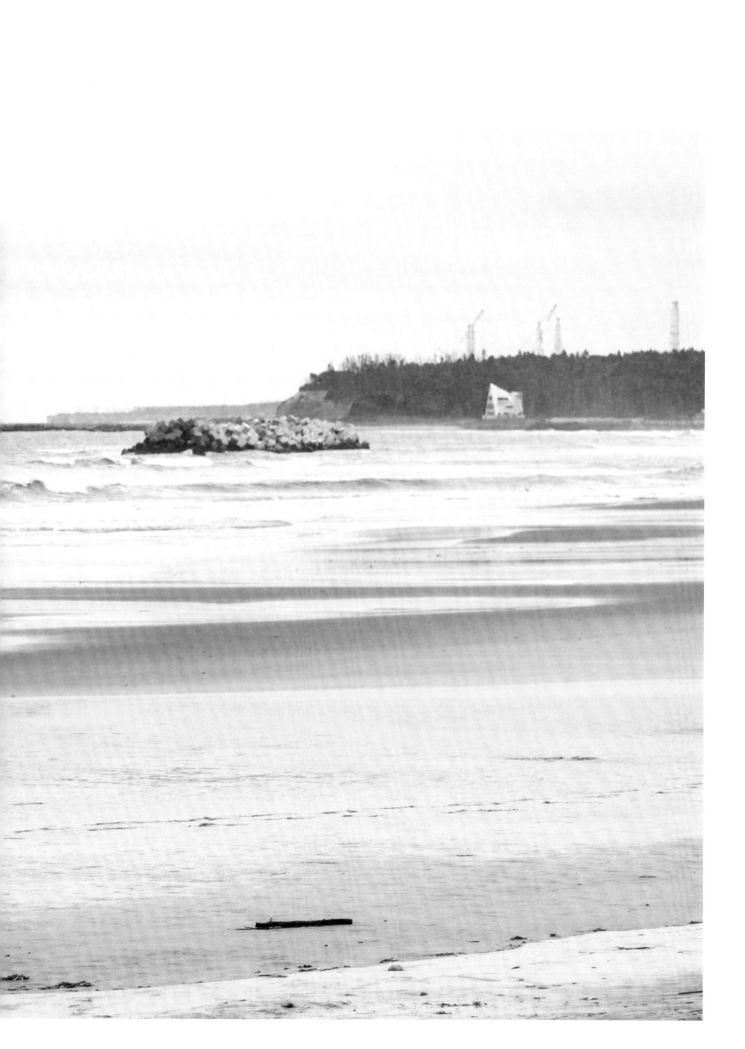

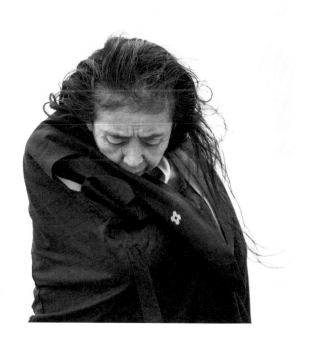

When we first visited in 2017, we both felt a powerful tension in the place; the booms of cranes working on the Fukushima Daiichi reactors were visible on top of the promontory in the background. Eiko's performance that day, both there (pages 12, 190–91, 193–95) and in the neighboring district of Yachihata (pages 196–97, 207, 210–11) seemed to channel the spirit of the place. When we returned in 2019, an enormous seawall had been built, blocking the once-inviting beach from the land (pages 250–51, 263, 271).

UKEDO BEACH 請戸海岸 (left, and above)

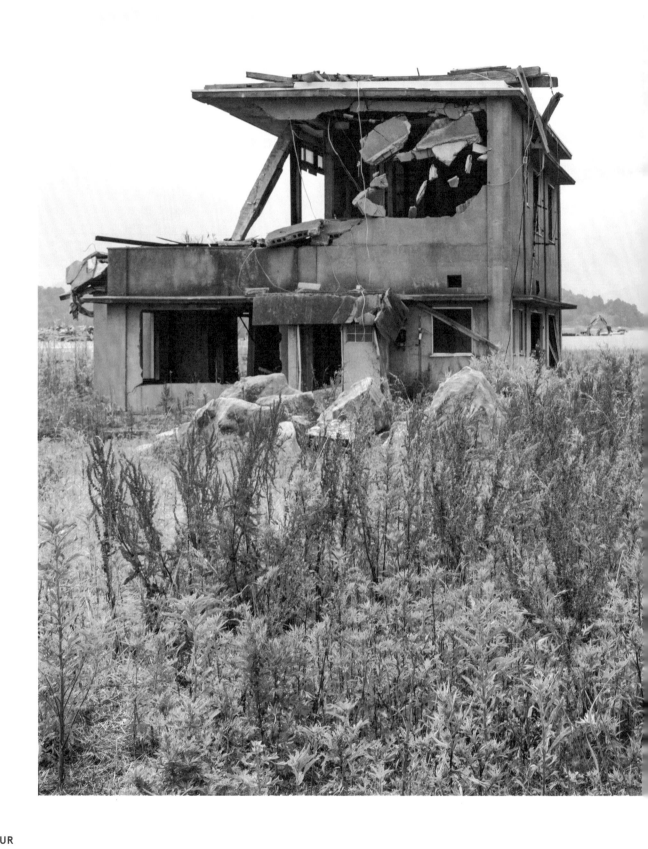

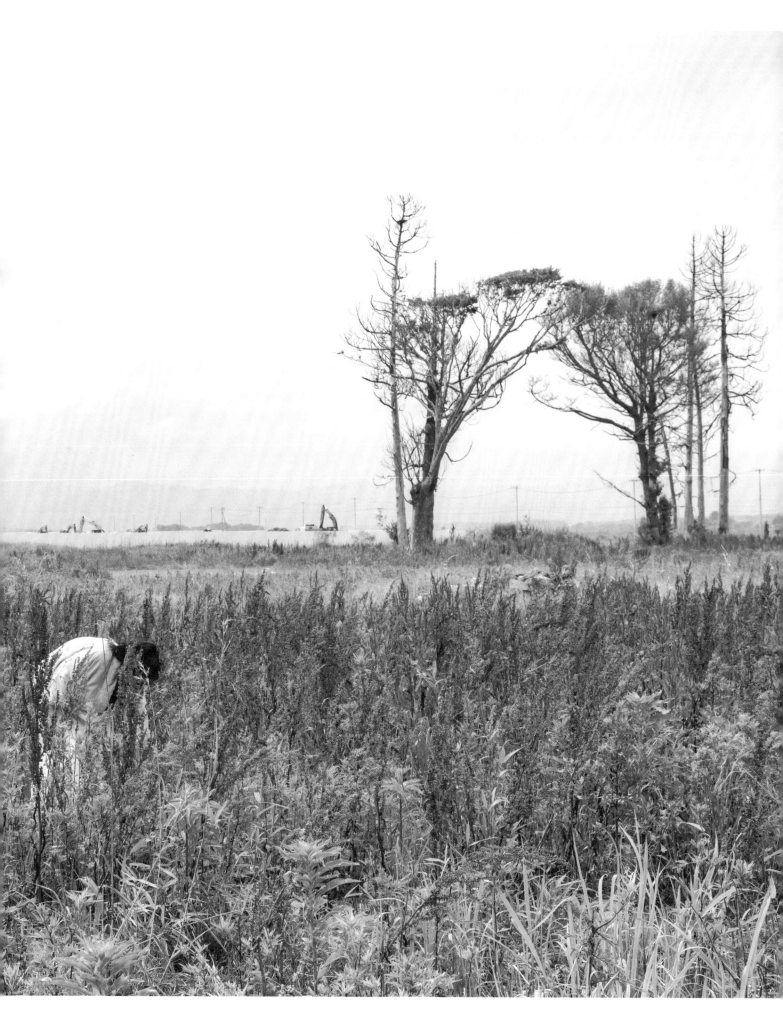

YACHIHATA 谷地畑

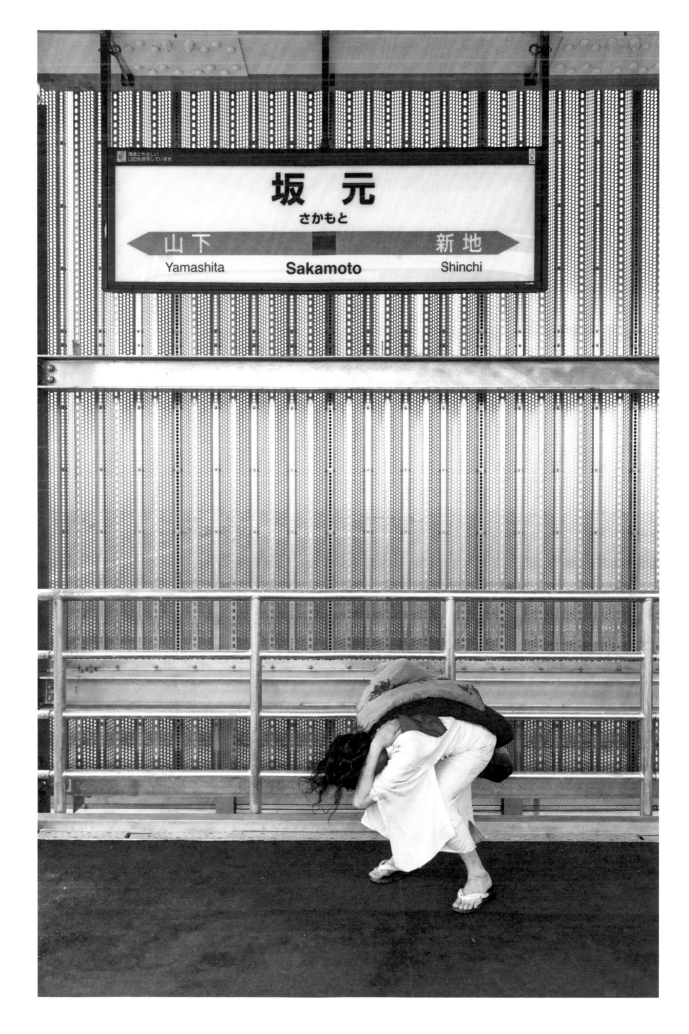

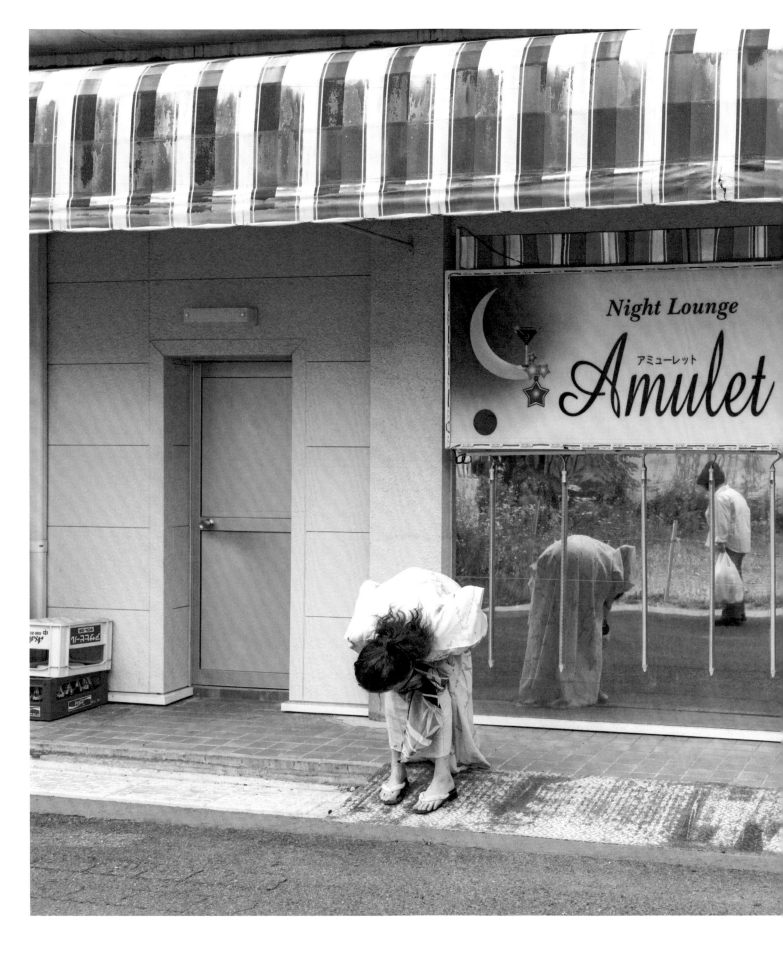

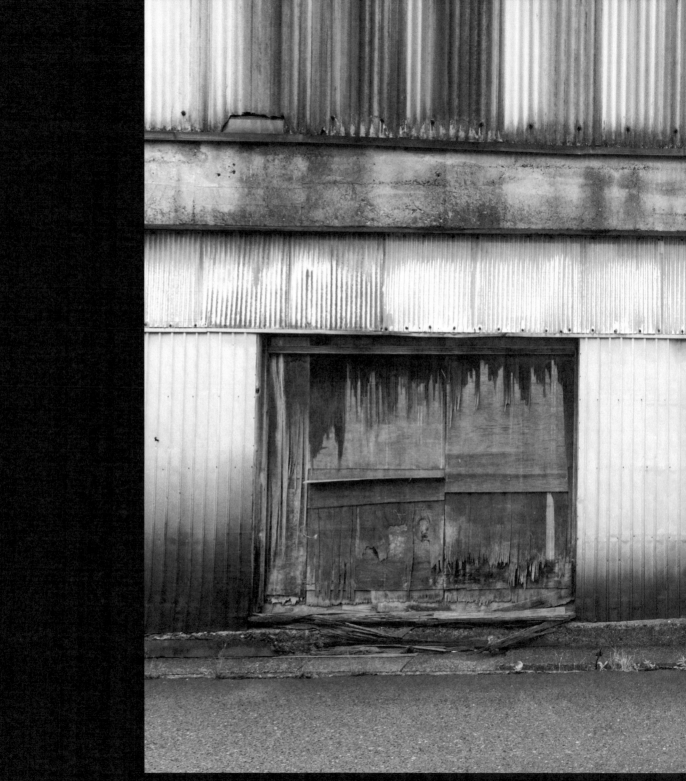

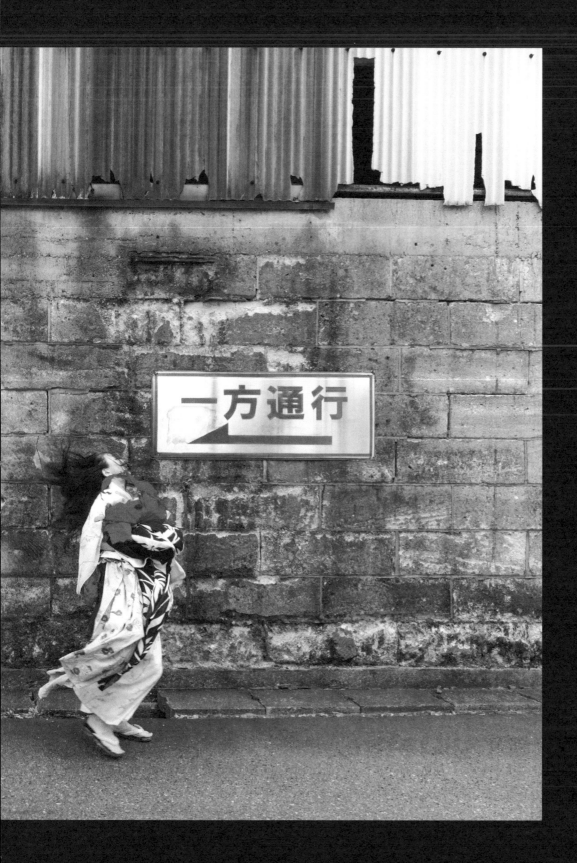

SOMA CITY 相馬市街. TOMIOKA STATION 富岡駅 (next page)

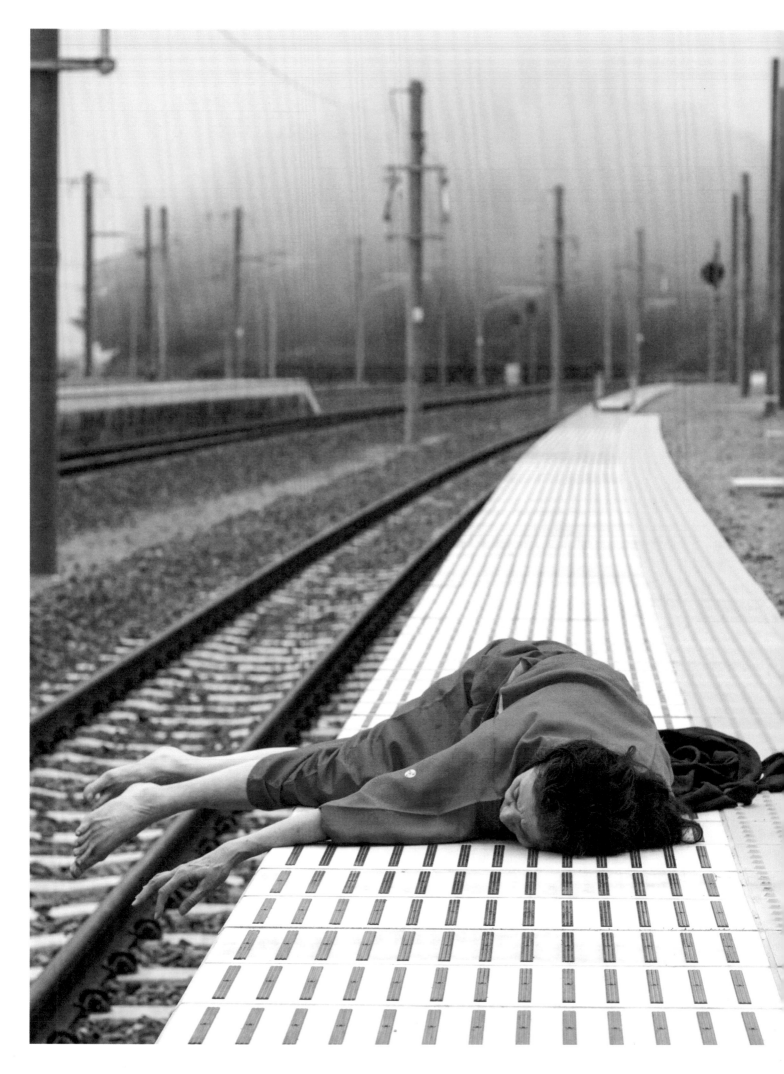

TIME

Space on stage is brushed by time

A performance starts and moves to the end
 A dancer resists that flow

She wishes to create, in and near her body,
a small pocket of time that lingers

She remembers a tree that had been there before a theater was built
Her arm moves to invite the return of the forest

She is careless of time
 She is careless of everything
 Time moves relentless

A baby is born surely to die
She smells the wounds
 in the choreography of an aging body
 She laughs at places,
 times,
 and pains

An atomic bombing is an implosion of time
Everything before gets sucked in
 achievements, desires, whispers

Everything after is spit out

Many bodies float in the black river
Time is not even,
 quiet,
 or patient
Time hurts
Place ruptures
Time is contaminated with knowledge

 Upstream swallows poison
 Downstream gets polluted
Time *swallows* time
Time is *naked*

 She dances to *linger* in that nakedness

MEMORY STAINS

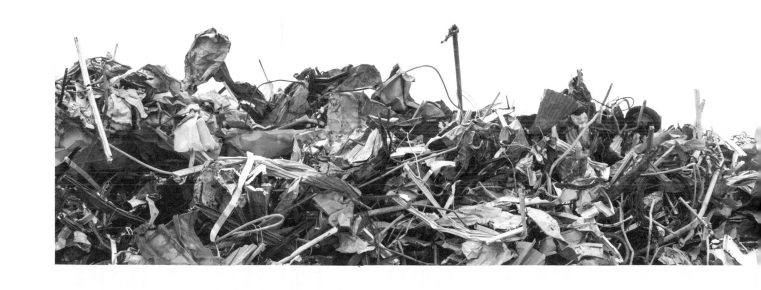

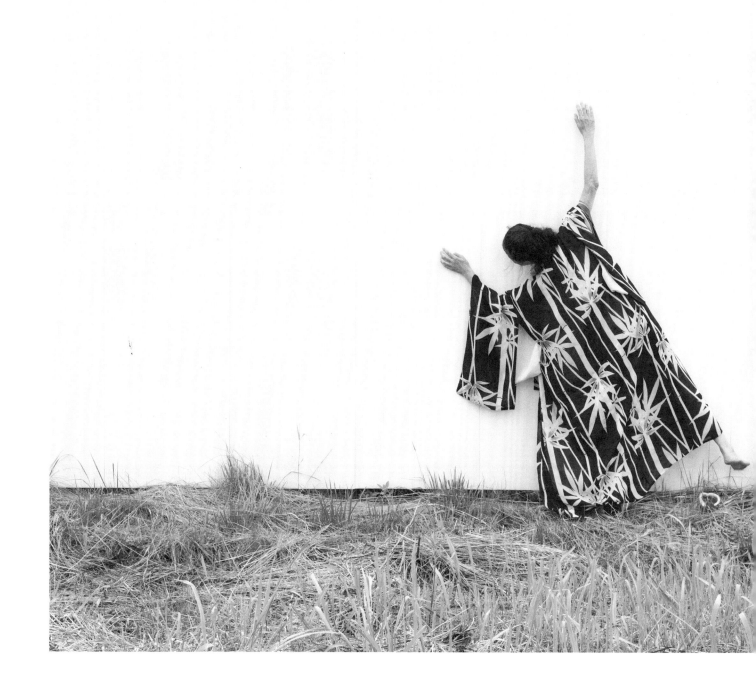

WHEN BILL AND PATRICK DOWDEY, FORMER GALLERY CURATOR FOR the College of East Asian Studies at Wesleyan University, suggested that the title of our photo exhibition be "Mourning in Fukushima," I was fiercely against it. I did not want to be a part of this chorus of sorrow. Yes, many people are sad. I am sad about the earthquake and tsunami—but about the explosions and meltdowns of the Fukushima Daiichi Nuclear Plant, I'm angry.

Yet this anger is not only directed at others, who were responsible for these particular disasters. What I really feel is remorse. I look at the people who are in power. Many are from my generation. I am a part of the generation that made this mess.

Bill and Patrick were worried that *A Body in Fukushima* would make people think of a corpse. But I'm presenting my live flesh, not a corpse. And I have never let others name my or Eiko & Koma's works. I had titled my solo project *A Body in Places*, and I wanted call our Fukushima photo project *A Body in Fukushima*. This is how I share Fukushima with my audiences, and this is how I remember Fukushima.

During the photo shoots, Bill does whatever he wants, and I do whatever I want. Afterwards, we view the photos together. We mark each photo with a grade of 1 to 5: 1 is "not over my dead body"; 5 is "this has to be shown." We honor each other's 1s and 5s, but our 2s, 3s, and 4s are negotiable. What Bill chooses looks good from a photographer's point of view. As a dancer and choreographer, my approach is to look at the place, myself, and my relationship to the place. Is my body affected by the place? Is my body doing something to the place? By looking at his photographs, I remember the place and my dance there.

After our first visit to Fukushima together, I began creating videos using still photographs. These now include photos from all five Fukushima visits with Bill. I *choreograph* photos by selecting, reordering, and assigning a different duration for each. For the videos I also create minimal texts and sound.

If a photograph is a 2 for Bill and I understand why, I would not use it in an exhibition, but he allows me to use his 2s in my video work—even if they're blurred or he feels they are not quite right. Such selections greatly interest me as a choreographer and a dancer.

In creating a video from photographs, I do not just want to line up great photos. My video-making is partly a rescue mission for the photos deemed unwanted by the photographer. Time-based art needs different textures and dynamics. What one sees and feels is conditioned by what scene is before and after, how long the frame stays, and if it is cut, faded, or transposed with another image.

Everywhere I go to perform a solo—in a station, a library, a museum—I bring the photo exhibition or a video of *A Body in Fukushima*, often both. From our very first exhibition, we have shown videos with projections or on monitors. I perform in an exhibition to activate the space and also to bring in more viewers. By doing so, I can more directly present my body as a conduit to Fukushima.

In galleries, I desire to present my body at its most raw. Working with photographic prints and videos that were selected, culled, and processed, as a performer I become more spontaneous, daring to betray some previous preparation. I certainly do not want to look like the same Eiko, though it is clearly the same person in the photographs. I want this performing body to be more chaotic than the one framed in the pictures.

YACHIHATA 谷地畑 (previous page)

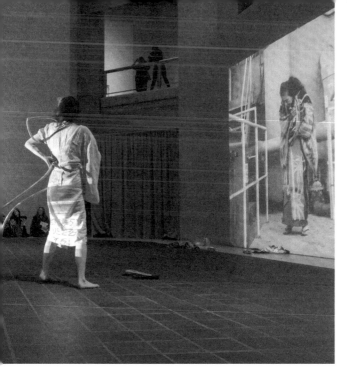
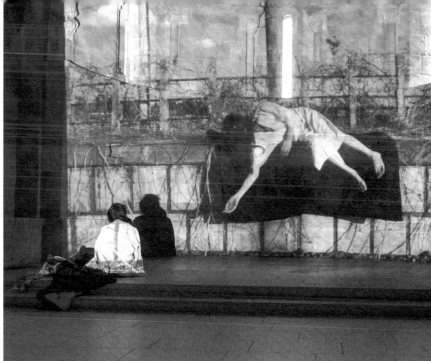

I have a distaste for making things just right. In museums and formal theaters, everything is supposed to be just right. The exhibited artworks have been chosen by curators. Nothing exhibited is supposed to be not worthy. That assumption agitates me. I cry out and tear Bill's photo prints as a performance action. He photographs such performances, and we have created an exhibition that puts the photographs of me in Fukushima next to the photographs of me performing with images from Fukushima.

I bring my body to Fukushima; Bill photographs me there. I select and edit videos. We create an exhibition of photo prints and videos. I perform among the photos in the exhibition and sometimes with projected video. Bill photographs these performances. We then make a new exhibition. Thus, our Fukushima project continues to expand its layers.

In November of 2017, I performed all day on three Sundays at each of the Metropolitan Museum of Art's three buildings, Cloisters, Breuer, and Fifth Avenue. The original invitation was to do a one-hour event in one place of my choice in the museum. I extended that to a total of twenty-two and a half hours of performance, because I wanted to project Fukushima images onto the Met walls. To fill a whole day of museum hours, I created a seven-and-a-half-hour video from the photographs Bill had taken in Fukushima. I knew it would be impossible for Bill and me to have a photo exhibition in the Met, but I could bring in projected images of Fukushima as a part of my performance. I wanted to connect the Met with irradiated Fukushima, as I had done in Philadelphia's 30th Street Station. I wanted Fukushima images metaphorically to stain the Met wall for as long as possible. A full three days was the longest time I could be in the Met's galleries, thus this was the duration of my longest solo performance.

Bill came to photograph the event in all three places. Looking at his photographs later, I realized that together with Fukushima images, I myself was also the stain in the Met. This is one thing a performer can do. Be a stain to grandeur. Memory stains.

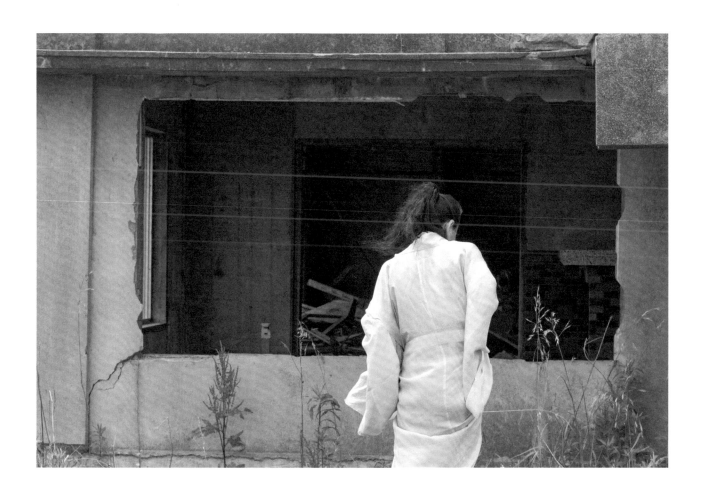

TRIP FIVE

竜田駅　TATSUTA STATION

前原　MAEBARA

富岡駅　TOMIOKA STATION

山田浜　YAMADAHAMA

破町　YABUREMACHI

木戸古墳神社　KODO KOFUN SHRINE

波立弁天　HATTACHI BENTEN

富岡漁港 TOMIOKA FISHING HARBOR

富岡し尿処理施設 TOMIOKA SANITATION PLANT

木戸駅 KIDO STATION

浪江町 NAMIE TOWN

請戸 UKEDO

角部内 TSUNOBEUCHI

太田川河口 OTA RIVER

新舞子浜 SHINMAIKO BEACH

DECEMBER 2019

Along the southern coast of Fukushima the road runs next to a small island consisting of two large rocks jutting high out of the ocean. A scarlet torii, or Shinto shrine gate, is clearly visible from the highway. This is Hattachi Benten, 21 mi. (33.8 km.) south of the Fukushima Daiichi reactors. The full name is Hattachi Kaigan (Hattachi, literally "standing wave," Seashore), Bentenjima (Island of Benzaiten). From as early as the tenth century the seaside ledge of the larger of the two rocks was called Wanigafuchi, literally the "crocodile ledge." This was because large waves often appeared as from nowhere, sometimes pulling people into the sea below—which almost happened to Eiko in 2016 (pages 14–15, 166–67). The goddess Benzaiten, also called Benten, originated as the Hindu goddess Saraswati, and was celebrated in Japan from the sixth century. Benten embodied both Shinto and Buddhist qualities, and the shrine to Benten on this island also remains a place of devotion among fishermen, who believe that Benten acts as their guardian while at sea. We went again while on our last visit in 2019, arriving as the light was fading (pages 215–17).

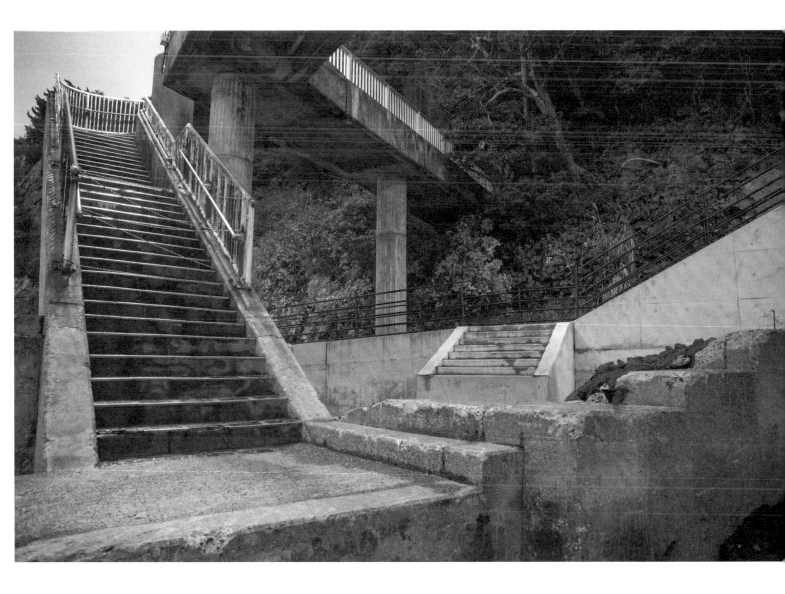

HATTACHI BENTEN 波立弁天

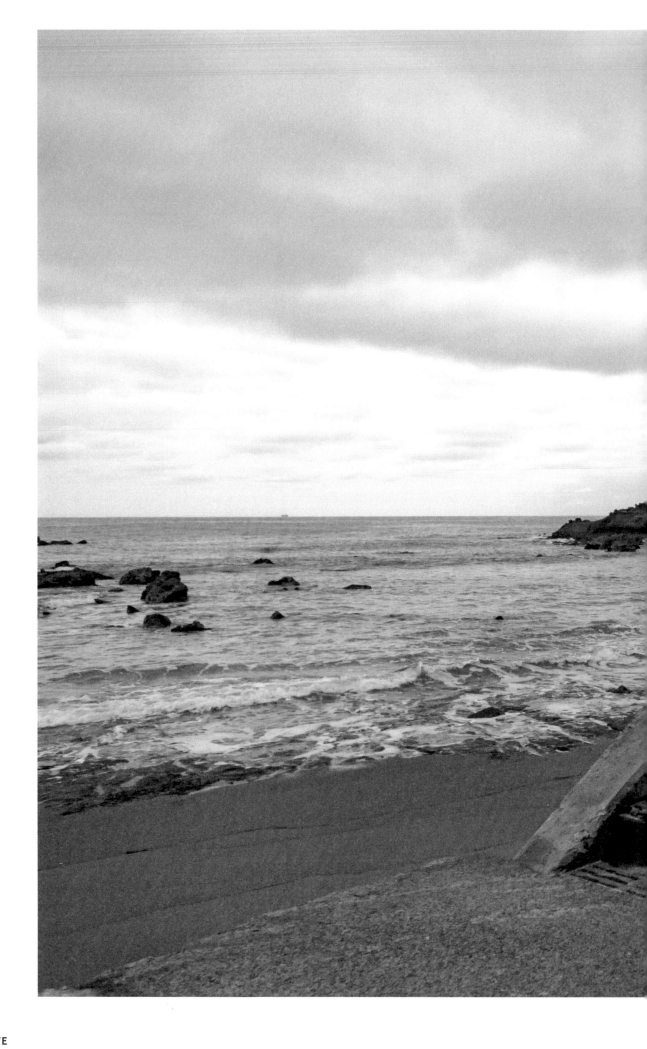

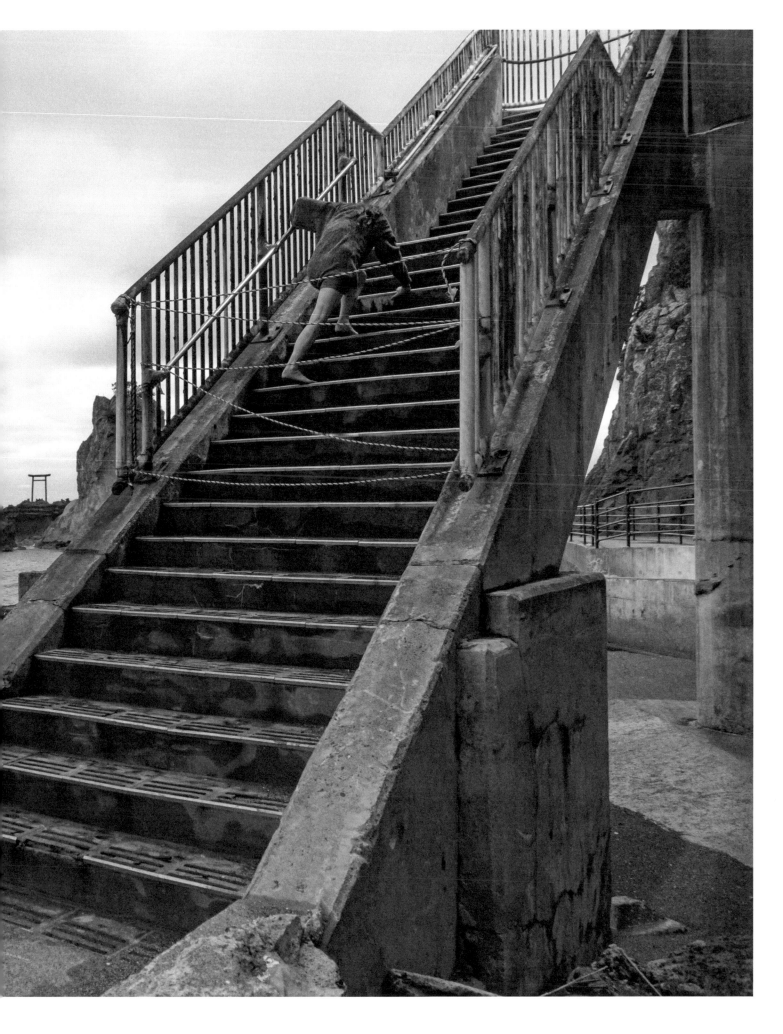

HATTACHI BENTEN 波立弁天

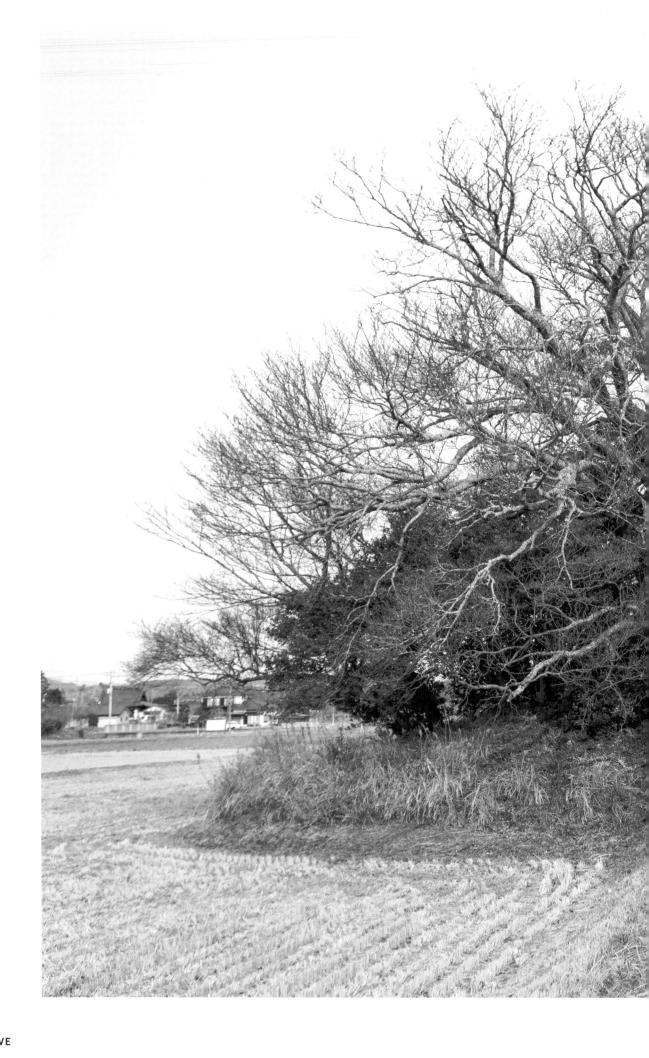

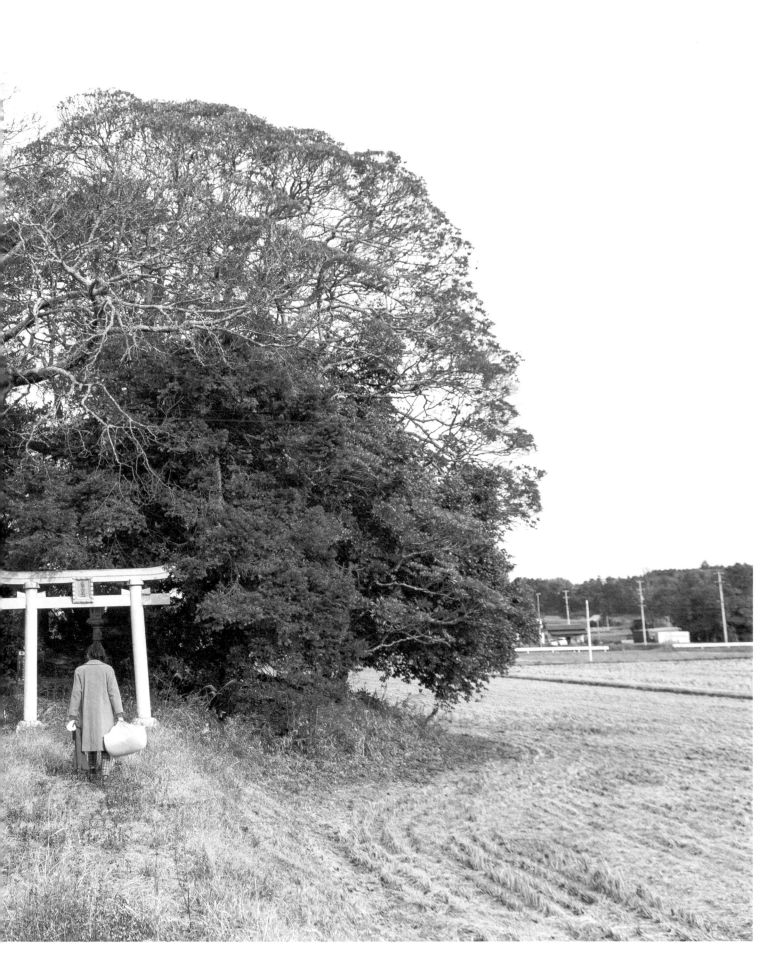

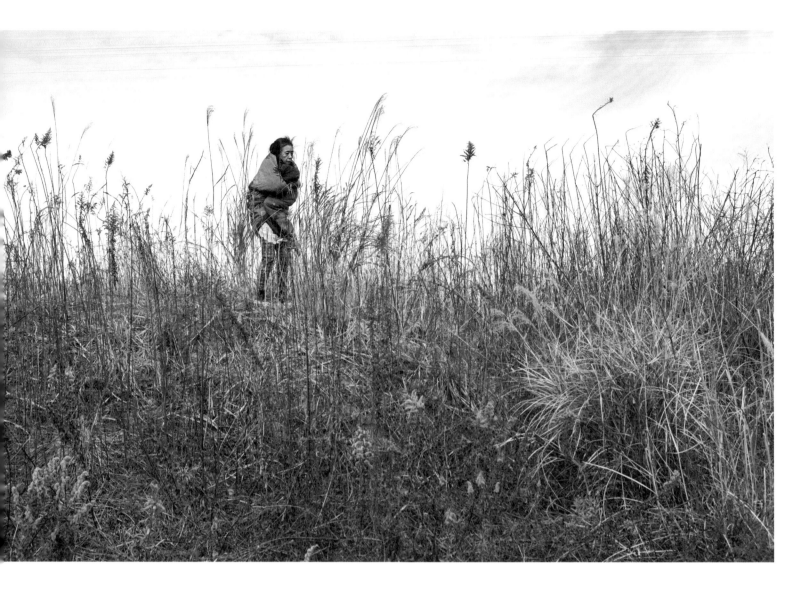

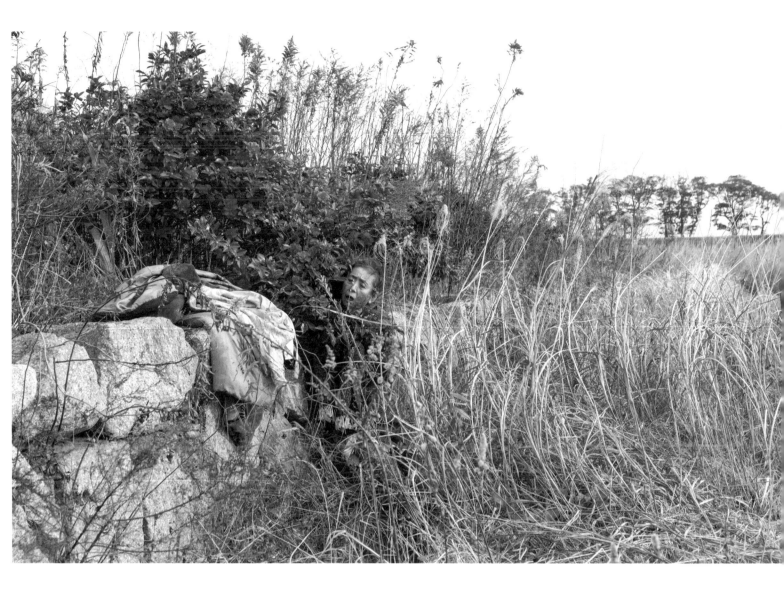

YABUREMACHI 破町 (above, and left)

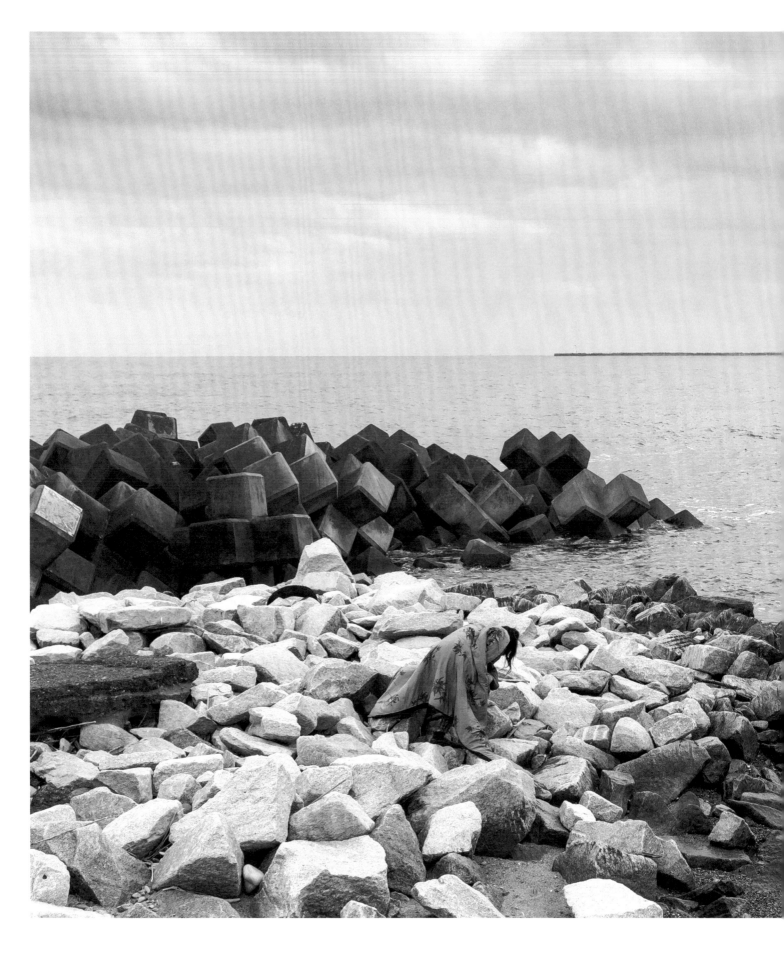

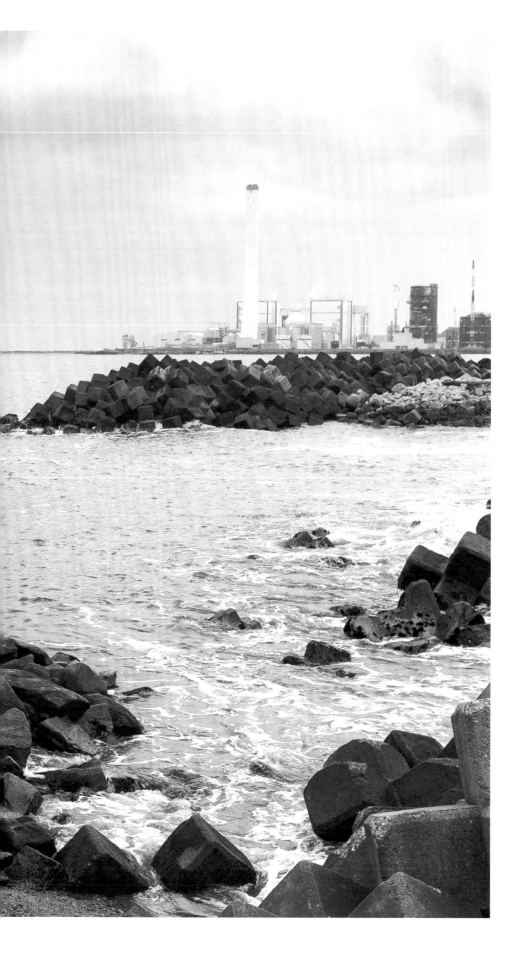

YAMADAHAMA 山田浜

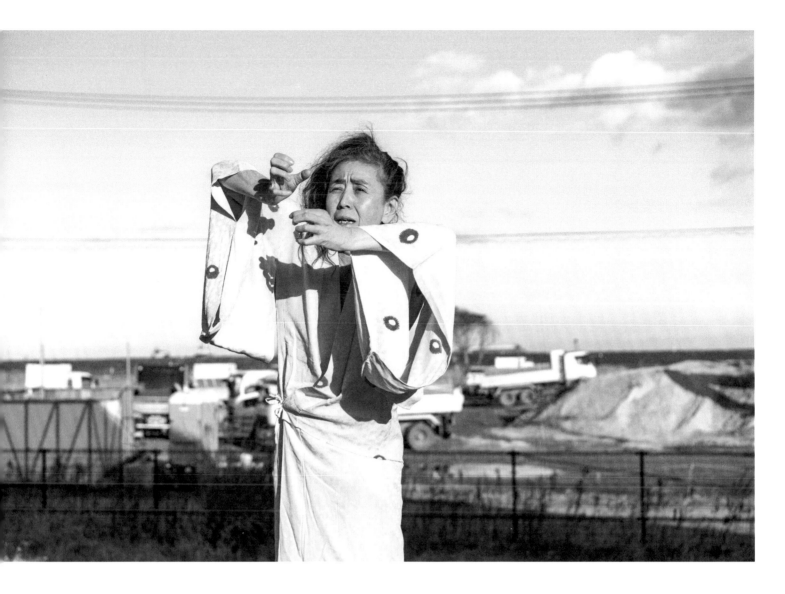

TOMIOKA STATION 富岡駅

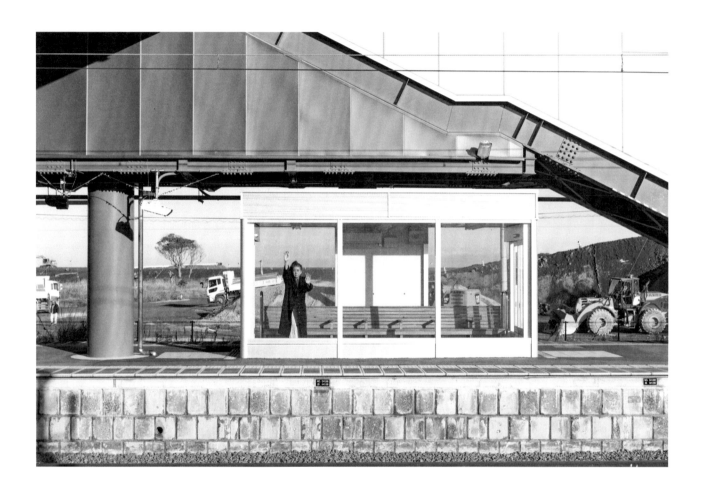

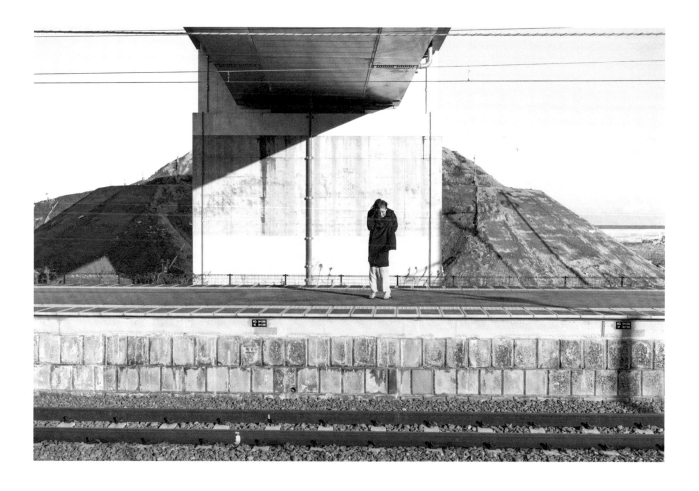

TOMIOKA STATION 富岡駅

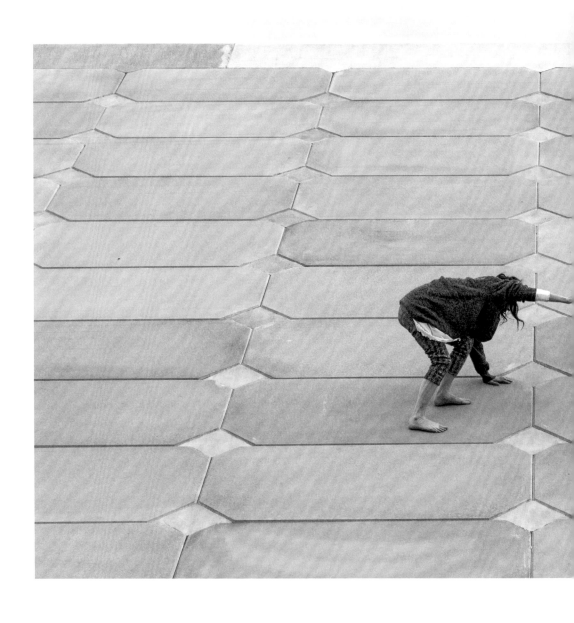

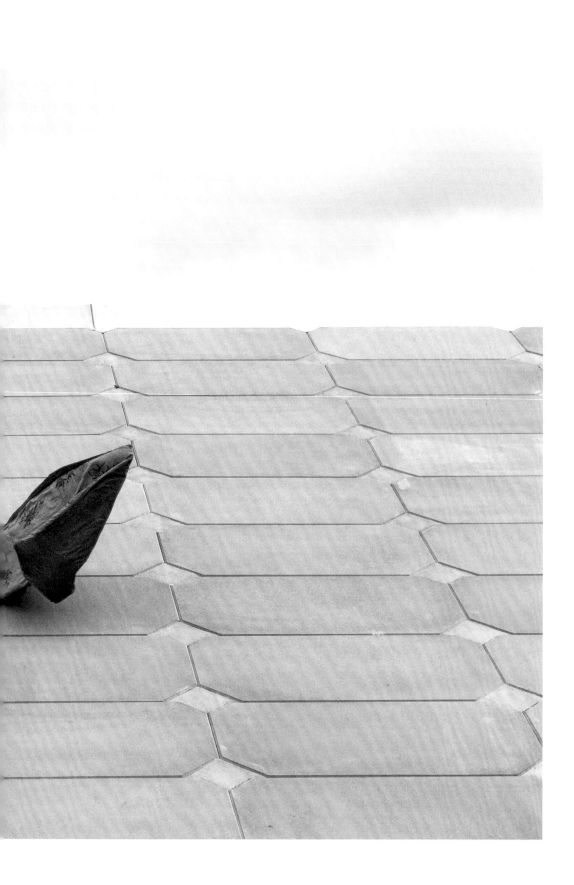

YAMADAHAMA SEAWALL　山田浜防波堤

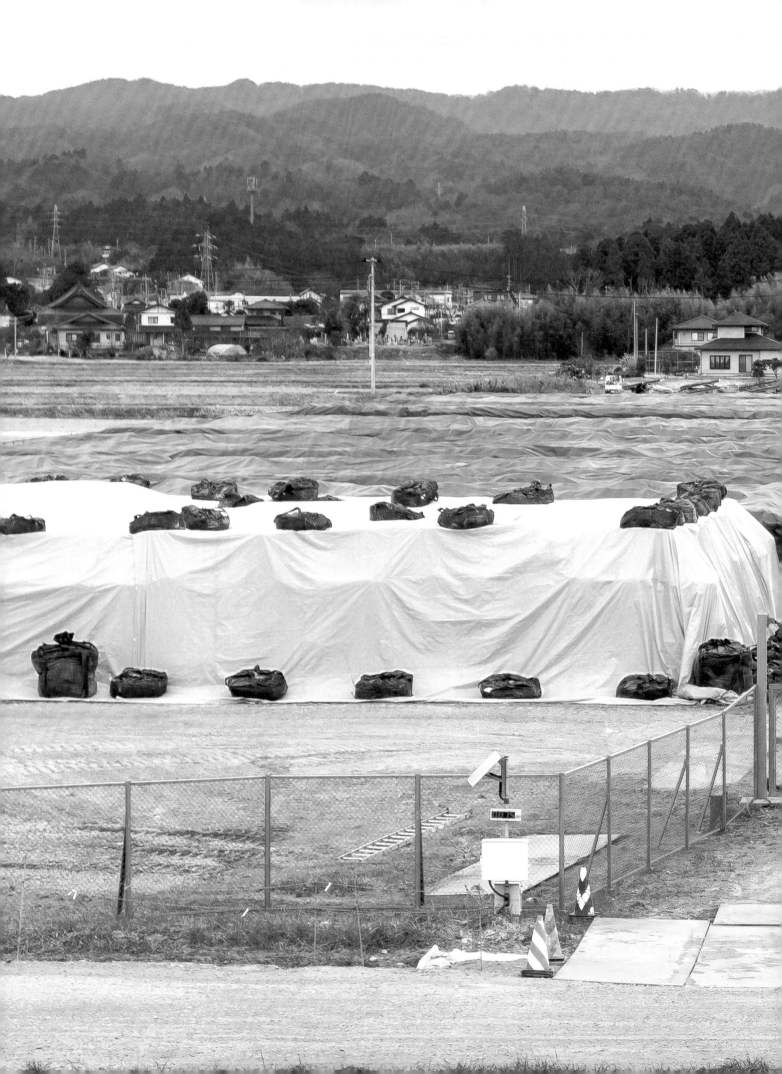

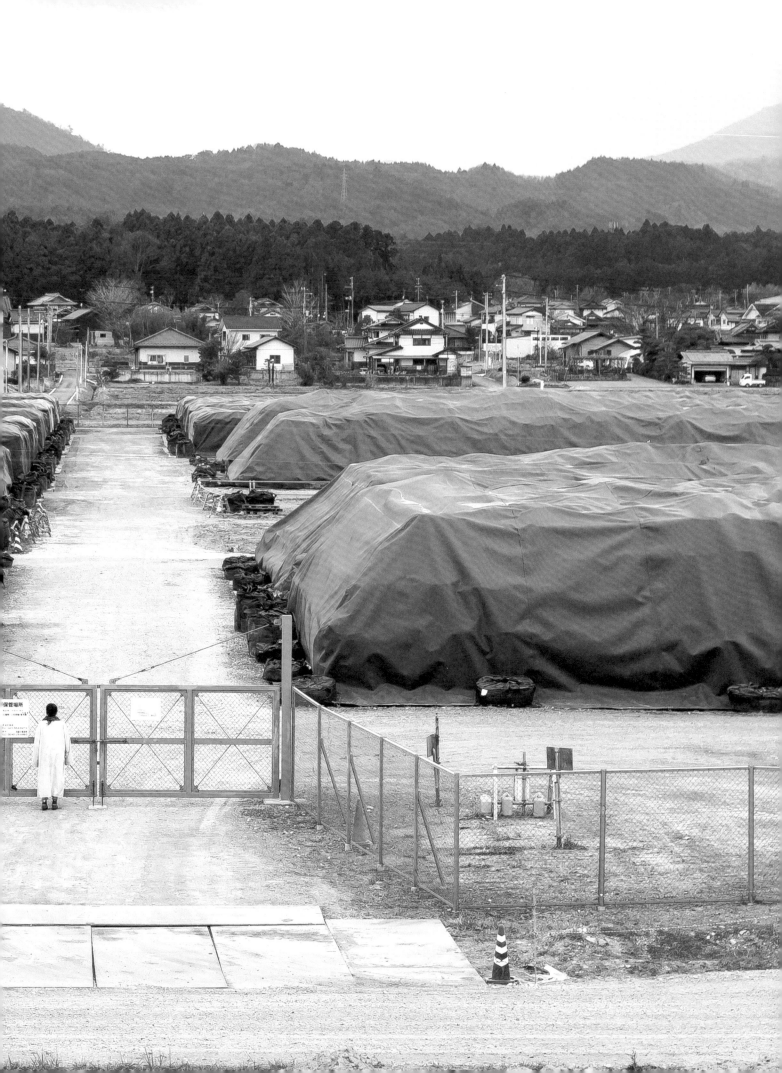

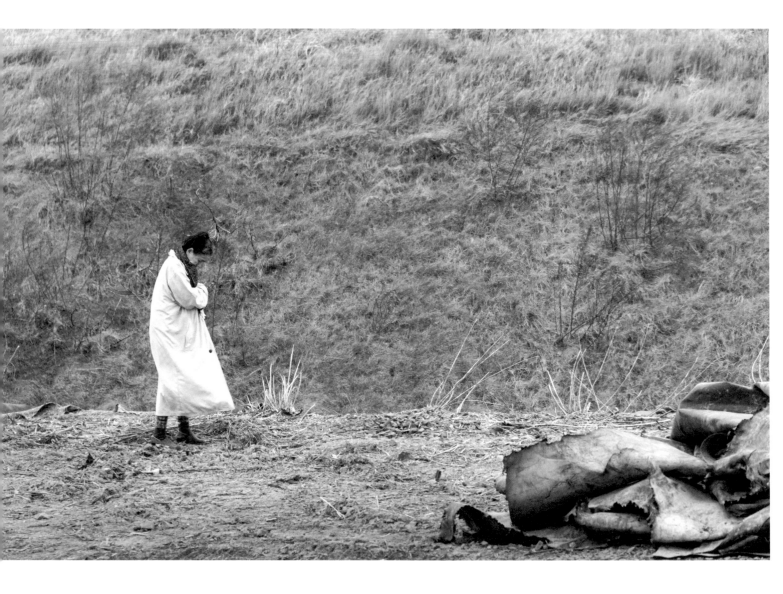

The area now called Maebara was once a small hamlet that was absorbed into the village of Kido when it was created in 1889. It was 11.4 mi. (18.1 km.) south of the Fukushima Daiichi reactors. In 2011, the tsunami reached far inland here. At the time of our first visit in January 2014 workers had started using the open fields there as a place to store one-ton bags filled with radioactive debris and soil taken from the surrounding houses and fields (pages 50–51). At the time of our second visit in July 2014, it had become a sorting ground for the irradiated goods and objects from abandoned houses and farms, including tatami, household appliances (pages 104-105), bicycles, tires, farm equipment, television monitors. When we visited Maebara in 2019 the sorting had ended, and it had become a de facto permanent storage place for innumerable one-ton bags of radioactive waste, lined up in rows and covered with enormous sheets of plastic (pages 230-32), like many other storage sites in the area.

MAEBARA 前原 (above left, and previous page)

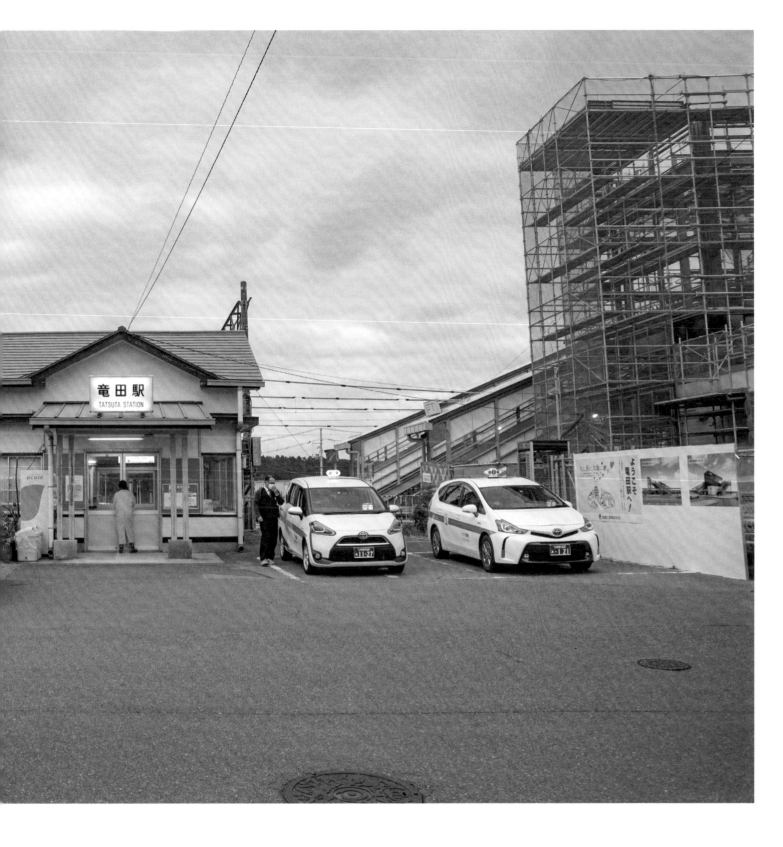

TATSUTA STATION 竜田駅

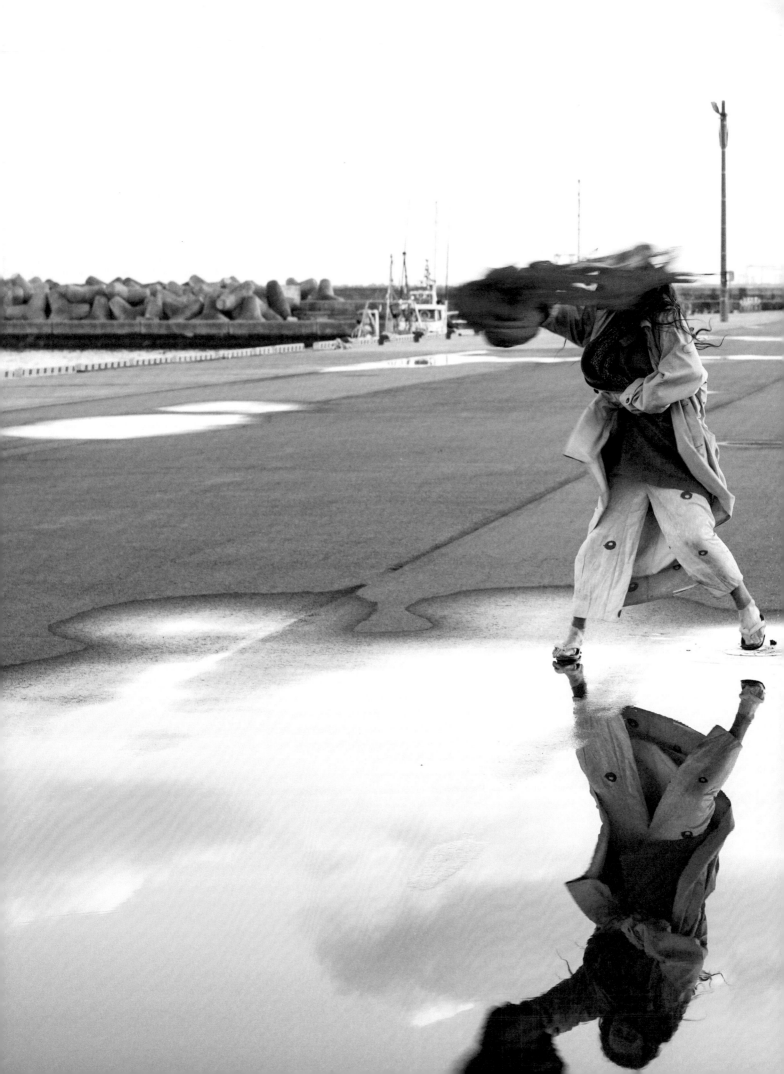

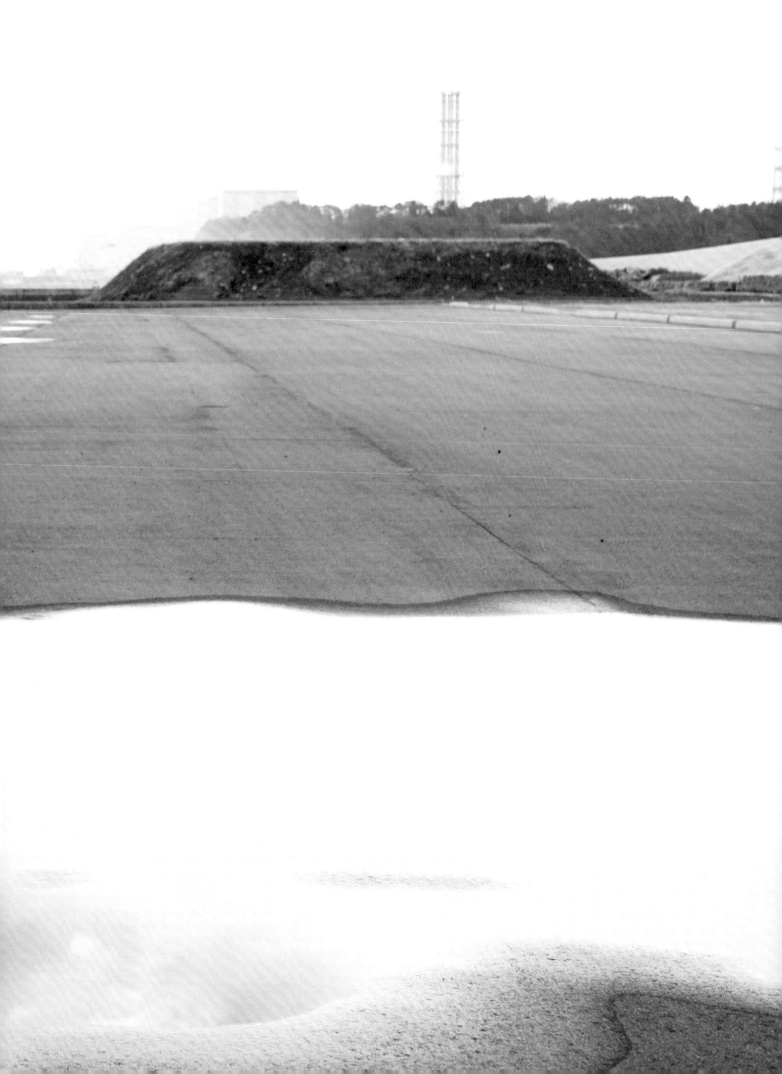

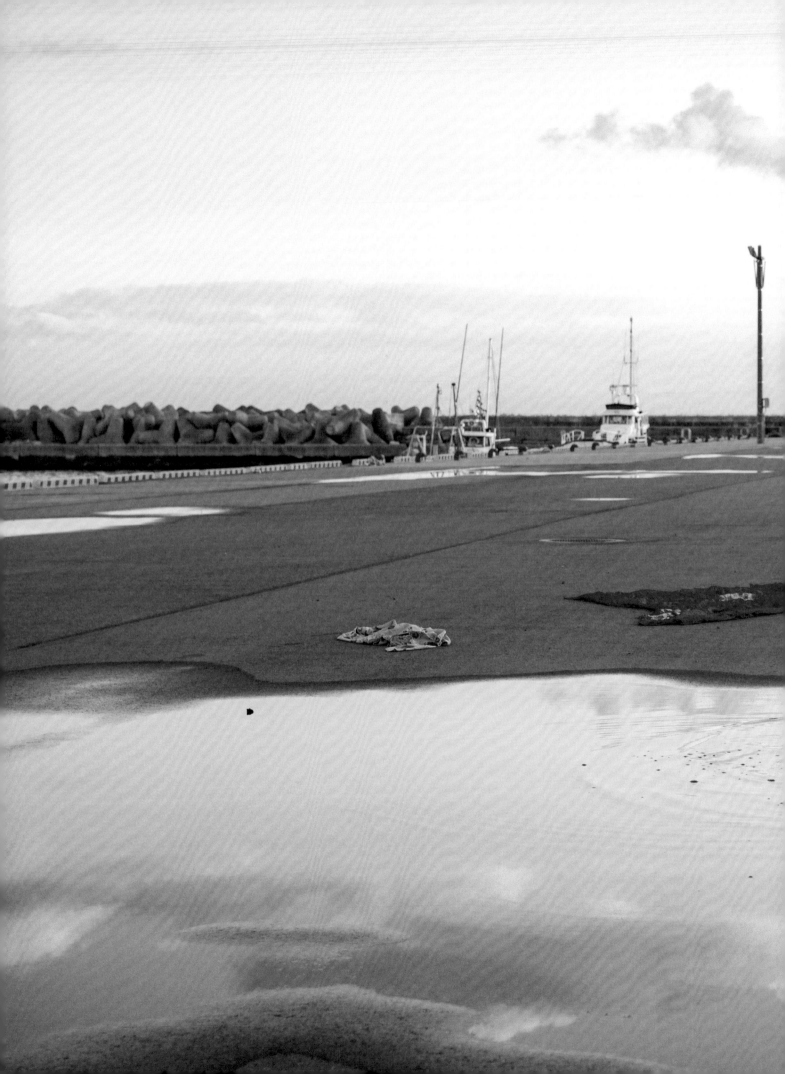

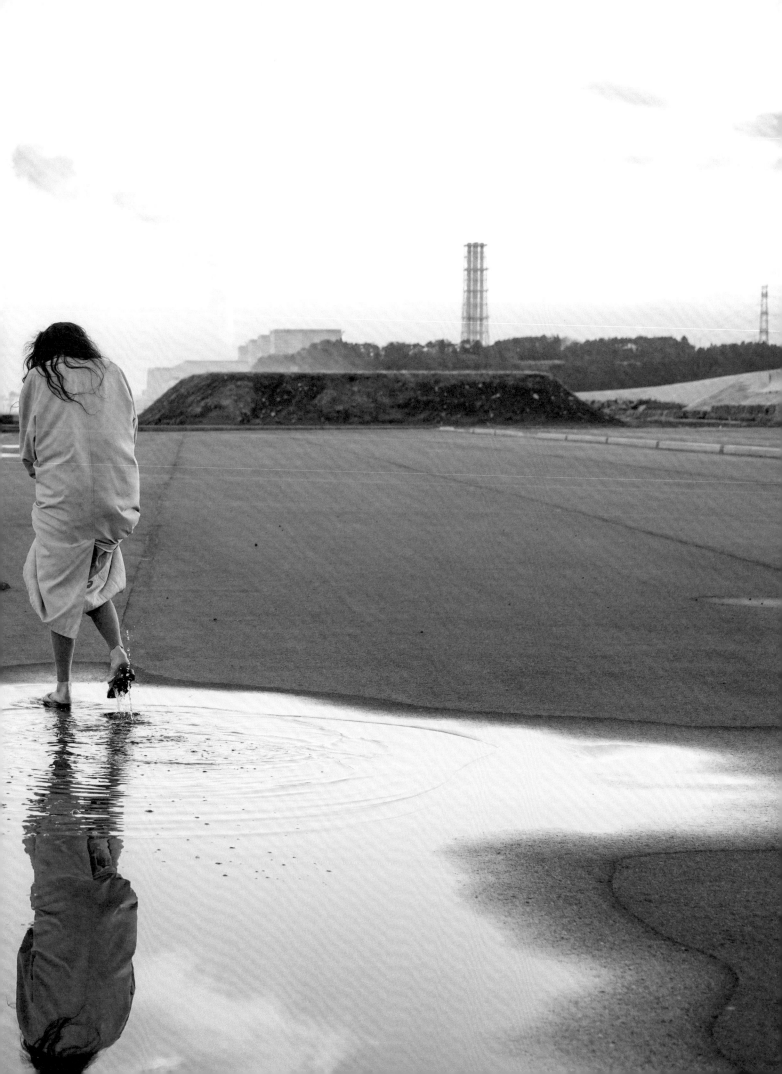

TOMIOKA FISHING HARBOR 富岡漁港 (previous pages)

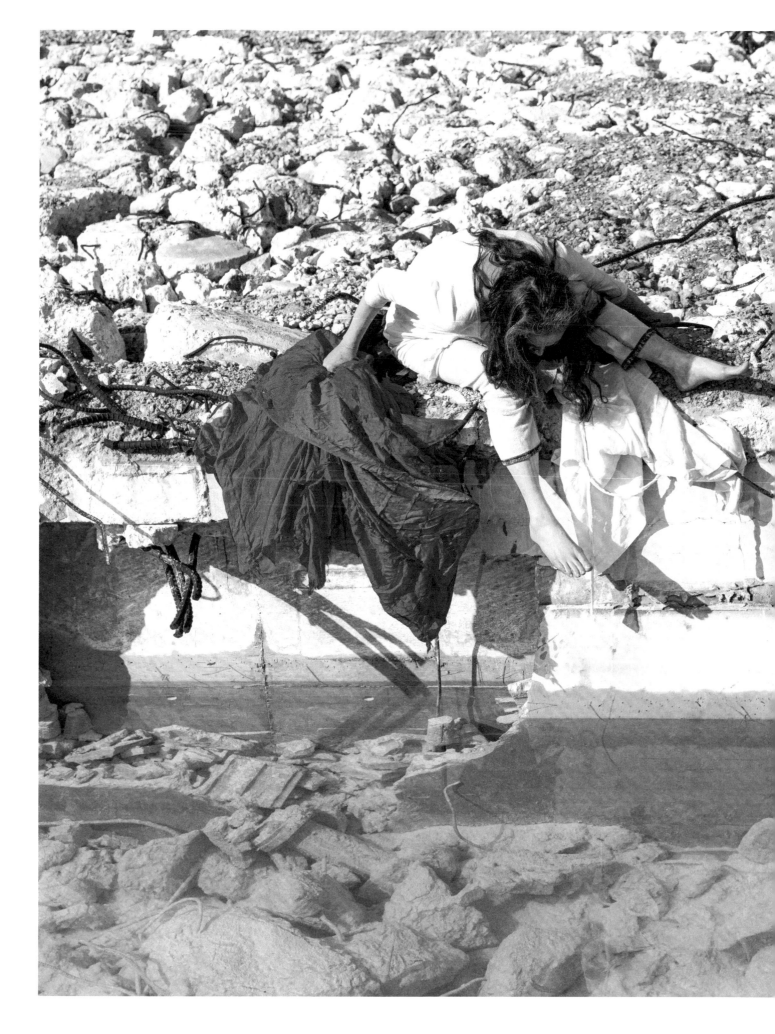

TOMIOKA SANITATION PLANT 富岡し尿処理施設

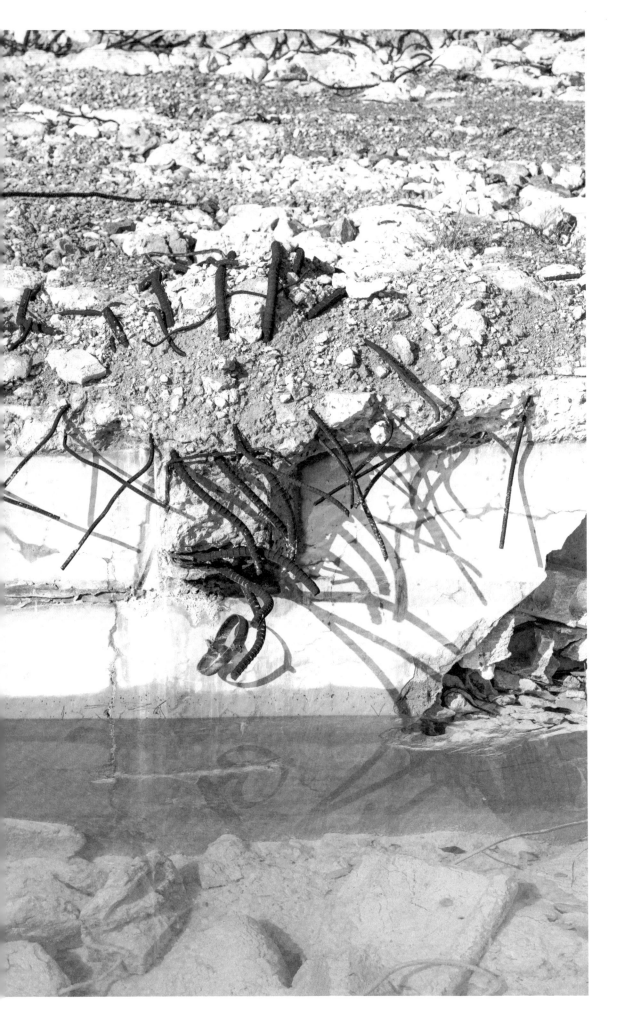

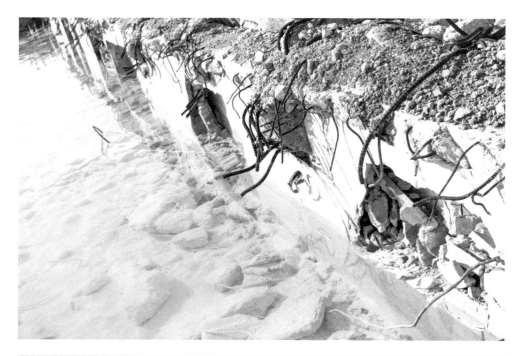

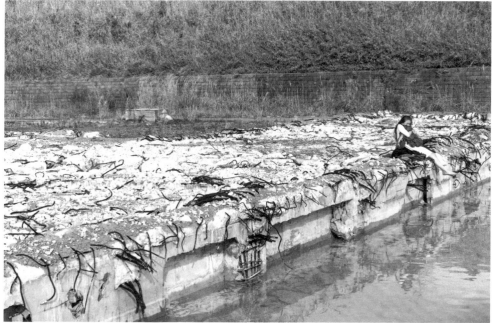

TOMIOKA SANITATION PLANT 富岡し尿処理施設

KIDO STATION　木戸駅

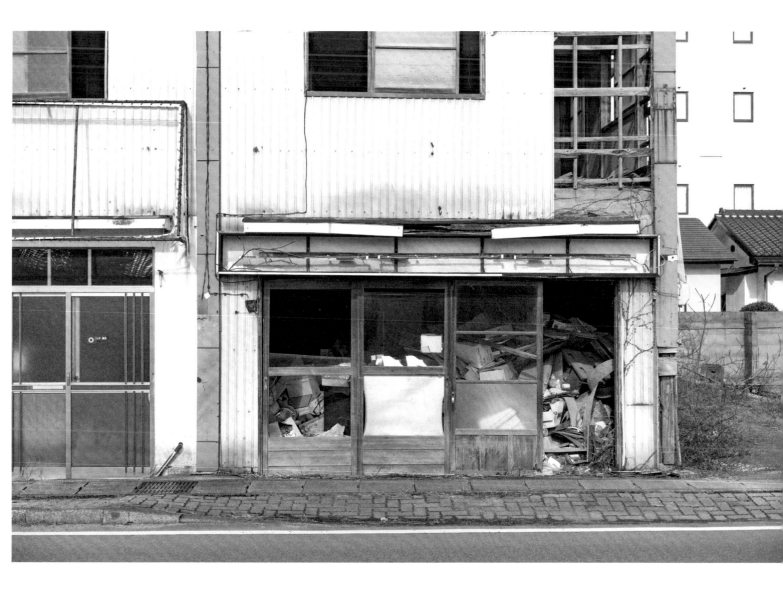

NAMIE TOWN 浪江町

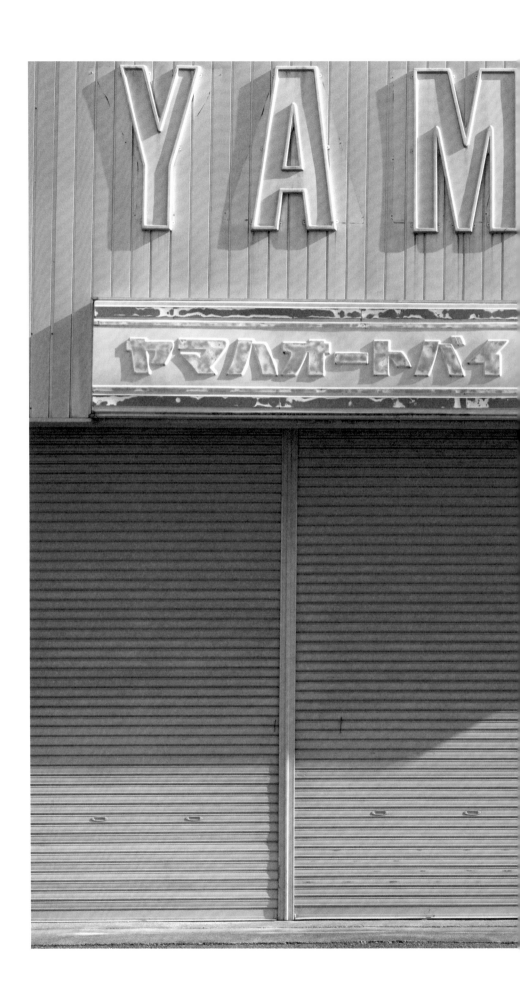

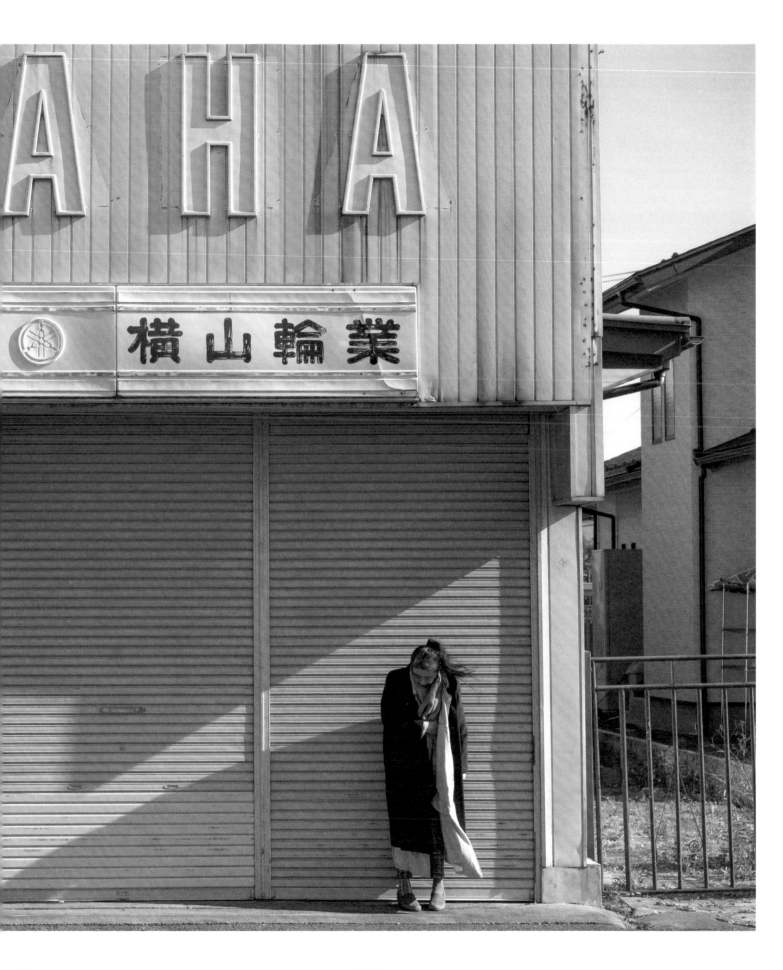

NAMIE TOWN 浪江町 (above, and next page)

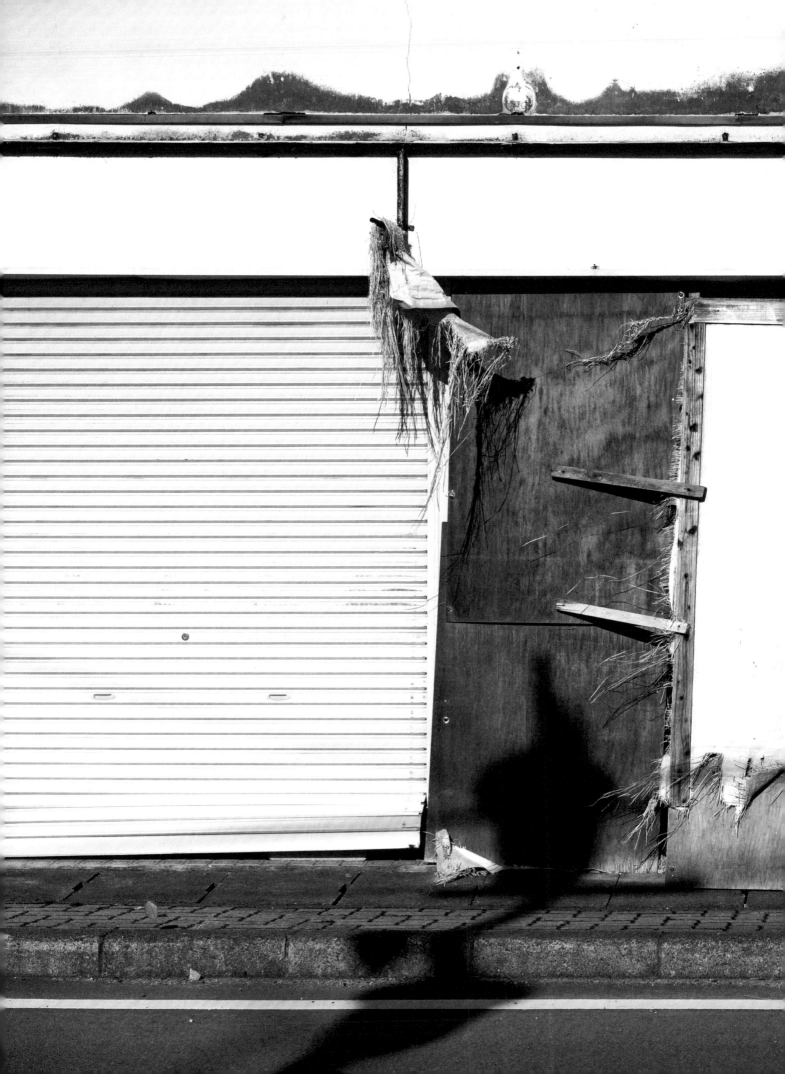

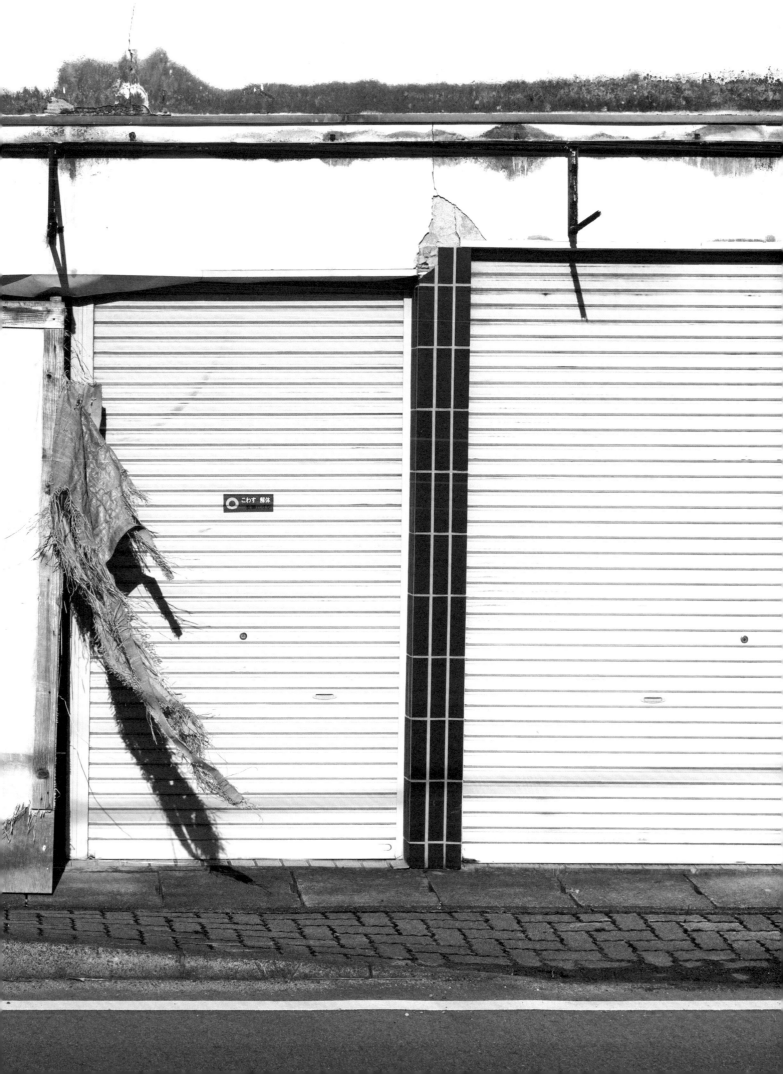

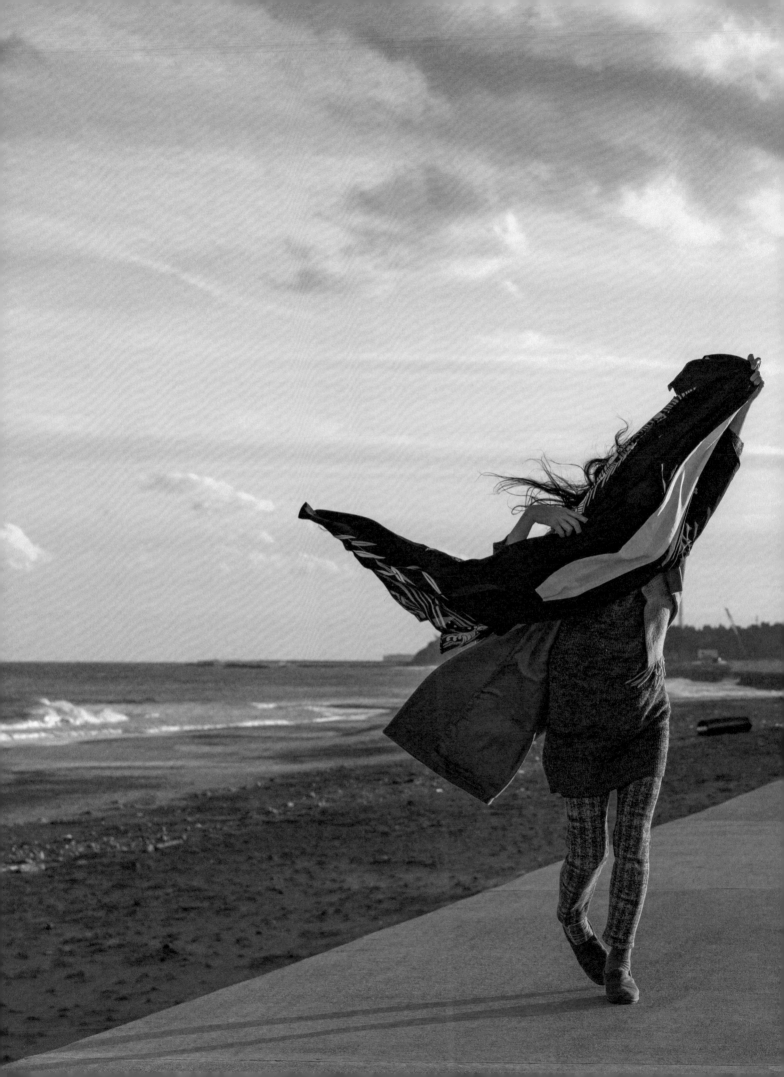

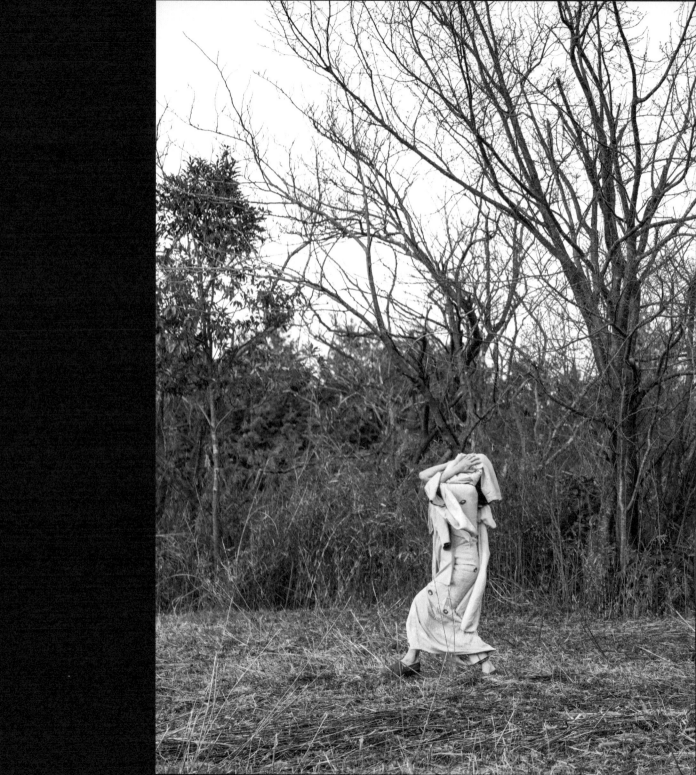

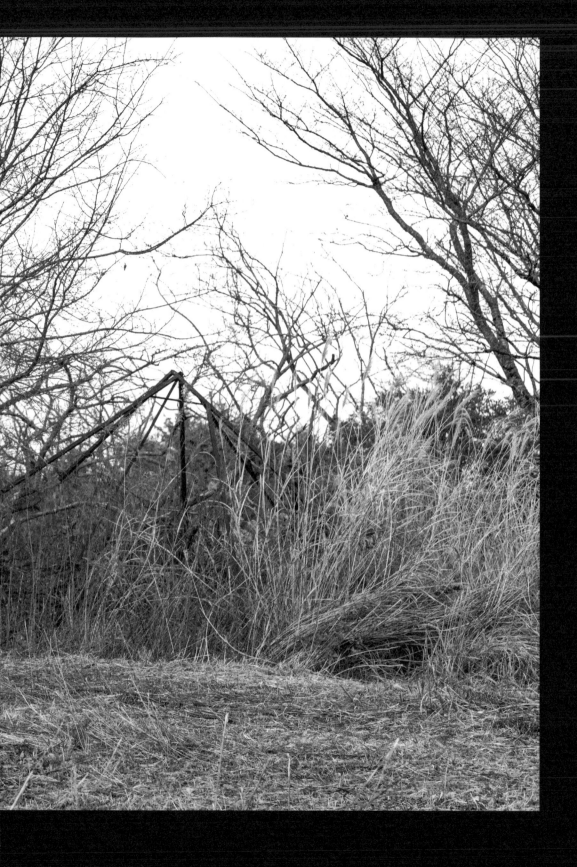

CONCRETE SEASHORE

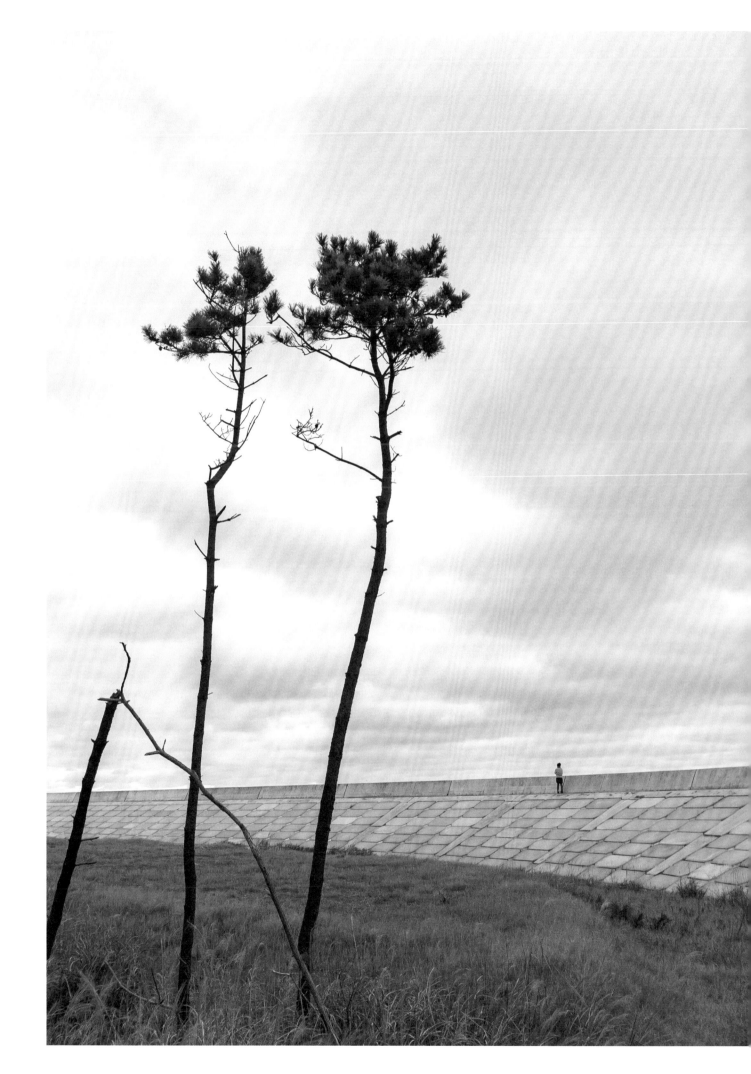

DECEMBER 20, 2019—AS I GET READY FOR OUR FIFTH TRIP TO FUKUSHIMA, something tells me to pay attention to which clothes I am to wear this morning. I murmur to myself to bring fewer kimonos. *Why? Am I tired of my grandma's kimonos?* I do not know. I pack my purple futon, red cloth, and an oversized raincoat my friend Sam Miller used to wear. His wife Anne gave it to me after he passed away, more than a year ago. I wear a dark grey dress, vaguely patterned pants, and a dark purple winter coat another friend gave me before she died in 2004. At the door I remember how cold the Fukushima winter is, so I pick up my mother's scarf. She died earlier in the year.

I feel comforted to wear clothes from the people I miss.

Bill and I take a train to Iwaki station in Fukushima Prefecture and drive to Shinmaiko. In the summer of 2014, the place was a beautiful, deserted beach, and we could easily imagine how popular it must have been with vacationers before 2011. Now Bill points to the familiar bridge, the river and the trees. The same place. But so changed. A big floodgate was built to stop the river from freely flowing into the sea. The mouth of the ten-kilometer-long Nametsu River is no more than a trickle of water. *I would feel humiliated if I was the river*, I say to myself.

The newly built seawalls run solid as far as I can see, depriving visitors of any access to the beach. I manage to pull myself up to get on a seawall. I am shocked to find many rows of new concrete blocks covering the once-praised shoreline. There are simply too many of them, for no good reason. They do not seem to have been placed with any plan. I feel the complete lack of respect for the sea.

I begin to sob. The tsunami surely destroyed the area, but now someone has decided to change the seashore completely, with their own hands. And though the new seawalls are high, they will not stop the kind of tsunami that hit the Fukushima shore in 2011. And these concrete blocks are here to stay.

I am too distressed to walk back to the car to pick up costumes. I begin to move in my street clothes. The shutter sound of Bill's camera intensifies. The way he photographs makes me know I am now performing in my street clothes, something I have never done before. I am still crying.

In 2014, in the destroyed landscape I felt the lingering presence of the generations of the people who had lived in the area for centuries. Wearing my grandmother's kimonos not only added color to the landscape but also connected me to the dead. Their remorse moved me. But in the changed Fukushima I no longer feel a channel to connect to these long-ago people.

I am merely Eiko who just arrived here again. During this 2019 visit, I hardly have any desire to wear kimonos.

DECEMBER 25, 2019

Up north, at the mouth of Ota River and along its surrounding seashores, we come to a similar but more even more crowded landscape. There are rows and rows, hills and hills of concrete blocks. There are several sets of different shapes, indicating they have come from different construction companies. These were not laid down. These were thrown out, so carelessly. I feel dizzy. When I have no clue how people can do certain things in certain ways, I feel dizzy. Putting out such a large bulk of heavy concrete

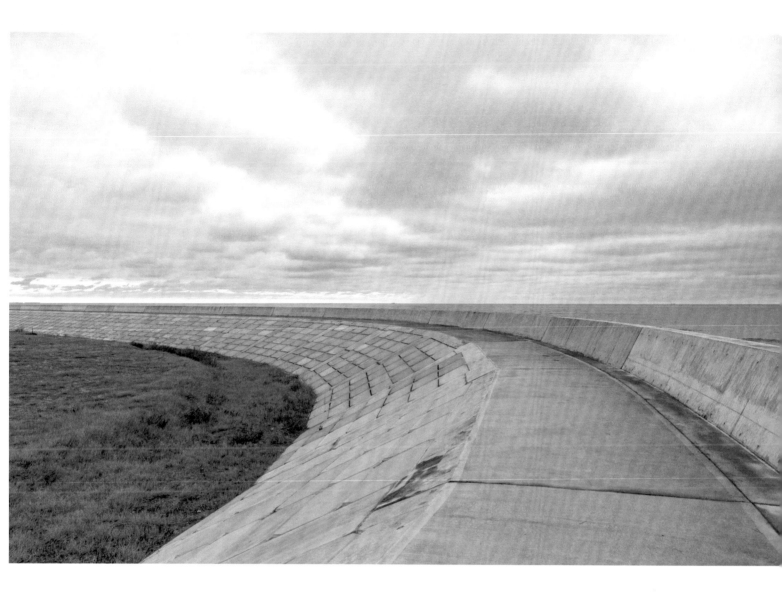

is not an easy task. One cannot really throw them without using large machines. I see a road built to do just that. I see no other function or people this road could possibly serve. Unlike Chernobyl, Fukushima Daiichi is not cemented-over to prevent further radioactive contamination. But so much of the Fukushima seashore is covered by concrete blocks.

We saw these already in 2016 and 2017. But now the intensity of destroying and altering the landscape is on another level. I feel sick to my stomach.

SHINMAIKO BEACH 新舞子浜 (above, and previous page)

WORKING WITH BILL

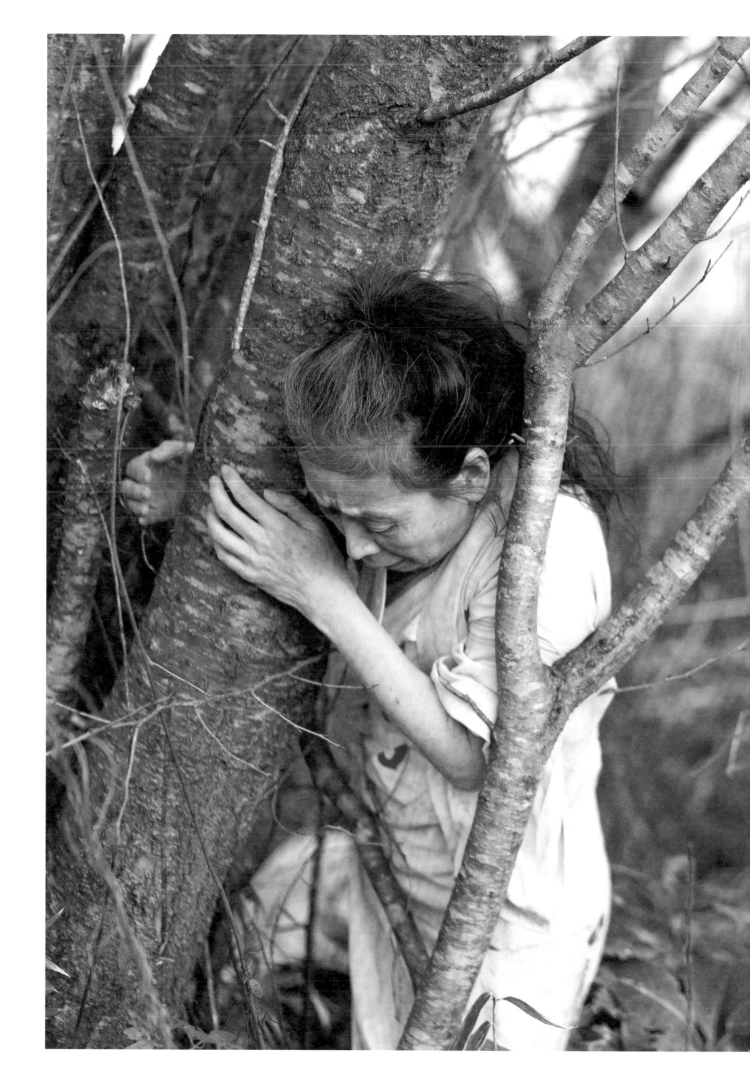

BEFORE MARCH 11, 2011, FUKUSHIMA WAS JUST THE NAME OF A PLACE. For me, a neighboring prefecture north of Tochigi prefecture, where my parents and I lived from when I was seven to eleven years old.

Since the nuclear meltdowns, many towns near the coast have frequently been in the news. People living far away have now learned the names of the communities most severely affected by the disaster and their distances from the Fukushima Daiichi Nuclear Power Plant.

But by being there and driving through the region, Bill and I really saw, and our bodies felt, that there are many "Fukushimas." Each house and each station within Fukushima prefecture had different memories and different feelings of hurt. We visited certain places twice, three times, even four times. The changes in these places showed us how humans intervene and accelerate time. In observing this, I appreciate that Bill is a trained historian as much as he is a photographer.

Soon after our December 2019 trip to Fukushima, Bill left for his Buddhist temple in Okayama, Japan, to sit and meditate. He has been a practicing Buddhist over forty-five years, much longer than I have known him.

Bill and I have different priorities, rhythms, life styles, knowledge, and training. Bill suggests that I meditate. I tell him I prefer to chew on my remorse, nurse my anger, and move with it. These emotions both immobilize and activate my body. Being *not able* to move is an important part of my movement work, indeed a source of all of my work. Not able, just as not being able to respond fast in words is also the base of how I talk and write. In this I remain to be a somewhat stubborn foreigner in the U.S. and in the dance field. Bill and I often have had to negotiate our vast differences to honor our commitments to working together.

When Bill went to his temple to meditate, I flew to China for a month-long residency, with an external hard drive that held tens of thousands of photos we had taken in our five trips to Fukushima. Then in mid-January, while Bill was analyzing the approaching threat of Covid-19, I was presenting a lecture at the Inside-Out Museum in Beijing. I shared with my Chinese audience the most recent photographs, many of which Bill had not yet had a chance to review thoroughly. The responses were intense. I felt that the Fukushima disaster was very much in the minds of Chinese people—at least those who have access to information and know that a "Fukushima" can happen in their country too.

One cannot see or smell radiation. From my first trip to irradiated Fukushima, I was keenly aware of this: I was in an irradiated area. And it is in Fukushima I learned that dancing alone is actually dancing with landscape, with the present time, and with the history of a particular place. I carried and re-examined that notion in all eighty-seven places I danced in Fukushima, and to all sixty-three other locations where I performed my solo *A Body in Places* for public.

While we were in Fukushima, Bill and I worked very closely together all day, everyday. The work with Bill actually head-started my Duet Project, without my recognizing it at the time. Thanks to Bill, I have since collaborated with twenty artists, including four who are now deceased.

My dances captured by Bill were never a solo. These photographs are duets with Bill. We hope both my body and his camera become conduits between viewers and Fukushima.

DISASTERS FAST AND SLOW

HISTORY, PHOTOGRAPHY, AND
THE ENVIRONMENT

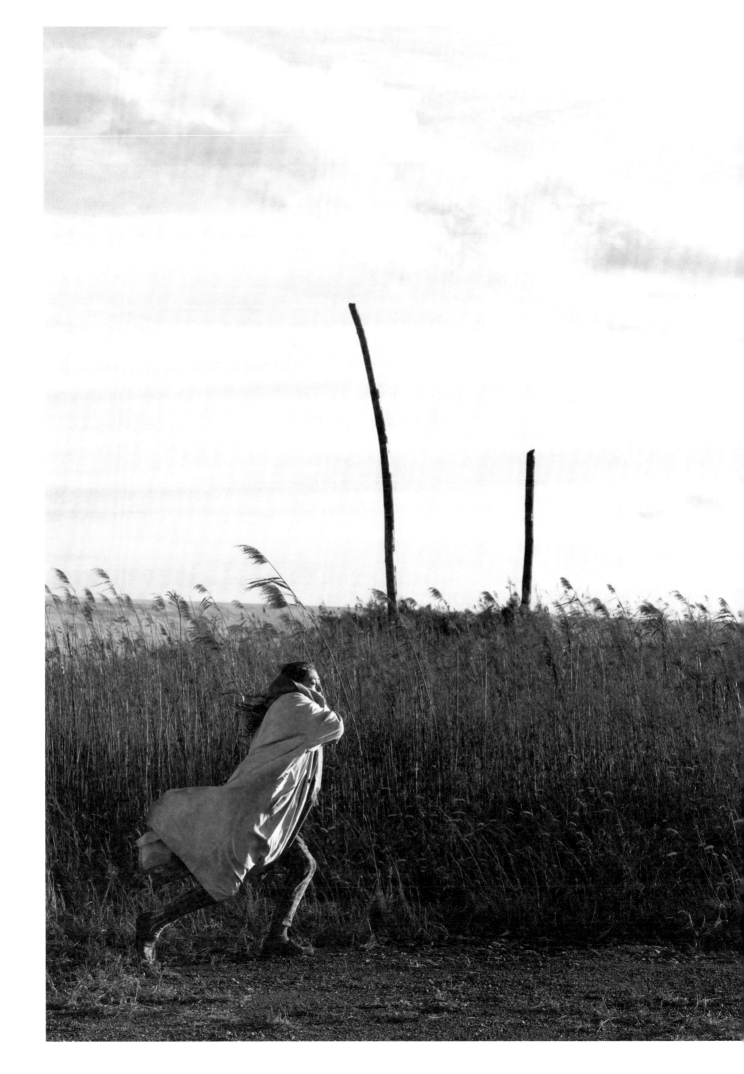

BEING A PHOTOGRAPHER

Until recently I have tended to think of my photographic life as fairly separate from my academic life. I've now had the good fortune to mount numerous exhibitions, yet few of my history colleagues are aware that I've been an avid photographer for over twenty-five years. Much of that time I primarily photographed landscapes, architecture, and still lifes using large-format cameras. For me, those images were reflections on a particular time and place in which I was especially conscious of the historical and environmental contexts. So in that respect, historical and environmental thinking have long been part of my photography.

At the same time technique fascinated me. I made platinum prints, hand-coating paper for contact prints from the large negatives. This itself had a historical quality. The technique originated in the late nineteenth century and changed little. It took an environmental catastrophe to move me technically from the nineteenth to the twenty-first century, pushing me from large, tripod-mounted cameras and sheet film to hand-held digital cameras and ink-jet color prints in order to pursue a collaborative project with Eiko Otake in post-March 11 Fukushima.

This all started in 2006, when I was invited to participate in a program on the Wesleyan campus that had the goal of integrating the performance arts into classes that normally have little connection with performance. It started at a lunch meeting where I met Eiko Otake, better known as half of the dance duo Eiko & Koma. They were well known among aficionados of modern dance around the globe. At the time we met, Eiko was working on a master's degree on atomic bomb literature at New York University, with a focus on the work of Kyoko Hayashi. Hayashi had survived the Nagasaki atomic bombing and then went on to create a body of fictional work based on her experiences of the Nagasaki bombing, her youth in Shanghai, and her later visit to the Trinity Site in New Mexico, where the world's first nuclear explosion occurred. For several years I had contemplated teaching a course on Japan and the atomic bomb that combined the history of science, warfare, diplomacy, and culture, and so I invited Eiko to co-teach with me a course called "Japan and the Atomic Bomb." By 2011, we had co-taught that course three times.

FUKUSHIMA

In the weeks after the Triple Disaster of March 11, as the combined earthquake, tsunami, and nuclear catastrophe have come to be called, Eiko and I had many conversations about their gravity. Both of us were disturbed at how the meltdowns of the Fukushima reactors were human-made disasters with political origins, facts that TEPCO, the company that ran the reactors, and many in the Japanese government strove to hide. In the summer of 2011, Eiko visited Fukushima. She recounted how witnessing the destruction that the earthquake and tsunami had caused was unforgettable. Even more pressing was the ongoing disaster of nuclear meltdowns and evacuations. Eiko asked: How was it that the only country ever attacked with nuclear weapons in wartime could inflict nuclear disaster upon its own people? Her anger and despair were palpable. They were to be expected; we shared those feelings. But I did not expect it when two years later, Eiko suggested that we go to Fukushima with the goal of creating a body of photographs in which she would perform in train stations along the Joban Line, the train

DISASTERS FAST AND SLOW
WILLIAM JOHNSTON

UKEDO 請戸 (previous page)

line that runs along the northeast coast of Honshu from Tokyo to Sendai. Before the disaster, the stations had hundreds of commuters coming and going every day. After March 11 most lay silent. Many were so highly irradiated that they were completely off limits.

We traveled to Fukushima first in January of 2014, and then again in July of that year. Almost as soon as we got there, however, it became obvious that not only the railway stations called for witnessing and documentation, so did many other places. After visiting Fukushima twice in 2014, it seemed prudent to stay away for a couple of years because of exposure to radioactivity, especially for Eiko, but we returned three more times, in August 2016, June 2017, and December 2019.

FAST AND SLOW DISASTERS

While the photographic aspect of this project is obviously central, the process also has allowed me to structure my thoughts about disasters, history, performance, and the environment. We need to consider disasters along a two-dimensional spectrum: one continuum is fast to slow; the other is causal, from "natural" to "human." Neither pole on either spectrum is completely independent of the other. In addition, both dimensions have histories. They are the result of change over time, whether the impetus be as distant as comets shifting the paths of asteroids or as intimate as mutable trends in societies, cultures, economies, and politics.

Moreover, photography gives us a means to reflect on environmental changes, especially those caused by disasters, whether fast or slow. By including a performer in those photographic images, they gain an emotional element that in this case might best be compared to a work of historical fiction. The images are honest and "real" but more artistic than journalistic.

The idea that we should understand disasters as both fast and slow is derived from the way many (and perhaps most) people think of disasters, whether natural or anthropogenic, as occurring over short periods of time. Earthquakes, tsunamis, tornadoes, floods, and volcanoes, for example, express themselves catastrophically over minutes, hours, or days. A search on the topic of disasters most often refers to them as compressed in time, defining them as "natural." Human-caused disasters ranging from rapidly unfolding explosions and fires to famines, wars, and genocides, may last months or even years, but even these, when considered in environmental terms, are of short duration. My thinking about slow disasters was inspired by Rob Nixon's book *Slow Violence and the Environmentalism of the Poor* (Harvard University Press, 2013). Nixon argues that environmental pollution often results in unhealthy living conditions for disadvantaged groups in a society, and results in violence to the body ultimately as damaging as beatings or bullets. It was clear to us that the Fukushima disaster needed to be considered in this context, over a timeline that long preceded and followed from the events of March 11.

What made the Fukushima nuclear disaster possible? While most accounts start with the magnitude-9 earthquake that occurred at 2:46 p.m. on March 11, 2011, followed by the enormous tsunami that swept the entire coast of northeast Japan, the Fukushima nuclear disaster actually started in the 1950s, or possibly before. The tsunami swamped the backup generators of the Fukushima Daiichi Power Plant, causing them to fail. But even more importantly, the flooding caused the external cooling pumps to

fail, since they weren't intended to be submersible. Even if the backup generators had not been made unworkable, the pumps could no longer circulate the sea water that was part of the normal cooling system. In short, the Fukushima Daiichi Power Plant was designed based on assumptions that the risk of such a catastrophic tsunami was insignificant: "beyond imagining" (*sōtei gai*), as TEPCO—the Tokyo Electric Power Company—repeatedly claimed. They had overlooked the history of major earthquakes and tsunamis in or close to Fukushima, recorded in the years 869, 1611, 1833, 1858, 1896, and 1936.

During the 1950s and early 1960s the Japanese government, encouraged by the United States government, started to make plans for construction of nuclear power-generation installations. They chose to build these far enough from Tokyo that their failure would not endanger the city, but close enough to maximize efficient electrical transmission. With government backing, the electrical industry courted relatively impoverished parts of the country such as Fukushima. Industry executives plied local leaders with promises that substantial income would enter their regional economy from the nuclear plants. School children invented slogans, and mayors and town councils boosted nuclear energy. Those who opposed or who argued that nuclear development came with immense dangers were silenced, sometimes with cash or other incentives and sometimes with threatened or actual violence.

A blind faith in technology was essential to silencing resistance. Engineers and corporate managers assured communities that nuclear energy would be safe, knowing well the dangers of technological failure. The promise of potentially unlimited electrical energy at low cost was attractive. This faith in technology was backed by a standing pattern of coordination and collusion between Japanese governments, both national and local, and private industry, with mutual back-scratching being a long tradition. Part of this practice was the falsification and misrepresentation of scientific and technical data by government and corporate officials. Their collusion is apparent in devastation caused by the Ashio Copper Mine, which continued for decades from the 1870s onward; in the Minamata Bay mercury poisonings of the 1950s and later; and in subsequent environmental disasters, both fast and slow. After its formation in 1955, the Liberal Democratic Party (LDP), which has dominated the office of prime minister and the national cabinet since, created cozy ties with companies and industrial organizations. The nuclear industry and complicit government bodies, especially when under LDP control, hid data that documented numerous accidents and failures at nuclear plants. Economic exploitation, technological overconfidence, and a culture of governmental and industrial prevarication were all causes of the March 11 disaster in Fukushima.

Government and corporate collusion continues in the aftermath of the Fukushima overheating and explosions. TEPCO, a regional monopoly, and Japanese authorities under the LDP have continued to work in lockstep. Government intervention has kept TEPCO from collapsing; without taxpayer support the company would have gone bankrupt soon after the meltdowns. TEPCO and government leaders boast about how smoothly the cleanup and recovery efforts are going at the reactor and surrounding areas—reflecting again a confidence backed by incomplete or inaccurate evidence. LDP leaders backed a plan to host the 2020 Olympic baseball competition in Fukushima to show the world that the nuclear emergency

was a thing of the past. And attempts by the International Olympic Committee and Japanese government to suppress the results of radioactive sampling from the stadium in which the games were to be held continued the trend of misrepresentation that goes back decades.

These are the grounds on which it is best to think of Fukushima as a slow disaster, one whose true consequences will require decades to become apparent—if indeed they ever do. If Fukushima follows the example of Chernobyl, dissembling and prevarication will continue indefinitely.

What supporters of the nuclear industry do not want us to know is that the "safe" limits for radiation are unknown. Pronuclear voices assert that below certain—if varying—limits, radiation is safe; and that under the guise of "hormesis," radiation in small doses improves health. Those voices might want to interpret Eiko's performances in Fukushima as evidence of how safe it has become. But that was not the voice that we heard when visiting Fukushima. Fear and uncertainty remained a sustained theme in each location. Yet those in power are not eager to engage in long-term epidemiological studies of radiation across the region. The withholding of data and halting of research helps those who proclaim the safety of nuclear technology. It also helps ensure a slow, long-term disaster.

The idea of slow disasters seemed to me a logical continuation from the idea of slow violence. I eventually discovered that Scott Gabriel Knowles, a historian of technology, catastrophes, and public policy, had previously published an essay entitled "Disasters Fast and Slow." His discussion seemed particularly apt in the case of Fukushima, as he writes: "The slow disaster stretches both back in time and forward across generations to indeterminate points, punctuated by moments we have traditionally conceptualized as 'disaster,' but in fact claiming much more life and wealth across time than is generally calculated." Knowles also cites Rob Nixon's *Slow Violence* to emphasize the need to reconsider our thinking about environmental damage. As Nixon writes, "We need to engage a different kind of violence, a violence that is neither spectacular nor instantaneous, but rather incremental and accretive, its calamitous repercussions playing out across a range of temporal scales. . . . The long dyings—the staggered and staggeringly discounted casualties both human and ecological that result from war's toxic aftermath or climate change—are underrepresented in strategic planning as well as in human memory."

The nuclear disasters of Chernobyl and Fukushima are best thought of in this way, as forms of slow violence expressed over time as vast and continuing disasters.

NATURAL VS. HUMAN

While what happened and continues to happen at Fukushima reflects the characteristics of both fast (earthquake and tsunami) and slow (nuclear contamination) disasters, this combination also points to the necessity to think carefully about relationships between natural and anthropogenic cataclysms.

Most definitions of "disaster" refer to catastrophic events that result in great loss of life, property, or both. In short, they focus on how these events affect humans. And disasters are almost invariably divided, as previously noted, into natural and human-induced. Yet so-called natural disasters do not occur only because of forces in nature. There are natural hazards, and there are human conditions—social, cultural, and economic—that make

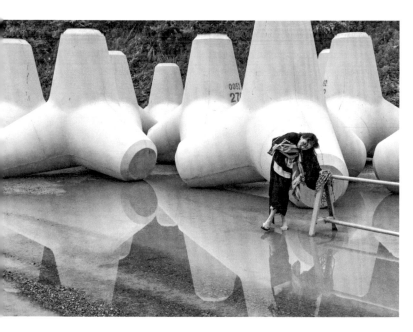
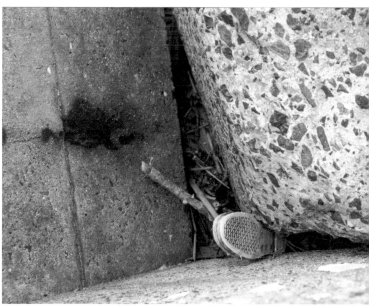

natural hazards into disasters. If Lisbon had not been built where it was, with its characteristic architecture, the 1755 earthquake that shook both Portugal and Europe more broadly would not have resulted in the subsequent region-wide destruction. For cultures in which people expect natural hazards, such as the indigenous Calusa peoples of southern Florida, who maintained structures that could be easily fled and rebuilt at short notice in response to flooding or hurricanes, those natural hazards do not constitute a disaster. The category of "disaster" is culturally determined. Not all hazards are disasters and whether they become catastrophic depends on local knowledge and practice.

Furthermore, in this age of anthropogenic climate change, massive earthworks, unprecedented subterranean drilling, and colossal injections of chemicals into the earth through fracking, there are few environmental phenomena that humans have not influenced. Earthquakes, floods, droughts, hurricanes, and tornadoes have all been caused directly or influenced indirectly by human interventions in the environment.

We must, in other words, re-structure our understanding of disasters. One step in that direction is to recognize that our landscapes are hybrid: the lines between human and non-human environments have been blurred for millennia. Toxic chemicals, dispersal of plastic waste, various forms of air and water pollution, acid rain, ozone depletion, sea-level rise, ocean acidification, and radiation from nuclear power, all of which have human causes, are also natural events, as is the global dissemination of Covid-19. A division between humans and nature is itself illusory. Humans and nature are inseparable.

Radiation from nuclear power obviates the line between the natural and human worlds in multiple ways. While there is natural radiation from numerous sources, the most dangerous forms are the result of human activity. Until the Manhattan Project, there was little chance of terrestrial radiation being concentrated enough or produced in sufficient quantities that its effects would be catastrophic. That changed from 1945.

The site of the Hanford reactor in Washington state, where the plutonium for the Nagasaki and later nuclear bombs was made, became one of the first slow disasters from anthropogenic radiation. Although shut down

for decades, its radiation will remain dangerous for centuries to come. The Trinity test, followed by the Hiroshima and Nagasaki bombings, began the release of radiation through atmospheric nuclear blasts; between then and 1993, there were at least 528 tests conducted in the atmosphere, and between 1945 and 2017 there were 1,528 underground blasts. These put significant amounts of radioactive materials into the environment, enough to create a unique geological stratum around the globe, marked by distinct radioactive traces. When I was in primary school, every now and then we were told not to eat the snow because a nuclear detonation had occurred somewhere, making the snow radioactive and dangerous if ingested.

Nuclear radiation releases have been both fast and slow, and these affect not only humans but potentially all forms of life on earth. The bombings of Hiroshima and Nagasaki were relatively fast disasters, as both cities became habitable within months of the bombings. Yet the efforts to make materials for those bombings in in Hanford, Washington, and Oak Ridge, Tennessee, are ongoing disasters. Chernobyl and Fukushima combine fast and slow disasters.

Nuclear power plants, even when operating routinely, are slow disasters. Ample evidence exists that in their immediate vicinity, radiation is causing genetic mutations in many organisms, including insects and birds; and the wastes produced by these facilities will be dangerous essentially forever. Despite the guidelines of the International Atomic Energy Agency and similar organizations, scientists continue to question whether there is a minimally safe level of exposure to radiation for humans, and if so for what forms of radiation. Some sources of radiation, for instance plutonium, seem to have no safe dose. Another problem is that nuclear watchdog agencies worldwide are also advocates of nuclear power, an inherent conflict of interest. As a consequence, governments and private interests have provided little funding for basic research regarding the release of radiation by "normally operating" nuclear sites. Their proponents want to see these technologies as closed systems that have no effect on their surrounding environments, when in reality their effects are widespread and profound. Nor have nuclear advocates allowed long-term longitudinal studies of populations exposed to accidental releases, including those in Chernobyl and Fukushima.

FAITH IN TECHNOLOGY

The environmental historian Sarah Pritchard, who has written extensively on the ecology of the Rhône, has described the danger of unquestioning trust in technology, acknowledging the writings of Charles Perrow, author of *Normal Accidents: Living with High-Risk Technologies*. Pritchard has written, "it is misleading, if not hazardous, to use the common term accidents to describe situations like Fukushima because it minimizes the inherent risks of modern technological systems. Such language implies that accidents are caused by technical glitches or human error when instead they should be understood as inherent to those systems. In short, accidents are normal and systemic, not extraordinary and inadvertent."

The complexities of these systems make accidents inevitable. We see this on our highways, in our mines and factories, in the abuse of opioid pain killers, in spills arising from petroleum drilling and the transportation of chemicals, and in many other loci in which technology, humans, and environments intersect. This is especially true for nuclear energy, whether used

for electrical generation or for weapons, since the consequences of accidents are so severe and long-lasting.

STILL PHOTOGRAPHY AS HISTORICAL RECORD

The human costs of these accidents, as well as the environmental impacts of technology, are hard to fathom. Still photography provides one method to make visible both non-disastrous and disastrous environmental changes. Photographers have long realized the importance of their medium in this respect, as have historians. When attempting to understand any disaster since the invention of the medium, photographs are one of the most dependable of visual media. While it has always been possible to manipulate photographs, when minimally manipulated their ability to document an event or situation makes the medium one of the best methods of understanding historical change.

Since the nineteenth century, the capacity to reproduce visual imagery through photography and auditory sensations through recordings have transformed how we perceive the past. Analogue recordings and photographs, and now digital recordings and photographs, give us a close approximation to how things looked or sounded at a certain time and place.

Still photographs are a particularly powerful medium of perception. When we remember something visually, we tend to remember single moments in time rather than a video-like replay. This is why, for example, people remember the still photograph by Eddie Adams of the Saigon execution that took place during the Tet Offensive in 1968 rather than the moving images of the same event. We can recall a still image much more easily than we can recall moving imagery.

Yet how we understand a photograph depends on how we read it, and in no small part that depends on the information that accompanies an image. To Eddie Adams himself, the execution photograph showed how the South Vietnamese dealt with a terrorist who had just killed several innocent civilians. To many contemporary viewers, who lacked that information, this was an image of the senseless violence perpetrated in Vietnam and became a strong motivator for those who opposed the war—exactly the opposite of what Adams intended.

The same is true for rural and urban landscape photography. Even without contextual information, a well-composed and vividly reproduced landscape can captivate a viewer. Yet contextual information is almost always necessary to position the image historically in time and place. As the landscape photographer and writer Robert Adams explained, a well-executed landscape should be geographical, autobiographical, and metaphorical. Adams added that geography alone can be boring, autobiography can be trivial, and metaphor can be dubious. However when all three work together they become much more than a sum of the parts. The significance of place, the photographer's own interactions with that place, and a sense of that place representing more than one specific location can combine to make a photograph into an illuminating historical document and a resonant work of art. This is all the more important today, a time when documenting the environmental and ecological changes that fast and slow disasters are causing is nothing less than an imperative.

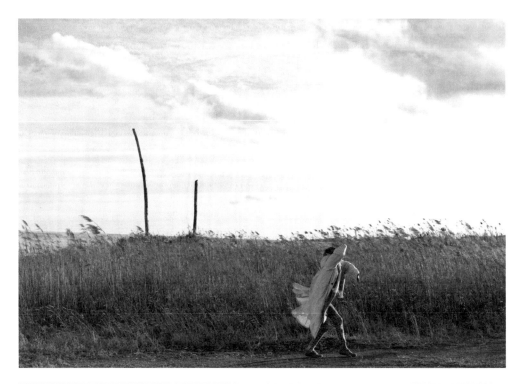

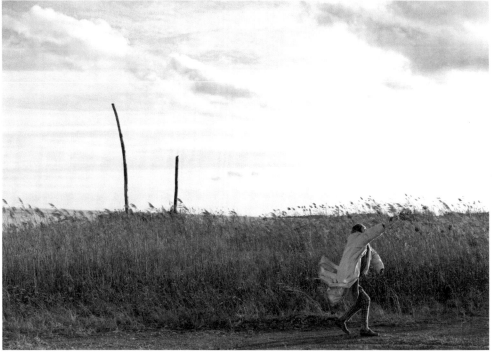

UKEDO 請戸 (above), YAMADAHAMA SEAWALL 山田浜防波堤 (next page)

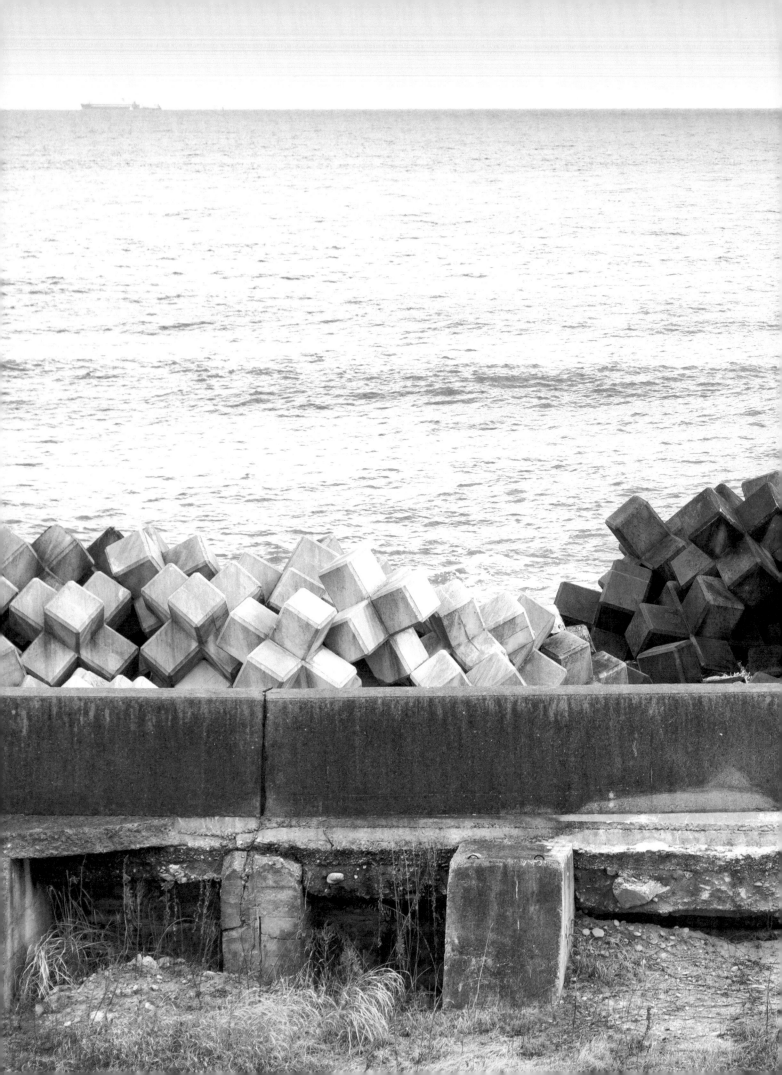

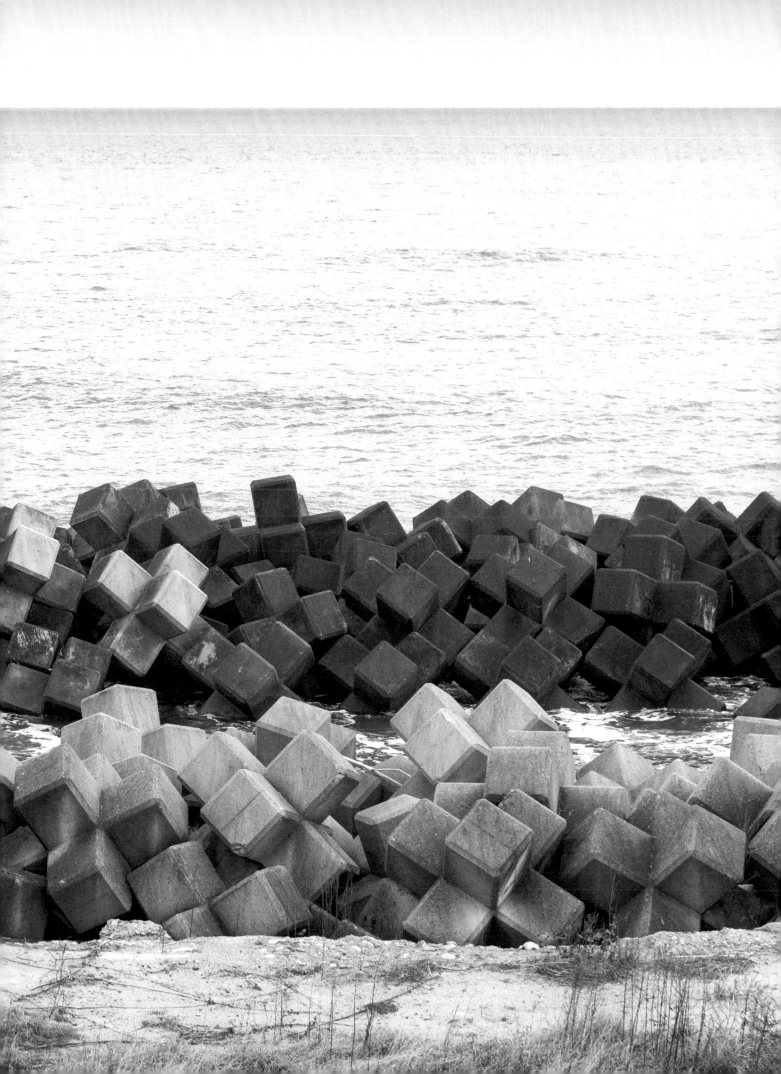

WHILE TEACHING CLASSES ON THE HISTORY OF THE ATOMIC BOMBINGS and nuclear disasters of Japan, Eiko and I assigned a book entitled *After Fukushima: The Equivalence of Catastrophes* by the philosopher Jean-Luc Nancy. He emphasizes how all catastrophes are networks of human actions and natural hazards. Forms of injustice, moreover, whether social, environmental, political, or economic, are also interlinked.

As Nancy emphasized, structural inequities of many different kinds combine in networks of interrelated power relations, which become most obvious when the relationships between humans and their environment change balance. Humans often imagine that they are keeping the advantage on their side, under the delusion that they can control nature. That delusion's unveiling reveals the levers of power that maintain inequalities. Those in power fear losing their advantages and do all they can to monopolize them. The suffering of those who were exposed to radioactivity in Fukushima and forced to leave their homes was the result of a system that also creates inequalities for those suffering from Covid-19 and discriminatory policing. As well as all the many other ongoing disasters, fast and slow. All are related. **WJ**

IN THE SPRING 2020, MORE THAN A FEW AMERICAN FRIENDS FAMILIAR with our work in Fukushima told me how streets in New York and other US towns impacted by Covid-19 were "so deserted" that they remembered Bill's photos from Fukushima. The scenes of a "no-man's-land" they thought unbelievable suddenly became familiar. A nuclear plant or a great city—everything humans make is breakable. We are breakable. All are fragile. We know this now more clearly than ever.

The Fukushima nuclear disaster is ongoing, and many of us know that every nuclear plant all over the world threatens the same danger. Especially while our lives are shaken by many unknowns and restrictions due to Covid-19, we must be more vigilant than ever about nuclear issues.

A Body in Fukushima is our letter to the future about what we witnessed, what we do not want to forget, and what we do not want to be forgotten. **EO**

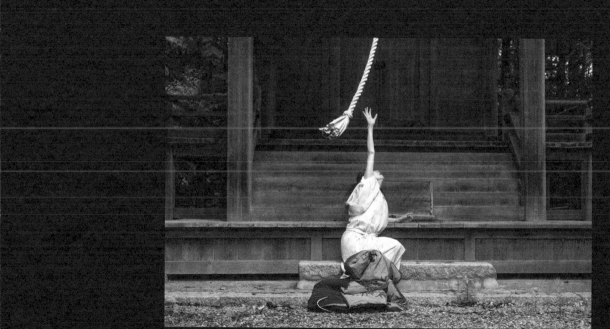

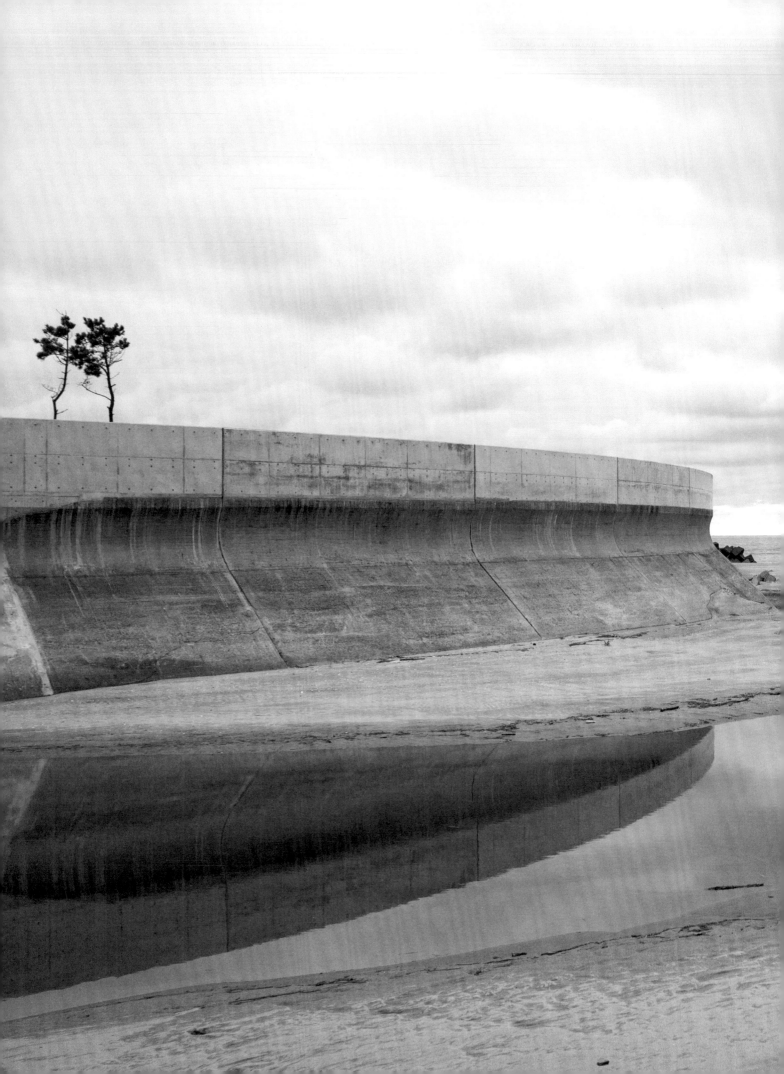

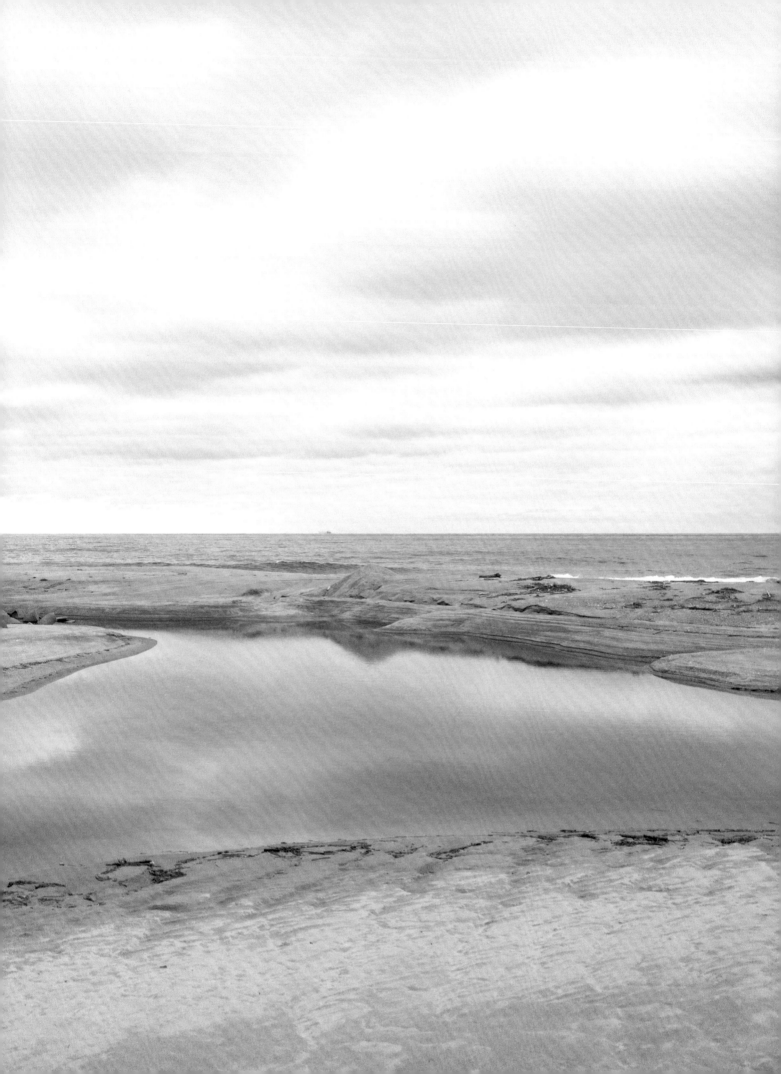

ACKNOWLEDGMENTS

EIKO OTAKE AND WILLIAM JOHNSTON

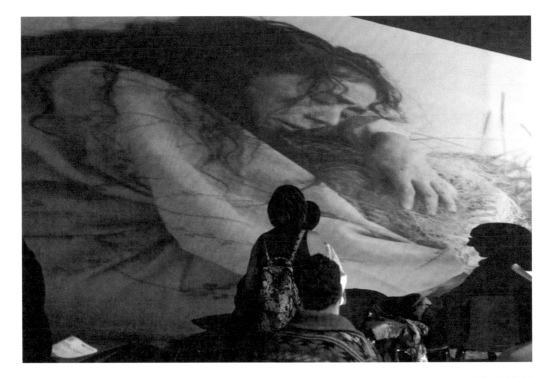

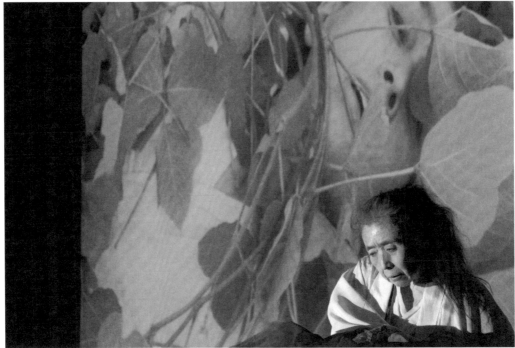

EO Several artists' have deeply influenced my thinking about going to Fukushima, and what it means to bring one's body to a place and reflect on one's experience there. Japanese novelist Kenzaburo Oe, who has sustained his active involvement in anti-nuclear and peace movements, repeatedly visited Hiroshima to write his *Hiroshima Notes*. More intimately, the late Kyoko Hayashi affected me deeply. Hayashi traveled as far as the Trinity Site in New Mexico and also visited Tokaimura where Japan's first casualty from a critical accident occurred at Japan's oldest nuclear plant. In the world of dance, I have been particularly inspired by the humility and bravery of Kazuo Ohno and Anna Halprin. Both are my dear teachers, and they danced everywhere possible.

I thank the presenters and curators I have worked with. I am a performer only because I have performed many times in many places.

At Wesleyan University, I am grateful for the support of the Center for the Arts, the Dance Department, and the College of East Asian Studies, in particular CFA's directors, Pam Tatge, Sarah Curran, and Jennifer Calienes, and their staff. Barry Chernoff at the College of the Environment offered me a one-year fellowship, where I created a video compilation of *A Body in Fukushima*. This allowed me to see the narrative and emotional trajectory within our multiple trips to Fukushima.

Linda Belans, Luisa Bryan, Rosemary Candelario, Suzanne Carbonneau, Holly Fisher, Iris McCloughan, Alexis Moh, Charlotte Strange, Shingo Umehara, and Tracy Williams have advised and helped me in editing. David Harrington has gifted me his sound. Lin Hwai Min translated and presented my Fukushima film in Taiwan. Wen Hui recently introduced the film in China, and Yumi Sagara and Reiko Aoki did so in Japan. These are incredibly passionate people I am lucky to have worked with.

My former assistant Nora Thompson helped me to structure the book and to select writing topics. Always ready to help me, my current assistant Allison Hsu kept me from derailing.

My friends have generously offered their time and attention. These include but are not at all limited to, Roger Bernstein, Bonnie Brooks, Cecily Cook, Rachel Cooper, Nicole Gordon, Yukie Kamiya, Mirda Kirn, Paula Lawrence, Takashi Okada, Irene and Paul Oppenheim, Martha Roth, Ralph Samuelson, Yoko Shioya, and Sharon Wyeth; archivist Patsy Gay; and my long-time manager Ivan Sygoda. A very special thank you goes to Hiroko Otsu, who first took me to irradiated Fukushima in 2011.

My partner Koma worked with me for forty-two years and supported my solo activities, including my working in Fukushima. Our sons, Yuta and Shin, and my parents, especially my mother, have helped my work throughout their lives. No one I mentioned above has limited their involvement to the roles I have mentioned here. For that, I am deeply grateful.

I sincerely thank Bill for accompanying me to Fukushima and for printing pictures himself for exhibitions.

WJ There are many persons who have helped me over the years in ways that have contributed to this project. Phil Trager and Rex Hennessey have provided technical assistance with photography and generous encouragement. Andy Szegedy-Maszak and Elizabeth Bobrick have been unstinting in their support of my photographic pursuits. Sasha Rudensky, Tula Telfair,

Julia Randall, and Keiji Shinohara, my friends and colleagues at the Wesleyan University Department of Art and Art History, also provided substantial suggestions and support. The Office of Academic Affairs provided support that helped make this project possible. Wayne Soon at Vassar College and Hoi-eun Kim at Texas A&M University hosted me to present earlier versions of "Disasters Fast and Slow"; they and their colleagues made comments that improved this essay. In Japan, Taeko and Kenji Seki opened their home to me as a base in the Tokyo area, which has been warm and welcoming over the course of more than forty years. My Zen teacher, Suzuki Seidō, Rōshi, has been encouraging throughout the years I've pursued this project. Above all, I would like to thank my partner Ikumi Kaminishi for her generosity, support, and companionship over many decades. WIthout Eiko having invited me to join her in this project none of this would have happened. Thank you.

EO & WJ Together, we would like to thank: Suzanna Tamminen and the Wesleyan University Press staff for publishing this book; Jim Schley for his passionate involvement and invaluable advice regarding copyediting; Lucinda Hitchcock and Cara Buzzell for their outstanding book design; Redwing Book Services for production management; Maureen Knighton and the Doris Duke Charitable Foundation for generous support; Harry Philbrick for first presenting our Fukushima photos to American audiences at Pennsylvania Academy of the Fine Arts; Daphne Geismar for conceptual advice; the Mellon Foundation for supporting the Center for Creative Research, which made Eiko's first years of residency at Wesleyan possible; the Japan Foundation and the National Dance Project for supporting our first trip to Japan as a part of Eiko's solo project.

We are grateful to the presenters, scholars, curators and their staffs who have shown our Fukushima photo exhibitions and videos. Pam Tatge, as director of the Center for the Arts at Wesleyan University, worked with curators Clare Rogan of the Davison Art Center and Patrick Dowdey of the College of East Asian Studies to present Wesleyan's first three gallery exhibitions. Later, as a director of Jacob's Pillow, Pam exhibited our photos during their 2017 festival as well as in the municipal library and a gallery in Pittsfield, Massachusetts. Jodee Nimerichter of the American Dance Festival also put up extensive multi-site exhibitions throughout the 2015 festival and showed more photographs in 2016.

On March 11, 2016, the fifth-year anniversary of the Fukushima disaster, Danspace Project director Judy Hussie-Taylor and then-managing director Lydia Bell co-curated with Eiko a 24-hour Fukushima exhibition during which many artists and scholars performed and conversed with us. Later that fall, Lisa Schubert of the Cathedral of St. John the Divine opened our photo exhibition in the nave. It is in the Cathedral that we presented two more 3.11 memorials.

In 2017, Limor Tomer of the Metropolitan Museum of Art commissioned *A Body in Places Met Edition*, for which Eiko performed and projected her video of Fukushima images all day at Met's three buildings. In 2019, Takashi Fujitani at the University of Toronto presented a special event *A Body in Fukushima: Reflections on the Nuclear in Everyday Life* with a performance, panel, screening, and multi-site exhibition.

Other presenters and curators include Jim Cheng of Columbia University's Starr East Asian Library, Doryun Chong of M+ Museum in Hong

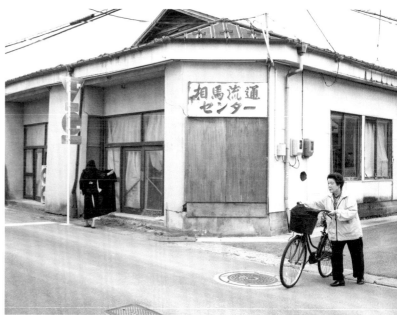

Kong, Gabriel Florenz of Pioneer Works, John Killacky of the Flynn Center for the Performing Arts in Vermont, Daisy McConnell of the University of Colorado in Colorado Springs Gallery of Contemporary Art, Carmen Romero of the Santiago a Mil International Theater Festival, Erin Boberg Doughton and Kristan Kennedy of Portland Institute for Contemporary Art, and David White of the Yard. Without these people, their staff, and Eiko's assistants who labored on shipping and installing, our Fukushima photographs would not have been seen by so many people. For a project timeline see: www.eikootake.org/timeline-of-a-body-in-fukushima.

We are grateful for scholars Marilyn Ivy, Joshua Chambers-Letson, and Karen Shimakawa for introducing and reflecting on our photographs in their presentations. To Karen, thank you for coming to Fukushima with us in 2019.

Additionally, we thank: C.D. Wright and Forrest Gander, for coming to Santiago, Chile to recite their poems and asking their Chilean poet friends to do the same in the gallery with our Fukushima photos prior to Eiko's performances; Arnie Gunderson and Jake Price, for visiting Fukushima multiple times ahead of us and providing reliable information and contacts; Rauschenberg Foundation Residency director Ann Brady and her staff for the help in making large size prints.

In Fukushima, we thank: Tomoko Kobayashi and everybody at Futabaya Ryokan; Miri Yū, novelist and owner of the Full House Bookstore in Odaka; artist Keisyu Wada; Nobuki Yamamoto of Art Meeting; and the people we met in the hotels, stations, and restaurants in Fukushima, for telling us their experiences.

We deeply acknowledge the students of the classes we taught together and separately. Our past, current, and future students and perhaps those yet to be born are those of whom we think foremost as we publish this book.

We especially thank the late Sam Miller for so many layers of help we cannot even begin articulating. We regret that Sam, Kyoko Hayashi, and C.D. Wright cannot hold this book in their own hands, but we trust that their gazes live in these photographs.

TOMIOKA TOWN 富岡町 (above left), SOMA CITY 相馬市街 (above right)

FURTHER READING
WILLIAM JOHNSTON

WJ The Fukushima nuclear catastrophe has resulted in a large number of books, academic and popular, along with articles, manga, and works of art.

Many of the publications are scientific, examining regional and global impacts, including the effects of radiation exposures on the bodies of humans and animals, or the effects of the disaster on agriculture and the fishing industry. Some analysts seek lessons for the nuclear power industry and how it can be made safer and more efficient. Others reveal the political, economic, and technological structures that made the Fukushima disasters possible. The enormous number of available works can be confusing.

For a straightforward explanation of how the explosions, meltdowns, and radioactive leaks occurred and how TEPCO and the Japanese government responded to them, an excellent book is *Fukushima: The Story of a Nuclear Disaster* by David Lochbaum, Edwin Layman, Susan Q. Stranahan, and the Union of Concerned Scientists (New Press, 2014).

Naoto Kan, who was the prime minister of Japan at the time of the meltdowns, has written a memoir of those events and his reflections since: *My Nuclear Nightmare: Leading Japan through the Fukushima Disaster to a Nuclear-Free Future*, translated by Jeffrey S. Irish (Cornell University Press, 2017).

Local residents, journalists, and artists have made innumerable photo images of the Triple Disaster of March 11, 2011. The Museum of Fine Arts in Boston has produced the book *In the Wake: Japanese Photographers Respond to 3/11* (MFA Publications, 2015), based on an exhibition curated by Anne Nishimura Morse; along with the work of fifteen Japanese photographers, the book includes incisive essays by the anthropologist Marilyn Ivy and others.

A volume of powerful photographs revealing the transformation of Fukushima in the aftermath of the disasters is *Retracing Our Steps: Fukushima Exclusion Zone 2011–2016*, with images by Carlos Ayesta and Guillaume Bresson and text by Christian Caujolle (Kehrer Verlag, 2016). This book includes photographs of the landscapes of post-3/11 Fukushima and of people who evacuated, later returning to their work places and homes, which had been empty since March 2011.

Artistic responses to the Fukushima meltdowns and subsequent events are explored in *Fukushima and the Arts: Negotiating Nuclear Disaster*, edited by Barbara Geilhorn Kristina and Iwata-Weickgenannt (Routledge, 2016), which includes essays on photographic, literary, theatrical, and musical works.

A personal interpretation from the perspective of an emergency worker in the early weeks that followed the disasters can be found in a manga by Kazuto Tatsuta, *Ichi-F: A Worker's Graphic Memoir of the Fukushima Nuclear Power Plant*, translated by Stephen Paul (Kodansha Comics, 2017), which focuses on the heroism of workers while avoiding issues of negligence by TEPCO and the widespread impacts of the radiation released across Fukushima Prefecture and beyond.

A bibliographic essay on all the available works about Fukushima would require many pages. We encourage readers to seek out and explore the numerous works that artists, writers, composers, literary critics, scientists, social scientists, and others have created in the intervening decade.

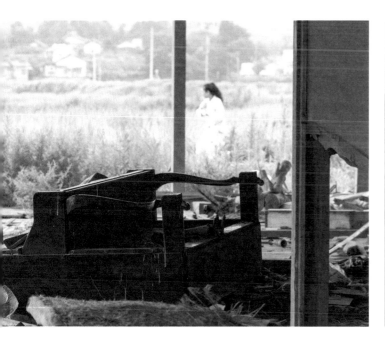

And I would like to make one final plea, which is that readers not equate the name "Fukushima" only with nuclear destruction, any more than we should do so with "Hiroshima" and "Nagasaki." All three sites of Japan's nuclear disasters have long and complex histories, profound cultures, and diverse ecologies, both preceding those disasters and continuing since them. We should honor these places as they've endured over time, both before and after the terrible events that have made them famous.

ABOUT THE AUTHORS

EIKO OTAKE, born and raised in Japan and a resident of New York since 1976, is a movement-based, interdisciplinary artist and performer. She worked for more than forty years as Eiko & Koma performing their own choreography worldwide. Handcrafting sets, costumes and sound, they created forty-six interdisciplinary performance works, two career exhibitions, and numerous media works. Since 2014 Eiko has performed her own solo project *A Body in Places* and in 2017 she launched a multi-year *Duet Project*, a series of collaborations with artists of different backgrounds and disciplines, living and dead. Eiko teaches about massive violence and movement study at Wesleyan University, New York University, Colorado College and Tokyo University. www.eikootake.org.

WILLIAM JOHNSTON was born and grew up in Rawlins, Wyoming. He received his BA from Elmira College, in Elmira, New York, and his MA and PhD from Harvard University, and also studied in Japan at Nanzan University and the University of Nagoya. Since 1988, he has been employed at Wesleyan University in Middletown, Connecticut, where he is the John E. Andrus Professor of History; he is the author of two monographs and numerous essays. Johnston has practiced photography since he was a high school student, for many years using large-format cameras.

YABUREMACHI 破町 (above left), SHINMAIKO BEACH 新舞子浜 (above right)

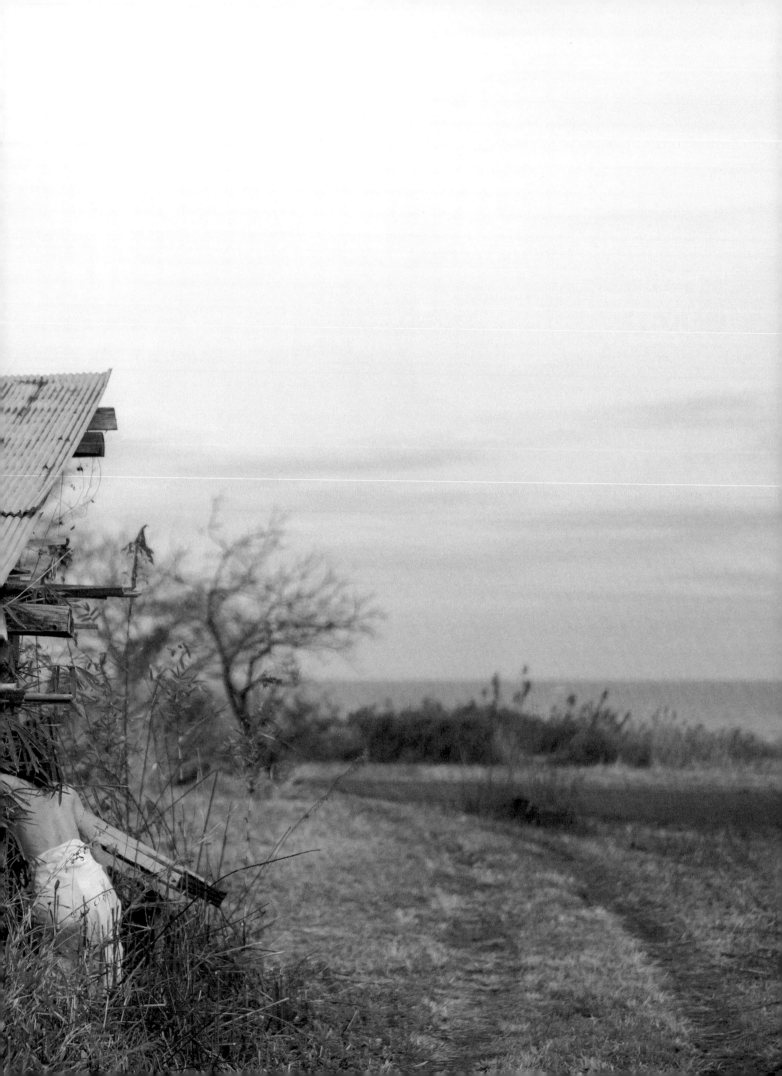

Wesleyan University Press
Middletown, CT 06459
www.wesleyan.edu/wespress

Texts © 2021 Eiko Otake and
William Johnston;
photographs © 2021 William Johnston.
Two photographs on page 209 are used
by courtesy of the photographer:
© Lev Radin Photography, @levradin

Designed by
Cara Buzzell and Lucinda Hitchcock
Typeset in Eric Olson's *Maple*
and Colophon's *Aperçu*

Manufactured by die Keure Printing in
Bruges, Belgium

The publisher gratefully acknowledges
the generous support of the Doris Duke
Charitable Foundation in the publication
of this book.

Library of Congress Cataloging-in-
Publication Data is available in the
online catalog: https://catalog.loc.gov

hardcover 978-0-8195-8026-9
ebook 978-0-8195-8025-2

5 4 3 2 1

"Dignity" is excerpted from an essay
published in *The Christa Project* catalog,
October 2016.

"Time" was presented in an earlier version
on January 7, 2009, as part of a 24-hour
Program on the Concept of Time at the
Guggenheim Museum in New York City.

"Ahh, Ah, Ah, Ah" was originally pub-
lished in an earlier version in *Asia-Pacific
Journal: Japan Focus* 15, issue 7, number
3 (April 1, 2017), https://apjjf.org/2017/07/
Hayashi.html

Locations and dates for uncaptioned
photographs:

page 3: Tomioka Fishing Harbor 富岡漁港
(2014); pages 4: Shinmaiko Beach
新舞子浜 (2014); pages 5 and 6 (left): Ota
River 太田川河口 (2019); pages 6 (right),
7, and 8: Shinmaiko Beach 新舞子浜 (2014);
pages 10 and 11 (left): Shinmaiko Beach
新舞子浜 (2014); pages 11 (right), 12, and
13: Ukedo Beach 請戸海岸 (2017); pages
14–15: Hattachi Benten 波立弁天 (2016);
page 73: Sakamoto Station 坂元駅 (2011);
page 76: Sakamoto Station 坂元駅 (2011);
page 130: photo by Eiko Otake; page 283
(right): photo by Eiko Otake; page 284–85:
Tsunobeuchi 角部内 (2019); page 286:
Shiogama Shrine 塩釜神社 (2017); page
287, top to bottom: Namie Town 浪江町
(2016), Fukushima City 福島市街 (2016),
Soma City 相馬市街 (2017); and page 288,
top to bottom: Tomioka Harbor 富岡漁港
(2017), Fukushima City 福島市街 (2016),
Soma City 相馬市街 (2017).

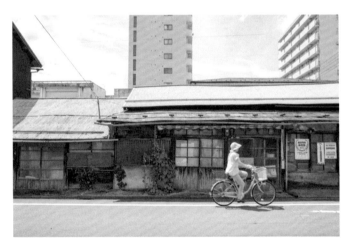

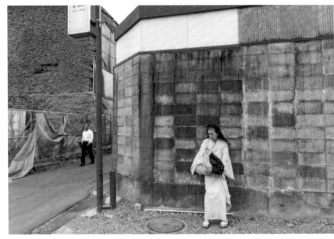